Routledge Revivals

The Earth, Humanity and God

Originally published in 1994, *The Earth, Humanity and God* discusses the relationship between science and religion. The book discusses the condition of the earth (as it was at the time of publication) and the future prospects of the planet, arguing that neither the conventional "mechanistic" view nor "New Age" philosophy helps alone in evaluating our relationship with the Earth. The book examines methods of combatting the threats to the Earth exploring both a scientific and non-scientific stance, investigating the uncontrolled expansion of technology as well as empirical pre-scientific mysticism. The book also explores the resurgence in ancient ideas of "Mother Earth" as a dangerous piece of romantic irrationality and suggests, that these views pose a danger to religious/scientific examinations. The book suggests instead a hard-headed attempt to relate Biblical and scientific data, and that this in turn can yield a valuable new understanding of the problems facing the world.

The Earth, Humanity and God

The Templeton Lectures Cambridge, 1993

by Colin A. Russell

First published in 1994
by UCL Press

This edition first published in 2018 by Routledge
2 Park Square, Milton Park, Abingdon, Oxon, OX14 4RN
and by Routledge
52 Vanderbilt Avenue, New York, NY 10017

Routledge is an imprint of the Taylor & Francis Group, an informa business

© 1994 Colin Russell

All rights reserved. No part of this book may be reprinted or reproduced or utilised in any form or by any electronic, mechanical, or other means, now known or hereafter invented, including photocopying and recording, or in any information storage or retrieval system, without permission in writing from the publishers.

Publisher's Note
The publisher has gone to great lengths to ensure the quality of this reprint but points out that some imperfections in the original copies may be apparent.

Disclaimer
The publisher has made every effort to trace copyright holders and welcomes correspondence from those they have been unable to contact.

A Library of Congress record exists under LCCN: 94183898

ISBN 13: 978-0-367-26121-4 (hbk)
ISBN 13: 978-0-367-26205-1 (ebk)
ISBN 13: 978-0-367-26204-4 (pbk)

The Earth, Humanity and God

The Earth, Humanity and God

The Templeton Lectures
Cambridge, 1993

Colin A. Russell

© Colin Russell, 1994

This book is copyright under the Berne Convention.
No reproduction without permission.
All rights reserved.

First published in 1994 by UCL Press

UCL Press Limited
University College London
Gower Street
London WC1E 6BT

The name of University College London (UCL) is a registered
trade mark used by UCL Press with the consent of the owner.

ISBN:
1-85728-145-4 HB
1-85728-146-2 PB

British Library Cataloguing-in-Publication Data

A catalogue record for this publication is
available from the British Library

Typeset in Baskerville.

Contents

Preface	vii
Acknowledgements	ix
1 Introduction	1
2 The Earth in space	6
From isolation to integration	6
From fixity to mobility	9
From organism to mechanism	12
3 The Earth in time	19
A static Earth	20
An Earth in decay	21
An Earth in equilibrium: cycles restored?	26
An Earth of great antiquity	28
4 Fragile planet	35
Perils for the planet	36
Technological responses	46
Theological responses	49
5 "Hurt not the Earth"	51
Visions of Apocalypse	51
Science and environmental problems	56
The special case of the chemical industry	58
The problems of nuclear technology	67

CONTENTS

6	***Foes of the Earth***	**72**
	Human ignorance	72
	Human greed	79
	Human aggression	82
	Human arrogance	86
7	***"Mother Earth?"***	**94**
	The antiquity of "Mother Earth"	96
	Empirical justification	99
	Return to myth?	104
8	***Gaia***	**107**
	Self-regulating systems	107
	The threefold meaning of Gaia	116
	The manifold uses of Gaia	118
9	***Surveying the prospects***	**126**
	A world perplexed: popular misgivings	126
	A world at risk: Doomwatch scenarios?	128
	A world re-deified: return to pantheism?	131
	A world estranged: "the silent planet"?	135
10	***Hope for the Earth***	**142**
	Intrinsic value	143
	Creation and restoration	144
	Human stewardship	146
	Divine destiny	148
	The day of the trumpet	150
	A new creation	155
	Notes	159
	Select Bibliography	183
	Index	187

Preface

From 1992 Sir John Templeton has endowed a number of lectures in the United Kingdom on the general topic of religion and science. In the autumn of last year the first extended series was given at Oxford by Sir John Houghton FRS on 'The search for God: can science help?'". It was my privilege to deliver a second series at Trinity College, Cambridge, in February/March, 1993. These five lectures have been the basis of the present book, where the opportunity has been taken to expand (and update) some of the topics under discussion.

The purpose may be evident from the title. It is to examine the present condition and future prospects of our planet, taking into account both the responsibilities of human beings and the over-riding providence of God. My intention has been to offer a Christian perspective on environmental problems that takes very seriously both the scientific and theological issues. In bringing science and theology together I suppose I may be charged with pandering to the current fashion evident in, for instance, the establishment of the Starbridge Lectureship in Theology and Natural Science at Cambridge. But while I welcome that particular development I see it as only a part of a much larger awareness of the interaction between the two fields. This is currently apparent in the writing of many scientists who are also Christians, in theological writings of people like Moltmann, Peacocke, Polkinghorne and many others, and above all in some fine work recently published in the history of science. To all of this I am of course much indebted.

That said, I must immediately disclaim any pretension of writing a textbook on geology, theology, ecology, or any other specialist subject. I am addressing not specialists but general readers who are genuinely concerned about "green" issues, the public understanding of science and the rise of

PREFACE

"post-modernism". I have tried to look at some underlying general principles that may guide debate and action, and precisely for that reason have not offered a collection of technical "fixes" (or for that matter any kind of political agenda). Although some tentative conclusions are offered it also seemed important to formulate some fairly fundamental questions; these need to be posed again and again as one environmental crisis succeeds another. And although the world-view within which I write is frankly Christian I believe that many of the conclusions will commend themselves to people who do not share all my presuppositions. We Christians have no monopoly on correct environmental policy.

Our source material ranges far more widely than I expected when I began the task. In some, though not all, quotations from earlier periods I have modernized the spelling. Unless otherwise indicated Biblical citations are from the New International Version; otherwise the King James ("Authorised") version is used (AV) and in one case the Good News Bible (GNB). To enable readers to follow up a great many themes that cannot be developed further in this book I have given fairly full footnotes, though I hope not too intrusively.

Finally I owe a great debt of thanks to many people, most obviously to Sir John Templeton and the Templeton Foundation for founding the lectures. The Templeton Committee and its Secretary, Professor Roland Dobbs, have been a fount of goodwill and assistance, as have many friends in Cambridge, especially Dr Robin Porter-Goff. The splendid facilities of the Winstanley Lecture Theatre at Trinity College prompt the thanks of all who were there to the Master and Fellows for their kindness. And to Shirley, my wife, who has been my companion on many academic adventures and who has now had to endure prolonged pre-publication trauma, go my best thanks of all.

<div style="text-align: right;">
Colin A. Russell

The Open University
</div>

Acknowledgements

The author and publishers gratefully acknowledge the permission to use copyright material granted by the following:

Figures 2.1, 2.2: The Open University.
Figure 3.2: Professor M. J. S. Rudwick.
Figure 5.1: Society, Religion and Technology Project, Church of Scotland.
Figure 5.3: London Research Centre.
Table 5.1: American Chemical Society.
Figure 5.4: Houghton & Stoughton Ltd/New English Library Ltd.
Figures 6.1, 6.2: SCOPE 28, *Environmental consequences of nuclear war.* Volume I, *Physical and atmospheric effects,* A. B. Pittock, T. P. Ackerman, P. J. Crutzen, M. C. MacCracken, 1986, © SCOPE, John Wiley & Sons, Chichester, UK; Volume II, *Ecological and agricultural effects,* M. A. Harwell and T. C. Hutchinson, 1985, © SCOPE, John Wiley & Sons, Chichester, UK.
Figure 7.1: Professor J. E. Lovelock and the Royal Society.
Figures 8.5, 8.6: *New Scientist,* article by A. Watson, "Gaia", 6 July, 1991, "Inside Science no. 48".
Plate 5a: The Rachel Carson Council Inc.
Plates 7a,b: David Alexander.
Plate 8: Nuclear Electric.

Unless indicated to the contrary, Scripture quotations are taken from the *Holy Bible, New International Version,* © 1973, 1978, 1984 by International Bible Society, published in Great Britain by Hodder & Stoughton Ltd. Used by permission.

ACKNOWLEDGEMENTS

Sources for the plates are as follows:

1a: Michaud's *Biographie Universelle*, 1813.
1b: author.
2a: author.
2b: John Kay, *Original portraits and caricature etchings*.
3a: H. B. Woodward, *History of geology*, Watts & Co., London, 1911.
3b: W. C. D. Whetham, *The recent development of physical science*, Murray, London, 1904.
4a: author.
4b: author.
5a: Rachel Carson Council Inc.
5b: J. Fenwick Allen, *Some founders of the chemical industry*, Sherratt & Hughes, London, 1906.
6: Anon, *The struggle for supremacy*, Liverpool, 1907.
7: David Alexander, *Natural disasters*, UCL Press, 1993.
8: Nuclear Electric.

The dust jacket shows an image of Earth taken from Apollo 17, and is reproduced with thanks to the Apollo Principal Investigator, Dr Frederick J. Doyle and the National Space Science Data Center through the World Data Center A for Rockets and Satellites.

Although they won't understand much of it yet,
this book is dedicated to

Benjamin
Jennifer
and Simon

who will soon discover what a wonderful Earth we live on
and how we should take care of it

CHAPTER 1

Introduction

On Sunday 22 April 1990, we landed at Boston airport for the spring meeting of the American Chemical Society. My wife and I were staying at a hotel a mile or two out of town in the general direction of Cambridge. To our great surprise the friendly taxi-driver informed us that our journey would be unusually long and unusually slow. On that beautiful spring afternoon thousands of Bostonians were out in the sunshine, blocking the highways with more than the usual number of automobiles. They were celebrating what he called "Earth Day". It was in fact the twentieth year that Americans had marked the beginning of a special week devoted to the care of our planet. It was mildly ironical that several *extra* tons of garbage were collected and much *extra* gasoline consumed in those ecologically directed festivities!

However, when the last balloon had been released and the last reveller had returned home there was a very serious purpose behind Earth Day. For one thing it was *an affirmation*. The populace (or many of them) were affirming a responsibility for the survival and future wellbeing of the Earth. With this went an awareness of the need to educate and inform. Hence for the following week newspapers, magazines and (above all) university bookshops gave Earth-care a place of supreme prominence. Of course in one sense "the Earth" is merely a symbol for the environment as a whole, and Earth Days are festivals of green politics and environmental concern. But Earth itself, in its more literal and restricted sense, has more than enough with which to challenge bewildered and questing humanity: depletion of the ozone layer; the greenhouse effect; urban pollution; diminishing rain-forests; threatened species etc. Underlying the determination to save the Earth is the urgent question: *what must we actually do?*

Earth Day was also a *celebration*, involving some kind of identification with the planet that is our home, some kind of global patriotism. So dancing,

INTRODUCTION

concerts, balloons, picnics, barbecues, family outings etc. were all appropriate. But the very celebrations posed another, more fundamental, question: what (some would even say "who") was being celebrated? *What is the Earth which we are so concerned to save?* The answer to that question in no small measure determines the answer to the first. How we perceive the Earth will at least partly determine how we use or abuse it.

In these chapters I shall be discussing aspects of both questions. However, I shall not seek to add to the already immense literature of "environmental recipes"; nor shall I attempt to prescribe specific courses of political action. Instead I propose to go, as it were, behind the scenes and to examine changing attitudes to the Earth and to ask why they are changing, and what are the implications for humanity at this crucial time in its history.

It is only fair that I should indicate at the outset the considerations that have shaped my perspective. I am aware of three in particular:

1. *A commitment to the scientific enterprise* as something inherently worthwhile and of even greater potential importance in the future than in the past. I do not share the view that science *per se* is responsible for all or even most of our present ills. Moreover, I am convinced that an exploding world population cannot survive without the benefits that science can bring. However, I cannot deny that the transformation of science to scientism, an object of worship and ultimate authority, has done immense harm. And the employment of scientific results in the abuse of nature, whether in the name of technology or profit or anything else, is equally reprehensible.

2. *A commitment to the Judaeo-Christian view of God* as Creator and Upholder of the universe. I am also persuaded, through the revelation of Christ in the New Testament, that God is actively concerned for the wellbeing of Creation, and indeed of humanity. Sir John Templeton, to whom we are deeply in debt for these Templeton Lectures, has argued for a "theology of humility" – "a theology really centred on God and not our own little selves". Yet that does not abrogate our responsibility. This is what he says of our human race:

> God has placed us at a new beginning. We are here for the future. Our role is crucial. As human beings we are endowed with mind and spirit. We can think, imagine, and dream. We can search for future trends through the rich diversity of human thought. God permits us in some ways to be co-creators with him in his continuing act of creation.[1]

INTRODUCTION

It may seem unfashionable to bring God into a discussion of environmental issues, though I am certainly not the first one to do so. Within orthodox Christianity alone there has been a spate of books[2] and papers,[3] together with numerous overviews.[4] I am persuaded that to discuss the fate of the Earth without reference to God would not only be like playing *Hamlet* without the Prince; it would also be like acting, producing or criticizing the play without reference or acknowledgement to Shakespeare. And it would also be a perverse and unforgivable distortion of history. Which brings me to the third factor that has shaped this book.

3. *A commitment to the value of scholarly historical enquiry*. The US President Bill Clinton recently quoted a famous aphorism of his hero Abraham Lincoln: "*We cannot escape history.*" Indeed we can't. Its consequences are always with us, and we cannot hope to understand the present (let alone the future) without reference to the past. In a highly controversial paper of the 1960s the American historian Lynn White was at least right in his objective: to expose "the historical roots of our ecologic crisis".[5] The fact that subsequent scholarship has undermined much of his argument does nothing to minimize the nobility of his objective, for knowledge of the past can be critically important for determining future actions. As another popular saying goes, "those who will not learn from history are condemned to repeat it". Nor should any failure in historical analysis inhibit us from striving for historical accuracy with the same diligence as the scientist who seeks for accuracy in his or her own field.

And so at the beginning of our enquiry we shall attempt a brief, broad overview of changing images of this Earth of ours from antiquity to today, looking especially at its relationship to the rest of the physical universe.

For those unfamiliar with the history of science, or historical discourse generally, there may be several surprising features in our exploration. We shall notice, for instance, that changes in human understanding occurred in quite complex ways. Sometimes movements of thought seem to be going in several directions at once or even going into reverse; great discoveries or ideas (such as those of Copernicus) may not necessarily command instant support or acquiescence. Moreover, there is no inevitable direction that events must take: they may tend towards what we might recognize as scientific truth, or they may not. History is far from the simple linear process it is sometimes supposed to be.

A second feature of our enquiry is perhaps more obvious. It is that all images of the Earth concern humanity in a multiplicity of ways. The images,

INTRODUCTION

of course, exist in human minds. But people are not merely image-makers, dreamers, explorers, observers or experimenters. They are also social creatures with a stake in the wellbeing of their own community. Their image of the Earth may well be a *cosmology*, laden with their own social values. Thus a hierarchical view of the cosmos may reflect a hierarchical view of human society, and in some cases almost certainly did. This is not to adopt a relativist view of scientific enquiry, but merely to point out that scientific theories *may* (not *will*) be governed by values that no one would recognize as inherent in science itself.

Thirdly, it will soon be apparent that most images of the Earth actually concern God, or at least aspects of the Divine. Occasionally this may be by virtue of his deliberate exclusion, but much more often in the past it has been with reference to specific religious values, consciously or otherwise. There are few "simple facts" of history, but this is surely one of them, that science and theology have been intertwined in a multitude of quite complicated ways.

Then, fourthly, it will be obvious that "history" is taken as a continuum right up to the present. As one humorist put it, "history finished last night". This, of course, is why a study of the remoter past may still have topical relevance. So we shall have no inhibition in commenting on ancient or recent developments in science or theology.

In current evaluations of the Earth's relationship to the human beings who inhabit it there are, broadly speaking, two viewpoints vociferously expressed. They may be identified as:

1. The conventional scientific view. This is largely materialist and reductionist, traces its credentials to the 16th and 17th centuries, and rests its case on unparalleled successes in understanding and controlling the world in those recent centuries. "Reproducibility", "predictability", "verification", "proof", even "falsifiability" are its buzz-words, and *for all practical purposes* it treats nature as some kind of a mechanism, even if living objects are under discussion.
2. A "postmodernist" view that treats science, at least in its conventional form, with disdain, and is in part a reaction to what it sees as the destruction of the Earth in the name of science and technology. It therefore affirms a more organismic view of nature, though the extent to which its adherents actually believe the Earth to be "alive" varies quite widely. A strongly mystical view of nature runs through much of their literature, some of which proclaims itself as representative of a "New Age".

INTRODUCTION

The contention of this book is that *neither* of these is adequate on its own, but nor is the fudged solution obtained by attempting to reconcile them. We should look outside both traditional science and classic mythology for deeper insights, and some of these are offered by Christian theology. Here again people do not all speak with one voice, but it is clear that a hard-headed attempt to relate biblical and scientific data can yield a valuable new understanding of problems relating to our modern Earth. From such an enterprise there gradually emerges a third approach, most adequately summarized by the key-word "stewardship". This offers not only the most practical understanding but also the best prospects for our world. We shall not, however, arrive there all at once, but first need to retrace the steps of humanity as it groped towards the modern image of the Earth in space and time, to expose something of the hazards to which it is currently exposed, to identify our own rôle in such matters and to address the current mythology of a living planet. Only then shall we be in a position to attempt a synthesis that will throw on our shoulders immense responsibilities but also offer a shining though realistic hope for the Earth.

Chapter 2

The Earth in space

One of the most obvious features of science, as any real scientist is soon made painfully aware, is that it changes, often quite rapidly. We do not need the purveyors of sociological relativism to tell us that. It is all too apparent from the proliferation of science journals and from direct experience of the complexity of nature. The idea of science as a body of unchanging and unchallengeable truth was *never* much in vogue amongst its practitioners, even those cocksure Victorians who would rather have liked the general public to see it thus. Otherwise why should they have continued to interrogate nature? Experimental work has rarely been simply a question of building up the body of irrefutable fact; there has usually been an intention of putting right the errors of a previous generation (or current rival). In these modern post-quantum, post-relativity days of Heisenberg uncertainty and chaos theory the fragilities of scientific hypotheses are more obvious than ever before. Over the last four centuries few more profound alterations in scientific perception have taken place than in the changing images of the Earth in space. If we add views that could hardly be described as "scientific" by any known criteria, we find a far longer history of image-transformation. Over some two and a half thousand years there have been three fundamental displacements of opinion regarding the nature, position and status of the Earth.

From isolation to integration

The first speculators about our Earth were almost certainly flat-earthists. This is hardly surprising. From Babylonian times men have imagined the universe rather as a saucer (Earth) under an upturned dish (the heavens). In

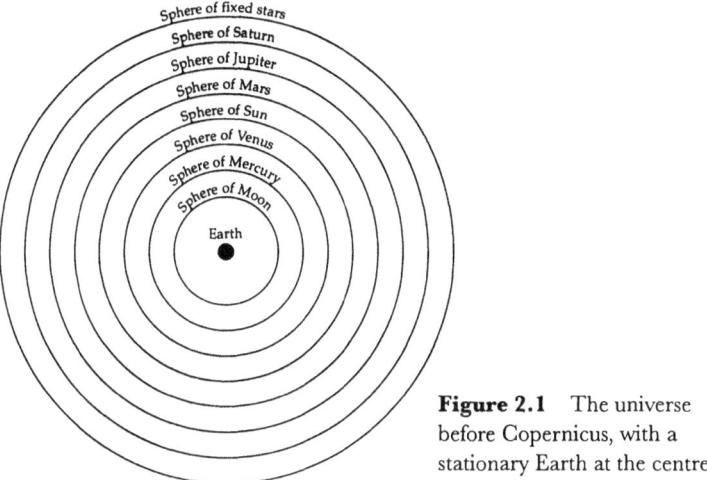

Figure 2.1 The universe before Copernicus, with a stationary Earth at the centre.

the 6th century BC the influential Greek philosopher Thales saw the Earth as a disc. Obsessed with the primacy of water in the universe, Thales proposed that this disc was floating on the ocean; a later member of his Ionian school, Anaximenes, thought the Earth floated on air, like a leaf. The pre-scientific notion of a floating disc persisted for centuries. A minor modification was introduced 1,500 years after Thales by Maurus, Abbot of Fulda, who thought the disc must be square (since Scripture speaks of "four corners of the Earth"!). To be sure there are biblical texts that could be interpreted as implying a flat Earth,[1] but subsequent experience has illuminated the danger of making scientific deductions from biblical passages (see pp.28–30).

Despite the persistence of popular belief in a flat Earth, the Earth was recognized to be a sphere at about the same time as Thales. Perhaps for aesthetic reasons the school of Pythagoras in southern Italy gave apparently the first reference to the Earth as a sphere, floating in space. The movement of the heavenly bodies around it was considered in mathematical terms by the Pythagoreans, Plato and (around 400 BC) Eudoxus of Nixos. A complicated fourfold movement of the heavenly bodies accorded reasonably well with the astronomical observations of the time and became incorporated in that great synthesis by Ptolemy, the *Almagest*, that was to last 1,400 years from the second century AD to the time of Copernicus (1473–1543).[2]

It is interesting that those early Greek philosophers, the Ionians, recognized no ultimate distinction between Earth and heaven.[3] That vision of

universal unity was abolished by Aristotle, who proposed that the sphere of the Moon marked a fundamental demarcation between Earth and Heaven. Above it the only natural motion was circular; no other type of change occurred; and the only element was the ether. Below it, in this vale of tears, all was change; the natural motion was rectilinear and downwards; and everything was constituted of the four elements earth, air, fire and water.

Our cosmological inheritance from the Greeks was thus twofold. On the one hand there was the mathematical tradition associated with the names of Pythagoras, Plato, Eudoxus and Ptolemy, useful to the astronomers and date-calculators of the Church. On the other hand there was a stream of ideas that can best be called Aristotelian physics and which entered the popular consciousness and vocabulary to such an extent that to this day we refer to air and water as the natural "elements" of birds or fishes. Indeed the popularity of Aristotelianism was enormous. Only at the end of the 16th century was its cosmology seriously undermined, when strange new objects appeared in the supposedly unchangeable region above the moon: a supernova in 1572 and a comet in 1577. Later, the physical laws of Newton were seen to encompass the whole visible universe, as Laplace triumphantly demonstrated in his *Système du monde* of 1796. In chemistry old ideas of chemical elements survived in some form until Lavoisier's redefinition in the 1780s. The chemical unity of the solar system was established by spectroscopy, beginning with discoveries by Lockyer and Frankland (1869). Nor was it merely a case of scientific achievement. The Romantic movement sought for unity of all creation, as exemplified by Davy, whose union of electricity and chemistry into electrochemistry arguably owed something to a prior conviction as to the unity of all natural knowledge.

To have opposed Aristotelian cosmology during the first 1,500 years of the Christian era would have seemed dreadfully heretical to most people (and there was no obvious "scientific" reason to do so). Yet, as Kaiser has reminded us, "Scripture made it clear that the heavens were not to be accorded any special status and that they were subject to the same laws as the Earth and its inhabitants."[4] Several early Christian writers were quick to recognize the implications of Scripture, at least after Basil and Philoponos (4th and 6th centuries respectively). Gregory speaks of "earth and sky" as "an admirable creation indeed . . . tending to the perfect completion of the universe as a unit".[5]

We may well wonder why it took so long for this *theological* view of the Earth (which is now part of the baggage of modern science) to gain general acceptance. Partly the answer seems to lie in the immense popular strength

of Aristotelianism, which enabled it to survive sustained theological criticism. Perhaps the most remarkable testimony to its durability in the 13th century was the attempt by Thomas Aquinas to construct a synthesis from the best of Aristotle and Christian tradition. Surprisingly, perhaps, even the Reformers did not see Aristotelianism as a necessary target, though Calvin's doctrines of universal providence may have helped to weaken the ontological distinction between Earth and heaven. In Sweden the state Lutheran Church remained for much of the 17th century a bastion of Aristotelian scholasticism. The surprising reluctance of so-called Christendom to perceive Earth's oneness with the rest of the universe must surely reflect on the timidity of its theologians faced with a popularly entrenched, and mathematically unfalsifiable, theory of the universe. As we shall see, other contemporary ideologies facing us today may pose the Church a very similar problem.

Thanks largely to scientific advance on several fronts, belief in a unity between Earth and heavens, conspicuously stressed in Scripture, eventually became so strong that its theological base was almost forgotten. Today Stephen Hawking and others look for a "theory of everything", and that must certainly include our Earth. So we have come to an image of planet Earth as just a minute part of an immense integrated cosmos. If the Earth is "special" in any sense then we cannot know this from science. Those who make a case for "special" scientific laws for our planet are skating on exceedingly thin ice.

From fixity to mobility

In Aristotelianism, as in most other ancient cosmologies, Earth was at the very centre of the universe. Then, in 1543, Copernicus published his *De revolutionibus* (Plates 1a & b). One might have expected an instant change in the image of the Earth, now transformed from an immovable object encircled by all the heavenly bodies into a sphere rotating daily and hurtling through space on its annual journey round the Sun. In fact response was slow, and by the end of the century the number of convinced Copernican astronomers in Europe was probably no more than 10. Thereafter the theory received gradually increasing support from a most extraordinary series of events, almost "signs", as they must have seemed at the time.

First there were signs in heaven. The greatest observer of the heavens before the invention of the telescope was the Danish astronomer Tycho

Brahe (1546–1601). It was he who observed the super-nova of 1572 and the comet of 1577, showing them to be in the supra-lunar regions of space and thus denying one of the fundamental tenets of Aristotelianism. Even more spectacular evidence emerged in the next few years as Galileo surveyed the skies with his newly acquired telescope and discovered the phases of Venus, solar prominences, sunspots, four satellites of Jupiter and other heavenly phenomena that were quite incompatible with the idea of unchangeable heavens.

Secondly there were spectacular signs on Earth. Since the late 15th century the Portuguese voyages of discovery had disclosed facts about our Earth that left in tatters the authority of ancient geographers, including Ptolemy. The land-masses were not all joined together, tropics were habitable, and the whole perceived shape of the globe was changing almost overnight. As William Watts observed in 1633, "the thoughts of the philosophers have been contradicted by the unexpected observations of the navigators". If this were true of Earth, why should something similar not be said of the heavens?[6]

Everyone knows of the ecclesiastical opposition to Galileo, but it would be naïve to describe this as evidence of a concerted *theological* reaction. The issues here were extremely complicated and have often been rehearsed elsewhere.[7] To be sure, there were questions of biblical interpretation (did the Bible really teach a stationary Earth?), but these had already been resolved in principle by Augustine's doctrine of accommodation. In matters of no

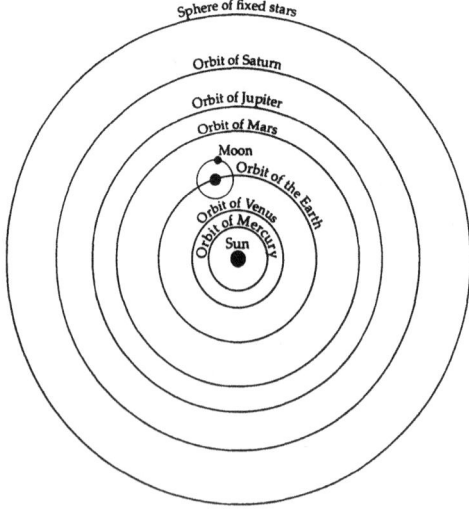

Figure 2.2 The Copernican universe, with a mobile Earth rotating round the Sun.

spiritual importance Scripture accommodated itself to the language of the common people. As Galileo himself put it, the purpose of the Holy Ghost was not to tell us how the heavens go, but how to go to heaven![8] But there were other fundamental problems of this new image of the Earth.

Consider the question of value. If our Earth is now displaced from the centre of the universe, was it similarly displaced from the sphere of God's care? It has sometimes been argued in modern times that here was a new challenge to faith. Yet simply to put the question like that is to invite the riposte that there is no necessary connection between *position* and *value*. Such indeed appears to have been the perception of most early Copernicans. But one can go further and observe that because the universe had been reckoned by Copernicus himself to be of immense size, the "displacement" was exceedingly small. Furthermore some actually indicated a positive advantage in the new arrangements. Kepler must speak for all: within the hierarchy of planets "the Earth, the home of the image of God, was going to be chief among the moving globes".[8] For one thing its intermediate position meant that it was shielded by the spheres of Mercury and Venus from the great heat of the Sun, a necessity for human existence.[10] The whole issue has been well described by John Brooke:

> Even if men and women were removed from the centre of the cosmos, this was not necessarily to diminish their status. The centre of the geocentric cosmos had not been salubrious. It was the point to which earthly matter fell, the focus of change and impurity, the physical correlate of humanity's fallen state. To be placed on a planet was to move upmarket.[11]

Thus humanity now lives in a mobile home or, as Kepler called it, "a ship", making "its annual voyage around the Sun".[12]

So much for the Copernican "conflict" with the Church. As an aside it is interesting to note how the Christian Church now lives so easily with such a transposed image. This surely indicates amongst many other things that it has come to terms with a hermeneutic that sees in Scripture a revelation of the ways and love of God but declines to draw scientific conclusions from the biblical text. Galileo's posthumous pardon in 1992 by the Vatican came not a moment too soon. It is curious how differently Darwinism fared in this respect from Copernicanism.

But to return to this transposed image for a moment, we can hardly fail to register the immense leap from a state of unchallenged centrality and immobility to that of a whirling speck of cosmic dust in the immensities of

a universe that would have left Copernicus spell-bound. The world-picture was transformed; what had altered little was the world-view, the understanding of human and other values that owes nothing to science but much to theology.

From organism to mechanism

Forty years ago the Henri Frankforts, in their seminal study of speculative thought in the ancient Near East, *Before philosophy*, made the following comment:

> When we read in Psalm xix that "the heavens declare the glory of God; and the firmament showeth his handiwork", we hear a voice which mocks at the beliefs of the Egyptians and Babylonians. The heavens, which were to the psalmist but a witness of God's greatness, were to the Mesopotamians the very majesty of godhead, the highest ruler, Anu. To the Egyptians the heavens signified the mystery of the divine mother through whom man was reborn. In Egypt and Mesopotamia the divine was comprehended as immanent; the gods were in nature.[13]

Most obviously was this true of the Earth. She was a divine power, Nintu, "the lady who gives birth" and also "the fashioner of everything wherein is the breath of life".[14] This deification of Earth was widespread in the ancient world (though we must exclude the Greek atomists), and of course it remains a feature of animistic religion to this very day. Yet in the West it became increasingly unpopular at a time when the Judaeo-Christian tradition was undergoing a strong revival, thanks largely to the growth of Reformation theology and a wider dissemination of the Scriptures amongst ordinary people. The de-deification of Earth was also closely allied to the rise of modern experimental science and raised a number of crucial issues for the Elizabethan Church and its successors.

The Earth as divine

Organismic views of Earth were part of a larger understanding of the whole universe as divine, or at least animate. Ignoring Earth and considering just the rest of the universe for a moment, we are reminded by R. C. Dales of what he has called "the de-animation of the heavens". This was to become

a matter of some controversy among the early Fathers, though all were agreed on the otherness of God from his universe and fearful of a lapse into nature worship.[15] Thus although Origen (3rd century) believed that the heavenly bodies had their own special "intelligences", he was roundly condemned for this daring speculation in 553.[16] Augustine agonized over whether "this world of ours is animate, as Plato and many other philosophers think". Making himself comfortable on the fence, he admitted "I do not affirm that it is false that the world is animate, but I do not understand it to be true".[17]

Despite the doubts of an Origen or Augustine, the strategies of the early Church included a de-animation of Earth and heavens. In so doing the Christian Church was drawing heavily on the older Hebrew tradition it inherited in the Old Testament. It was against the worship of "the queen of heaven",[18] of the gods of the forest grove, of even the very imitation of natural objects that the prophets thundered in relentless mockery. God alone must be worshipped, he who is above all nature and the Creator of it. One biblical image of the Earth is none too flattering: it is simply God's "footstool".[19]

With the overwhelming dominance of the Church throughout the Middle Ages it might have been expected that all traces of animistic, pantheistic or organismic thought about the Earth would have disappeared from the West. This was about as generally true of the medieval theologians as it was of the earlier Church Fathers, and exceptions did occur. The well-known case of St Francis of Assisi, whose famous *Song of the creatures* included references to "our sister water", "our brother fire" and "our mother the Earth, the which ... bringeth forth divers fruits and flowers of many colours and grass",[20] can easily be exaggerated. It was certainly a celebration of nature, though hardly an adoration, endowing it with divine qualities. G. K. Chesterton remarked, "Far from being a revival of paganism, the Franciscan renascence was a sort of fresh start and first awakening after a forgetfulness of paganism."[21]

Yet in fact an organismic view of the world (and the cosmos generally) persisted at almost every level of European society. Sometimes it is hard to tell when phrases are carelessly used as mere colloquialisms, or poetic conceits or other figures of speech; or whether they are conscious expressions of views about the world. Nevertheless there is abundant evidence that for many people the world was alive with influences, occult forces, mysterious powers. When the Elizabethan doctor Robert Fludd (1574–1637) wished to heal a battle-wound, he applied his salve, not to the injury, but to

the arrow which caused it. When he was confronted by the whole of "this splendid Nature", he wondered if she "is herself god, or whether god himself is she".[22] Survival in popular lore of the salvific or malignant effects of certain plants (like mistletoe and holly), superstitious veneration of sacred places, reliance on omens on Earth or in the skies, all these and many other practices testify to the enduring powers of folk-myths even in the face of official religious disapproval. And all depend on a mystical kind of union between Earth, man and other living things. Especially was this true for those who descended deep into medieval mines and those who fabricated the products of their labours. A ubiquitous phrase that was often on the lips of Francis and his successors long afterwards, "Mother Earth", is so important that it deserves special attention in another chapter.

There was more to it than folk-lore. For many centuries the ideas of the Christian Church were almost inextricably bound up with those of Aristotle and Plato. The former kept alive notions of inherent tendencies: a stone fell to Earth, for example, because it had some kind of "homing instinct". And the Plato who had so influenced Augustine enjoyed a spectacular comeback in the 14/15th centuries. One of the movements associated with the Renaissance was neo-Platonism, and this profoundly influenced men like Copernicus who encountered it during his student days in Bologna and later in books in his own library at Kraków. This makes sense not only of his tendency to endow the Sun with mystic virtue (as well as centrality) but also of his opinion that the Earth was in some way "fertilized by the Sun". Yet even Copernicus spoke of "the machinery of the world, which has been built for us by the best and most orderly Workman of all".[23]

William Gilbert (1544–1603), physician to Queen Elizabeth I, produced yet another image for the Earth: he said it was a giant magnet. But his views are reminiscent of the ancient Greek philosopher Thales, who said: "All things are full of gods; the magnet is alive, for it has the power of moving iron." Gilbert himself was unable to deny that the world has a soul and attributed to "this glorious Earth . . . the impulse of self-preservation".[24]

That was in 1600. Half a century later such sentiments would have been almost unthinkable among the European scientific community, especially in England. Another phenomenon had occurred so closely involved in a further demythologization of nature that it is hard to establish whether it was chiefly cause or effect: the coming of experimental science.

FROM ORGANISM TO MECHANISM

Experimental science and the Judaeo-Christian tradition

The Cambridge historian Herbert Butterfield once remarked of the so-called "scientific revolution" that for sheer importance "it outshines everything since the rise of Christianity".[25] Be that as it may, these two events (if we may call them that), separated by nearly 1,600 years, were not only related in a multitude of intricate ways. They also combined to generate the process that one author has called "the mechanization of the world-picture".[26] Attendant on the rise of what most of us would recognize as science there came about a fundamental shift in human perception of the world. For the brave new world of early 17th-century science nature can no longer be seen as an *organism*; it behaves much more like a *mechanism*. And Earth, which is part of nature, is similarly divested of its organismic attributes.

There has been much discussion by scholars in recent years on the connections between Christianity and the rise of a mechanistic world-view. There appears to be a general consensus that, far from undermining theology, mechanism actually represents a culmination of several centuries of Christian argument on the sovereignty of God. The laws of nature, impressed on inanimate matter, were an expression of his own will and purpose, gloriously manifesting his power and goodness. Thus the famous clock simile of Robert Boyle (the universe was "like a rare clock, such as may be that at Strasbourg") has its roots in the Middle Ages. Boyle (1627–91) further condemned the Aristotelians, who, denying that the universe was created by God, "were obliged to acknowledge a provident and powerful being that maintained and governed the universe which they called nature".[27] The rôle of Puritanism in the emerging science of 17th-century England has been much discussed and there is little doubt that, for all the difficulties of precise definition, that movement played an important part in the conception and early progress of the new Royal Society. It is remarkable that four features that we recognize as characteristic of modern science first emerged at this time, and each embodies distinctly biblical theology:[28]

(a) Removing the myth from nature
(b) Recognition of laws of nature
(c) Adoption of the experimental method
(d) Controlling the Earth.

One might add a fifth, which was doing science for its own sake, though for 17th-century advocates this was "for the glory of God".

The mechanical philosophy emerged in different forms at different places, reflecting the varied cultural emphases. One man who made the

painful personal pilgrimage from organicism to mechanism was Johannes Kepler (1571–1630). In 1597 he was still thinking in animistic terms; by 1605 he had crossed the Rubicon and announced that his aim was "to show that the celestial machine is to be likened not to a divine organism but rather to clockwork".[29] Later he had doubts, but by 1621 was firmly on track again. The first recognizably mechanical philosopher of the scientific revolution was Isaac Beeckman of the Netherlands, heir both to a strong Calvinist tradition and to an industrialized society where machinery was prominent. In Catholic France René Descartes, inspired by a dream in 1619, made the pursuit of mathematical and mechanical science a divine vocation. However, he too moved to Holland, publishing there his great *Discourse on method* in 1637. Descartes, Boyle and others sought to use matter and motion in their explanations of such diverse earthly phenomena as heat, falling bodies, the spherical nature of drops, magnetism, the behaviour of gases and the colours of chemistry. In the heady days of the early Royal Society discussions were largely predicated on this image of the Earth: a machine that was part of an even greater mechanism, the whole visible universe.

In England there were some who feared that the expulsion of non-mechanical forces from nature would lead inexorably to atheism. Prominent among the anti-Cartesian lobby was the neo-Platonist school at Cambridge led by Henry More and Ralph Cudworth. Much more important was Isaac Newton (1642–1726), devout – even fanatical – anti-Catholic, diligent student of Scripture, devotee of alchemy, and believer in occult forces in nature. Despite his monumental achievement in discovering universal gravitation he could never bring himself to believe that undiluted mechanism was sufficient explanation for physical phenomena in the world. That step was taken by his successors, most famously Laplace, whose *Système du monde* (1796) and *Mécanique céleste* (1799–1825) disposed of the need of invoking the deity at the level of immediate explanation.

Nor was this just the case with physics and astronomy. Reductionist biology, at least in principle, became popular in the 19th century. It would take us too far from our task to explore that question here. But in the science of the Earth a mechanical explanation of fossils began to replace the old idea that they were nothing to do with living creatures but the result of "plastic forces" at work in the Earth. This organismic view was revived briefly in the 19th century by religious people whom Hugh Miller calls "the anti-geologists".[30] However, as early as 1833 it had been banished as a "favourite dogma" from Charles Lyell's *Principles of geology*.

FROM ORGANISM TO MECHANISM

By the mid 19th century a mechanical world was nearly universal in physics; Lord Kelvin said he could not understand a thing unless he could make a mechanical model of it. In chemistry vitalism had similarly departed. The biologists harboured hopes that their subject might one day be reduced to chemistry and physics. And the science of Earth itself has been mechanized almost beyond recognition by developments in, successively, glacier theories, volcanology and plate tectonics.

The paradox of mechanism

I finish with a paradox: the mechanistic world-view has been both an enemy and an ally to the Christian faith. The reason is that it enshrined at least five different ideas. First there was the element of *design*. The clock demanded a clockmaker. Its intricacy spoke of his consummate skill. The world is a wonderful place! So in the 17th, 18th and early 19th centuries the mechanistic Earth became a routine tool of Christian apologetics. Mechanism and religion went hand in hand. It is interesting that opponents of Christianity, like Huxley, reverted to pre-mechanistic terminology like "Dame Nature",[31] even asserting that "living Nature is not a mechanism, but a poem".[32]

However, doubts gradually set in over a second aspect of the mechanistic Earth: the element of *materialism*. One could so easily be led to say that the Earth is *nothing but* an assemblage of atoms, forces etc.[33] Obviously flawed by the fallacy of reductionism, this interpretation was attacked by Greenwood in 1940s[34] and has been under sporadic fire ever since. This may offer some explanation for a recrudescence of organismic views of the Earth in postmodern thinking.

Moreover in the Christian community further anxieties arose over a third feature of mechanism: the element of *self-sufficiency*. The clockwork image banishes the clockmaker to an initial act of creation. This classic statement of deism, with its limitation of God to instant creation and never to processes, has been forcefully attacked both by scientists[35] and by the process theologians.[36]

Fourthly, a purely mechanical universe may seem to be purely *deterministic* and thus incapable of accommodating either human freewill or divine providence. This takes us rather far from a mechanical view of Earth alone, but has been effectively challenged by several writers, most notably Donald McKay[37] and John Polkinghorne,[38] neither of whom saw a mechanistic world-view as incompatible with Christian belief.

A fifth aspect of a purely mechanical Earth (or universe) may be an element of *expendability*. The mechanical universe, we are told, is particularly susceptible to environmental abuse; a mere machine may be abused with impunity, even kicked to make it go! There is, of course, no *logical* justification for abusing a machine (particularly if it belongs to someone else), but the argument has a certain emotional appeal to those disposed on other grounds to de-mechanize the Earth and reinstate an organism in its place.

It is clear that both science and Christianity have strong reasons for retaining a mechanical world-view. Christians have a strong interest in stressing the design aspect of a mechanistic world. Mechanism is theologically reprehensible only if one indulges in the fallacy of rigid determinism or of a semi-divine Earth, pulsating with life. Such an arcadian fancy is entirely at variance with both Old and New Testaments. Equally, to hold to an organismic Earth is to revert to pre-scientific categories of thought, and thus to undermine one of the important bases of the scientific enterprise.[39] It is thus significant that in our own era, when a living Earth has become a central theme of postmodernism, New Age movements and so on, that era can be simultaneously described as post-Christian *and* post-scientific. The perils of this position will be further discussed in Chapter 9. Meanwhile we may note the sombre prediction of C. S. Lewis that "we may be living nearer than we suppose to the end of the Scientific Age".[40]

Chapter 3

The Earth in time

As we have seen in Chapter 2, the image of the Earth has undergone a series of profound transformations since it was first imagined as a disc floating on air or water. These have all been about its *ontology* – what it really is. They have concerned its status in relation to the rest of the universe, and thus as an object in space. A modern scientific view would affirm that the Earth is a mobile and roughly spherical object, not sitting quietly at the centre of the universe but traversing an annual course around the Sun and rotating daily. It would also affirm that the Earth is most usefully considered as subject to mechanical laws and devoid of those capricious characteristics associated with living things.

Perhaps it is this last feature that needs most to be affirmed today, since it has important implications for the whole of ecology and environmental concern. However, to make sense of our condition as human beings on the planet we need a deeper understanding of the Earth, particularly with respect to its history and its possible destiny. In other words, it is an understanding of Earth *in time*. Questions like "does it matter?" acquire a new urgency when it is realized that our home is a fragile spacecraft cruising through an apparently hostile universe. It may help at this point to gain comprehension of the earlier stages of our journey, leaving a later chapter to pose questions about a possible destination. The argument of these lectures is that such an understanding requires a reasoned intellectual response prepared to face the available scientific facts but not to ignore what God may have chosen to reveal outside science itself.

As we ask how Earth history has been traditionally seen it becomes clear that at least four kinds of response have been made, and we are heirs to them all. Four further images of the Earth emerge, images of Earth in time.

THE EARTH IN TIME

A static Earth

To us it is obvious that the natural world is not static. A century of evolutionary thought and speculation has seen to that. This planet is not today "as it was in the beginning, is now and ever shall be". While pious believers may hold that to be true of God, they surely cannot believe it to have been the case with his creation. Yet pre-scientific humanity was not so sure, and a pattern of history that kept the universe much as it always was became a commonplace in human thought.

This pattern was the idea that human history works in cycles, endlessly returning to a beginning and thus giving an Earth that was effectively static. This was as true of the dynastic cycles of the ancient Chinese as of the long cosmic cycles of first-millennium India and its Buddhist successor.[1] Our own debt is most obviously to the Greeks, not least to Plato, whose commitment to circular paths for the planets was paralleled by his belief in a cyclic course for history. Among his successors one need mention only the Stoics and Epicureans. It was not only human history but also natural history that partook of this repetitive character, all the heavenly bodies returning to their original positions in the period of the Great Year.[2]

Such ideas may also be found in the Wisdom literature of the Old Testament. The writer of Ecclesiastes shows more than a trace of apparent Epicureanism when he writes:

> Generations come, and generations go, but the earth remains for ever. The sun rises and the sun sets, and hurries back to where it rises. The wind blows to the south and turns to the north; round and round it goes, ever returning on its course. All streams flow into the sea, yet the sea is never full. To the place the streams come from, there they return again.

He goes on to add, in a kind of cosmic refrain, "There is nothing new under the sun."[3]

Such passages bothered some of the Church Fathers, not least St Augustine. For them, the Christian doctrine of creation, in its broadest sense, demanded, if it did not presuppose, a linear view of history, in which all events, natural and human, were in some way under the control of God and progressing towards a certain destiny.[4] As one more recent writer has put it: "The magic circle of time has been broken."[5] Application of this idea to the physical universe and to the Earth can be found in various patristic writings, some of which suggest (however vaguely) a series of restorations of a fallen nature to its original state of purity and bliss.

None of this, of course, has much to do with science, though it has a great deal to do with Christian philosophy, Platonism and even some of their more obscure derivatives such as hermeticism. With the scientific revolution in the 17th century, we begin to recognize all manner of new and curious interactions between science and theology, none more remarkable than in this very matter of the history of the Earth. So we come to a second image.

An Earth in decay

This is the polar opposite of a static Earth, a notion of a world in decline (rather than cyclic renewal or progressive improvement). It surfaced with astonishing clarity in the 16th and 17th centuries.[6] Perhaps it is not surprising that the first serious attempt to trace the natural history of any part of the cosmos should have been to our own planet. After all, Aristotelian philosophy had supposed the heavens to be unchanging, save for the endless cycle of astronomical movements. The Earth, on the other hand, was recognized as the scene of change, corruption and decay. There had also been a long Jewish tradition that all of nature was somehow decaying. In the Middle Ages this led to some bizarre expressions of millennial hope.[7] The age-old process of decay was somehow coming to an end, probably as 1,000 years of peace that some readers of the book of Revelation (the Apocalypse) considered to be a literal millennium at the end of history. It was given powerful support by Martin Luther, who, following Augustine's schematic breakdown of Christian history into seven ages, reckoned that he was now in the last but one, with the seventh (the millennium) just around the corner: "The last day is already breaking ... the world will perish shortly." Indeed he felt "the whole world degenerates and grows worse every day" and reckoned that the Earth itself shares in the results of man's wrongdoing: "When He [God] punishes sin, He still curses at the same time the earth also."[8] The view that a literal millennium would be ushered in by the personal return of Christ was favoured by influential English commentators like John Alsted and Joseph Mede in the early 17th century. With the unrest of the Civil War some of the wilder commentators saw this as imminently likely, notably the "Fifth Monarchy" men.[9] Against that background Ranters and others saw in the face of the Earth itself signs of impending social dissolution.

Yet none of these writers went to such lengths, or took so seriously the scientific data then available, as the author of a most remarkable book, *The sacred theory of the Earth*, first published in 1681. The author, Thomas Burnet

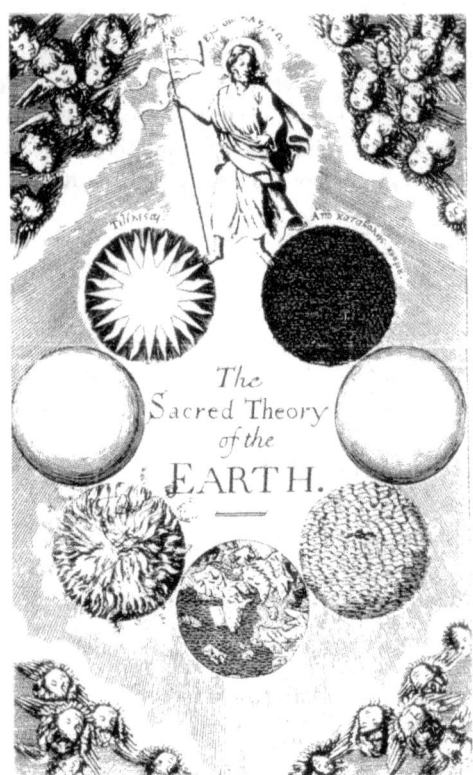

Figure 3.1 Frontispiece to Burnet's *The sacred theory of the Earth.*

(*c.* 1635–1715), was Master of Charterhouse and Chaplain to the King. It has been said that had he not written this controversial book he would have become Archbishop of Canterbury. And, in truth, it was controversial in a high degree (Plate 2a).

Burnet's reaction to the terrestrial scene was not unlike that of Pascal, appalled by the infinite spaces of astronomy.[10] Confronted with the spectacle of the mountains and irregular features of the Earth's surface, Burnet reacted with something approaching horror. Surely God had not made the world *like this*? That was a common view in the 17th century. John Donne had little doubt that the earth was in decay. He asked of the mountains and hills:

> Are these but warts, and pock-holes in the face
> Of th' earth? Thinke so; but yet confesse in this
> The world's proportion disfigured is;[11]

and in his poem "The anniversarie" proclaimed that

All other things to their destruction draw,
Only our love hath no decay.[12]

To account for this impression of decay Burnet invoked the Flood of Noah. In this respect he played a notable part in "Flood geology",[13] now discredited as a scientific explanation[14] but still popular nearly 100 years later, when John Wesley could write: "The Earth then [before the Flood] retained much of its primaeval beauty and original fruitfulness. The face of the globe was not rent and torn as it is now."[15]

At that time, Burnet supposed, the axis of the Earth's rotation was tilted from a vertical position relative to the plane of the ecliptic to one at an angle, thus producing irregular seasons and all that followed from that. He went on to consider a further phase of judgement, by fire rather than by water, beginning at Rome (as might be thought appropriate by a Protestant!). There follows the millennial reign of Christ, a final conflict and the ultimate transformation of Earth into a fixed star.

Burnet was particularly offended by mountains (which he regarded as generally hollow and much worse inside than outside):

> There is nothing in Nature more shapeless and ill-figured than an old rock or a mountain, and all that variety that is among them is but the various modes of irregularity; so as you cannot make a better character of them, in short, than to say they are of all forms and figures, except regular. Then if you could go within these mountains, for they are generally hollow, you would find all things there more rude, if possible, than without: And lastly, if you look upon an heap of them together, or a mountainous country, they are the greatest examples of confusion that we know in Nature; no tempest or earthquake puts things into more disorder. 'Tis true, they cannot look so ill now as they did at first; a ruin that is fresh looks much worse than afterwards, when the earth grows discoloured and skinned over. But I fancy if we had seen the mountains when they were newborn and raw, when the earth was fresh broken, and the waters of the Deluge newly retired, the fractions and confusions of them would have appeared very ghastly and frightful.[16]

As Marjorie Hope Nicholson observed,[17] Burnet had discovered the Sublime in nature (soon to be an important concept in literature). But he had done something more. He had shown a new deference to observed facts

about the Earth's crust. Actually to *see* wild scenery demanded some kind of rational explanation, as "when it was my fortune to cross the Alps and Apennine mountains":

> There is nothing doth more awaken our thoughts or excite our minds to enquire into the causes of such things, than the actual view of them; as I have had experience myself when it was my fortune to cross the Alps and Apennine mountains; for the sight of those wild, vast and indigested heaps of stones and earth did so deeply strike my fancy, that I was not easy till I could give myself some tolerable account how that confusion came in Nature.[18]

There were many obvious reasons for Burnet's sacred theory. For example, it was a commonplace to compare the world around us with man himself: the macrocosm and the microcosm. If man grows old, why should not the Earth? There was also a persistent tendency to look nostalgically back to a mythical "Golden Age", with a greater "adherence unto antiquity" which implied things were a lot better once than they are now. Many were the debates as to whether ancient wisdom was preferable to that of modern times, though Pascal had observed that "Whatever authority antiquity may have, truth takes precedence, even if it is newly discovered."[19]

The whole millenarian structure of Burnet's thought cannot be disconnected from the political movements of his day which saw another and a better Golden Age in the future, even though matters would temporarily get worse before it. Like some other Anglicans of the time, but unlike many more radical thinkers, Burnet spelled out his millennial hopes in terms of a Golden Age to come *after* a major catastrophe. Thus, though the Earth was now decaying, that process would one day cease, even though cyclic renewal was not envisioned. Beyond the experience of present doom lay a throbbing expectation of future redemption. As one commentator put it,

> The Apocalypse, which at the beginning of the Reformation seemed only to augur a dark future for humanity, became, with the assistance of a new scientific philosophy of universal law, and encouraged by the great advances in the knowledge of nature, the very guarantee and assurance of progress. The cyclical philosophy revived in the Renaissance was submerged by an optimistic concept of the whole human race.[20]

Burnet's manifesto is a classic example of the way in which theological, social and scientific issues can be intertwined so closely that it is almost

AN EARTH IN DECAY

impossible to separate them. It is clear that science played a vital rôle in the final synthesis. Most remarkably to modern perceptions, Burnet deliberately attempted to construct a new synthesis of that science with Scripture. Quite apart from obvious references to Noah's Flood, and Paul's familiar remarks about "the whole creation groaning and travailing together", there were other biblical passages suggesting a deterioration of the Earth's surface with the passage of time. They include Job's graphic picture of soil erosion:

> As a mountain erodes and crumbles and as a rock is moved from its place, as water wears away stones and torrents wash away the soil, so you destroy man's hope,[21]

Isaiah's lament over the devastation of the Earth:

> See how the Lord is going to lay waste the earth and devastate it ... the earth dries up and withers, the world languishes and withers,[22]

and the Psalmist's vision of the Earth (and the heavens) waxing old like a garment:

> In the beginning you laid the foundations of the earth, and the heavens are the work of your hands. They will perish, but you remain; they will all wear out like a garment. Like clothing you will change them and they will be discarded.[23]

For modern science Burnet's importance lay in his recognition that not only the Flood but also earthquakes and other episodes could "contribute something to the increase of rudeness and inequalities of the earth in certain places". He was thus accepting a general view of what modern Earth scientists were to call "denudation". As one of them wrote:

> The geostrophic cycle of modern geology ... probably owes its first formation to the existence of a religio-scientific problem which perplexed scholars two hundred years ago.[24]

It will not have escaped attention that this notion of a decaying Earth attributes nothing *directly* to man but regards God's judgemental activity as a response to human sin in general. Though we may not be moved by the same phenomena as Burnet (many moderns *like* mountains), or impressed by the arguments for a universal deluge, we may choose to recognize seeds of truth in his overall concern that the Earth is not now what it should be.

An Earth in equilibrium: cycles restored?

The idea of a decaying Earth retained much popularity in the 18th century, and dislike of rugged features like mountains continued. Thus the poet Thomas Gray, who so delighted in the beauties of the English Lake District (1769), was yet compelled to regard the mountains as "the reign of Chaos and old Night".[25] Speaking of the same area, Daniel Defoe objected

> Nor were these hills high and formidable only, but they had a kind of inhospitable terror in them. Here were . . . no lead mines and veins of rich ore, as in the Peak, no coal-pits, as in the hills above Halifax, but all barren and wild – and no use or advantage either to man or beast.[26]

However, before long doubters became more vociferous. Thus of Burnet himself Bishop Croft of Hereford concluded that "either his brain is cracked with overlove of his own inventions, or his heart is rotten with some evil design".[27] Isaac Newton himself seemed to maintain a passive view of the Earth's history, tending to favour its stability rather than its change. However, he gave Burnet some encouragement, and by 1706 was making clear references to "decay". If the amount of motion in the universe was decreasing, it could be renewed by divine intervention. His conjectures about such renewal were connected with his studies on the book of Revelation. The result was a series of alternating phases of decay and renewal which led not so much to a cyclic cosmos in the old sense but rather to one that showed an *overall* stability.[28] John Hutchinson (1674–1737), who opposed Newton on many important matters, regarded the Earth as essentially a stable machine, operating in a cyclic manner, all its physical features being a consequence of either the Creation or the Flood.[29] John Woodward (the geologist who coined the phrase "no stone hath been left unturned") affirmed that "the earth, sea and all natural things will continue in the state wherein they now are without the least senescence or decay, without jarring, disorder or invasion of one another".[30]

Several explanations have been offered for this change of emphasis, which certainly grew in strength in the 18th century. One concerns the displacement of Calvinist by Arminian theology. Gordon Davies (whose history of British geomorphology is aptly called *The earth in decay*[31]) has argued that the Calvinist with his brooding emphasis on sin would be more ready to accept the idea of inevitable decay and doom.[32] However, this is unlikely for a variety of reasons. For one thing Calvin himself (brought up among the

AN EARTH IN EQUILIBRIUM: CYCLES RESTORED?

mountains of Switzerland) had nothing derogatory to say about them, explicitly denied that "the earth is exhausted" and stressed that divine punishment was exacted on man, not the Earth.[33] And in any case the picture of Calvinists and Puritans as gloom-laden misanthropes owes more to caricature than fact.[34]

However, a second reason suggested by Davies is much more plausible. It concerns the rise of natural theology (a very appropriate topic for the Templeton Lectures).[35] This was, of course, the argument from design, applied above all to the mechanistic universe of the scientific revolution. Once again, it was especially strong in England. A theology that emphasized the goodness and benevolence of God, that claimed that this "was a happy world after all", and that stressed the utilitarian value of almost everything would be hard pressed to account for an Earth that was in decay. So the brakes were applied (as it were), topographic erosion was down-played and mountains were reinstated. Criticizing "some of our late theorists" the author of *A natural history of Westmorland and Cumberland* affirmed that "God had made nothing in vain." The high hills offer not only

> most curious and delightful landskips but present us with a set of vegetables peculiar to their cold and elevated soil, and most proper and agreeable with the hot natures of sheep and other creatures bred upon them which are most refreshed with the coldness and frigidity of the mountain-air.[36]

William Derham said that "mountains are so far from being a blunder of chance, a work without design, that they are noble, useful, yea a necessary part of our globe".[37] Where this was not obviously the case writers like Defoe felt compelled to single out the fact for special mention (if not complaint).[38]

In similar vein, John Ray, the great English naturalist, asserted that "the rain brings down from the mountains and higher grounds a great quantity of earth, and, in times of floods, spreads it upon the meadows and levels, rendering them thereby so fruitful as to stand in no need of culture or manuring". He argued that mountains were "of eminent use for the production and origin of springs and rivers . . . for the generation and convenient digging-up of metals and minerals . . . as screens to keep off cold and nipping blasts of the northern and easterly winds", and so on.[39] Natural theologians could not deny some limited denudation, but turned it to their own purposes by arguing it had a beneficent effect.

Meanwhile there were others who thought that so mechanical an explanation as Burnet's could only have the effect of making God superfluous.

This objection lay behind the vituperation of Bishop Croft[40] and was also the substance of a complaint by the mathematician John Keill.[41] By the late 18th century Enlightenment views of the Earth favoured a globe that was active with "regular, uniform progression" [i.e. not *decay*].[42] To reconcile this with the known facts of erosion etc. required more than ordinary insight. That was provided by James Hutton (1726–97; Plate 2b). His achievement – in a word – was to demonstrate the probability of a *geological cycle* in which material is removed from one area, transported, consolidated and eventually reappears elsewhere. Water and fire play their part, as do earthquakes. Thus though parts of the world decay at any one time, as a whole it does not. Such a cyclic process can go on indefinitely, and Hutton put the matter in these immortal words: "no vestige of a beginning, no prospect of an end".[43]

Thus if Hutton is right, the Earth is neither static nor young nor in decay. Earth history is open-ended and has entered a radically new phase, as Martin Rudwick so elegantly illustrates (Fig. 3.2).[44] It now has to be seen in terms of eternity, not time. Thanks to the work of Lyell (Plate 3a) and others it became possible to view the Earth as extremely old, old enough for Darwinian evolution to have taken place.

One final word needs to be said on the rôle of Scripture exegesis in all the controversies over cyclic Earth history. One is reminded of earlier problems: Hutton's disciple John Playfair asserted that, so far as biblical authority is concerned, "the theory of Dr. Hutton stands here precisely on the same footing with the system of Copernicus".[45] Yet many churchmen were unwilling (or unable) to learn from that example. They seem to illustrate the popular reluctance to draw appropriate conclusions from history. Some words of Burnet himself are particularly, if unconsciously, apposite:

> 'Tis a dangerous thing to ingage the authority of scripture in disputes about the natural world, in opposition to reason, lest time, which brings all things to light, should discover that to be evidently false which we had made scripture to assert.[46]

An Earth of great antiquity

Most people have seen in old Authorized Versions of the Bible the date 4004 BC given by Archbishop James Ussher in the early 17th century as the supposed date for the Creation. Some may have smiled at the further assertion

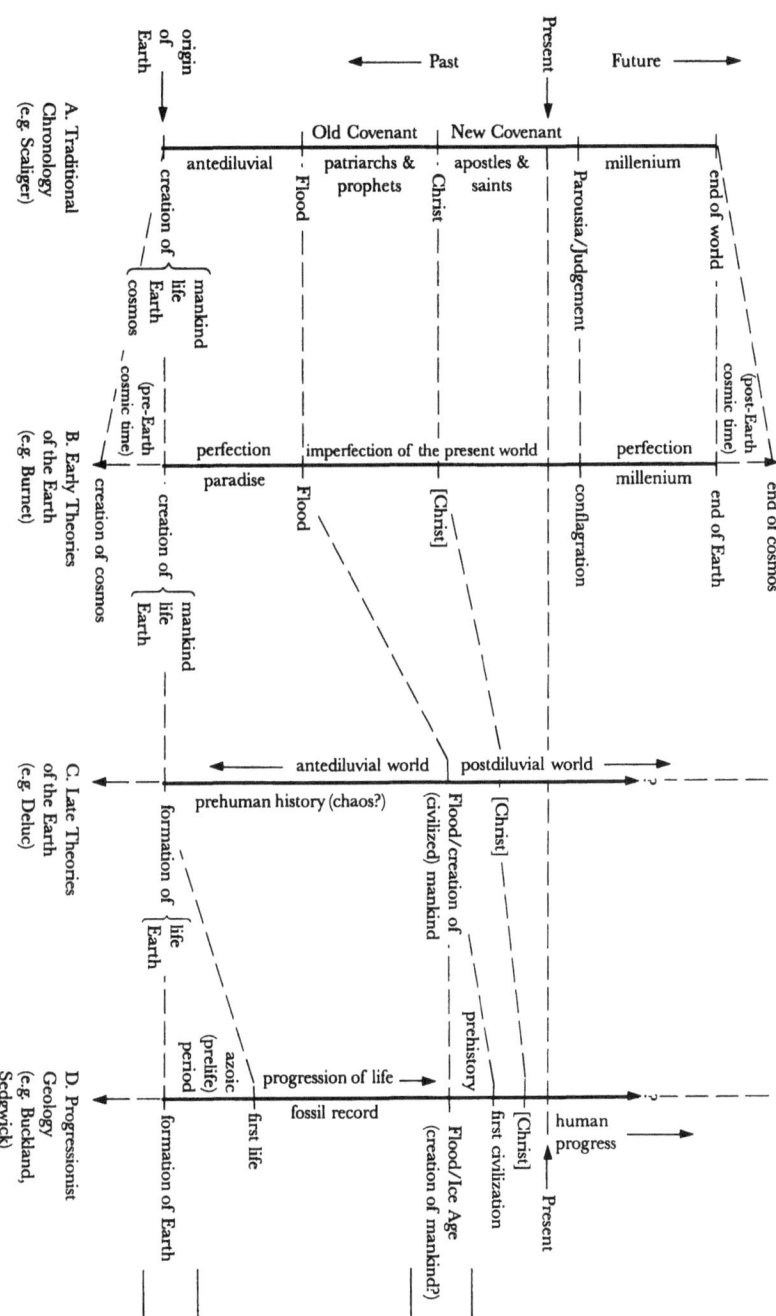

Figure 3.2 Changing views of Earth history[44].

by John Lightfoot, Vice-Chancellor of Cambridge University, that the event can be defined with even more precision, namely on the day of 24 October and at nine o'clock in the morning.

The idea of such a recent origin for the universe was mooted long before Ussher (1581–1656). So, of course, was the general doctrine of "a young Earth". Back in patristic days Origen taunted Celsus for letting himself be forced into a position of arguing for a young Earth (<10,000 years). Theophilus of Antioch ridiculed Appolonius the Egyptian for supposing Earth to be 153,075 years old, which is, he says, contrary to the biblical evidence.[47]

Speculation about the origins of familiar features of the Earth's surface was not absent in the early years of the Christian era. It was thought that a young Earth would have demanded strenuous and frequent interventions by God, especially at the Flood. Eusebius thought mountain-top fossils provided evidence of the depth of the Flood rather than the age of the Earth.[48] But with the advent of geological science, certainly from Hutton onwards, a young Earth became increasingly hard to defend.[49]

By the middle of the nineteenth century uniformitarianism was a commonplace among geologists, most of whom accepted an active Earth (though not just a decaying one), where the slow processes of erosion, precipitation and even glaciation demanded a much longer time-scale for Earth history than had been customarily granted hitherto. Those who held the past Deluge responsible for most of the Earth's topographical features had either died, quietly changed their minds or publicly recanted. Few went as far as Lyell in believing that the rates of change in the past were as slow as they are today. But whatever the precise time-scale adopted, most interpreters of nature would have agreed with Lamarck, who had said at the beginning of the century:

> Time is insignificant and never a difficulty for Nature. It is always at her disposal and represents an unlimited power with which she accomplishes her greatest and smallest tasks.[50]

With an Earth millions, rather than thousands, of years old the scene was set for something even more disturbing to traditional thought, the evolution of biological species. Questions as to the age of the Earth suddenly acquired a new and (for some) religious significance. Yet because of widespread misunderstanding it is necessary to make four general points about theological stakes in this subject.

AN EARTH OF GREAT ANTIQUITY

1. The first is that several major figures in Church and science found it necessary to distance themselves from old ideas of a young Earth. Most notable of all was Adam Sedgwick, Professor of Geology at Cambridge and President of the Geological Society. It was in the latter capacity that, in 1831, he electrified the company with the following declaration:

 Having been myself a believer, and, to the best of my power, a propagator of what I now regard as a philosophic heresy . . . I think it right, as one of my last acts before I quit this Chair, thus publicly to read my recantation. We ought, indeed, to have paused before we first adopted the diluvian [Deluge] theory, and referred all our old superficial gravel to the action of the Mosaic Flood. For of man, and the works of his hands, we have not yet found a single trace among the remnants of a former world entombed in these deposits.[51]

 These are the remarks of the man who founded the Cambrian system of modern geology. They are also the opinions of a Christian whose devotion to Scripture and its teaching places him clearly within the ranks of orthodox theology, even of evangelicalism.[52]

2. The second point is a corollary to the first. Attempts to produce *detailed* correlations between science and Scripture were no more successful than they had been in the case of Copernicus or Burnet. Idiosyncratic interpretations of Ecclesiastes and literalistic readings of Genesis were to prove as irrelevant to understanding Earth history as were appeals to the Bible in matters of cosmology (p. 7). The one thing that did become clear was that Scripture was not going to solve specific scientific problems. No better reason could be given for caution in applying biblical data to the age of the Earth than the words of Playfair and Burnet just cited (p. 28) or these later remarks of James Clerk Maxwell:

 The rate of change of scientific hypothesis is naturally much more rapid than that of biblical interpretations, so that if an interpretation is founded on such an hypothesis, it may help to keep the hypothesis above ground long after it ought to have been buried and forgotten.[53]

3. The third point is that when a major attack on the old Earth doctrine was mounted, it came, not from the dark corners of theological obscurantism, but from one of the very citadels of prestigious exact science.

31

THE EARTH IN TIME

The first salvoes were fired even before Darwin's *Origin of species* had appeared, and their effect was to challenge a fundamental prerequisite for Darwinian evolution, an Earth of extreme antiquity. The involvement of exact science was as follows.

With the invention and use of the steam engine a new interest had developed in the phenomena of heat. Out of this had emerged the new science of thermodynamics, which was developed not only by engineers but also by those concerned with academic physics, such as J. P. Joule (a wealthy amateur in Manchester (1818–89)), J. R. von Mayer (a German physician (1814–78)) and R. J. E. Clausius (Professor of Physics in Berlin (1822–88)). None, however, was more influential than William Thomson (1824–1907), later Lord Kelvin, who for 53 years occupied the Chair of Natural Philosophy at the University of Glasgow (Plate 3b). He it was who applied the new science to this very problem of the age of the Earth. He used several lines of attack.

First, he sought to establish the source of the Sun's heat. How could it continue to have poured heat upon the Earth for even a few thousand years of human history? The ordinary laws of heat suggest a glowing, solid sphere should have cooled down long before now. No chemical reactions were known capable of generating such energy, and nuclear energy had yet to be discovered. The idea was being canvassed that its heat was sustained by continuous bombardment by meteors, and that this also could account for the fact that it slowly rotates (once every 11 years). Back-of-the-envelope type of calculations using these two phenomena led him to conclude that the period in which the Sun had heated the Earth cannot have exceeded 32,000 years. Later modifications led him greatly to modify this age of the Sun to a maximum of 20 million years – vastly longer than his earlier estimate, but far too short for the time needed for geological and biological change on Earth as postulated by Lyell, Darwin and their followers.

In 1863 Kelvin tried another approach, calculating the age of the Earth from the rate at which it was cooling down from a once molten state. He now had a powerful new tool in the shape of Fourier's mathematical treatment of heat conduction. Assuming that the temperature at the Earth's centre was approximately the melting temperature of rocks on the surface, he obtained a temperature gradient from core to surface. Using known thermal conductivities for the rocks, he calculated the rate of the heat loss and was able to extrapolate back to the time when the process began. He concluded this would be at most 400

AN EARTH OF GREAT ANTIQUITY

million years ago, though later refinements of the method eventually reduced that figure to 24 million years. A final attack on the problem involved his theory that the rotation of the Earth was being gradually slowed down by the movement of the tides on its surface, acting as a kind of liquid brake. Assuming also that its slightly flattened ("spheroidal") shape was acquired at the moment the Earth solidified he could calculate its rotational velocity at that moment, compare it with the lower value today, and work out how long this reduction would take. The result was of the order of 100 million years.[54]

Although his arguments made little impact at first, a paper called "The doctrine of uniformity in geology briefly refuted" (1865) proved to be the first phase of a long battle between Kelvin and his geological and biological opponents. Charles Darwin, though publicly defended by T. H. Huxley, was deeply upset by the whole episode. He did not live to see Kelvin's own figures greatly increased by the discovery of radioactivity in the Earth and recognition that it can release immense amounts of energy (1903). With this additional, interior source of heat Kelvin's whole conclusion was undermined. The Earth must now have taken a much longer time to cool down to its present level, and would, therefore, be much older. His methods were essentially right, but one assumption (no extra source of heat) was not. And in the more fundamental aspects of his thermodynamics he still commands assent.

4. A final consideration about theology and science in this context is that an underlying theism provided a matrix in which scientific thinking, far from being inhibited, was nourished and encouraged. Kelvin's arguments were predicated largely on the assumption that the Earth is, in fact, cooling down.[55] If so, our world genuinely is "in decay", and thermodynamics has established that fact almost beyond contradiction. Yet there is a sense in which he was already half-prepared for such a conclusion. In an early manuscript of 1851, Kelvin had written that the "tendency in the material world is for motion to become diffused" – in other words, everything is slowing down. In that connection, he cited a biblical reference to the Earth growing old. As Isaiah had proclaimed:

Lift up your eyes to the heavens, and look upon the earth beneath: for the heavens shall vanish away like smoke, and the earth shall wax old like a garment, and they that dwell therein shall die in like manner: but my salvation shall be for ever, and my righteousness shall not be abolished.[56]

Kelvin nicely illustrates the difference between a Christian world-view and an allegedly Christian world-picture. He rejected the latter, with its pseudo-science constructed from miscellaneous texts in the Bible; the former he made a foundation for a life-time of scientific enquiry. For his science, like that of so many of his predecessors and contemporaries, was thoroughly theistic. Though not opposed to evolution as such, he most vehemently opposed Darwinian natural selection for its emphasis upon "chance" and apparent denial of design in nature.[57] For over half a century, he told his students that "the power of investigating the laws established by the Creator for maintaining the harmony and permanence of His works is *the noblest privilege which He has granted to our intellectual state*".[58]

Today, thanks to studies in many branches of geology, and others ranging from astronomy to radioactive dating, it is widely held that the oldest rocks are at least 700 million years old, and that our planet has existed for about 4,000 million years. How it has survived to become our home and what may be its prospects for the future are our concerns for the remainder of this book.

Chapter 4

Fragile planet

It was on Christmas Day 1968 that three astronauts on the US spaceship *Apollo 8* became the first human beings to go round the dark side of the moon. As they turned for home they saw an object of white and blue shimmering beauty begin to appear over the rim of the moon. This fragile, tiny sphere suspended in black space was their destination, their home, their own planet Earth. They were the first people ever to behold the phenomenon of earthrise. And to them came a new understanding of the poignancy of a metaphor for Earth that had recently come into favour: a *space-ship*.[1]

A space-ship (as opposed to a mere satellite) usually contains living creatures. David Attenborough took up that point in his TV series and book *The living planet*:

> As far as we can tell, our planet is the only place in all the black immensities of the universe where life exists. We are alone in space. And the continued existence of life rests in our hands.[2]

In this chapter we consider the awesome questions of our loneliness in space, the vulnerability of our cosmic situation, and the sheer fragility of this tiny planet suspended in a universe whose vastness defies the comprehension of most ordinary mortals. The term "Space-ship Earth" is singularly appropriate. Only the most obtusely optimistic can fail to recognize certain potential threats to the planet and its inhabitants. But by identifying and facing them we can prepare intelligently for the future. Some of these threats will be considered later; they include self-inflicted destruction of the environment and adherence to dangerous and false ideologies. But now we examine threats for which we do not seem to have any responsibility, natural phenomena[3] that insurance companies still sometimes call "acts of God".

Perils for the planet

The most obvious physical dangers to our home in space come from Earth itself, either from beneath the Earth's crust or even within the biosphere that extends some miles above it. They were well recognized in the early years of the scientific enterprise, not least by people like Burnet. For whatever reason, it was apparent that the Earth's surface had been and was being shaped by immensely powerful natural forces. The effects on the planet were most urgently perceived as dangerous to life, though there were plenty of other visible effects in changes to topography.

Flooding

As we have already seen, a ready explanation for the rugged state of the Earth's surface lay in the great Flood of Noah, recorded in such graphic detail in the book of Genesis.[4] It was an obvious strategy for Burnet and others, given a new awareness of surface morphology, a renewed attention to the Bible and a political ideology into which it could be neatly fitted. Evidence for a catastrophic flood in prehistoric times was not, of course, limited to Genesis. Rather similar accounts exist in cuneiform tablets of the Near East and in stories of a great deluge from many other parts of the world. What is at issue is not whether the Flood occurred, or even how extensive it was, but whether it was responsible for the Earth's surface features that we see today. That belief, usually called "diluvialism", is still popular among those who call themselves "creationists", though it has little support among modern geologists (see p. 23). However, in the late 18th century a view of Earth history emerged which did invoke water as a major agent for shaping the Earth's surface, even though the Flood of Noah was not necessarily involved.

Proponents of such a view were not inappropriately termed "Neptunists", and included in their number that great teacher of mineralogy, Abraham Gottlob Werner (1749–1817). In his view water formed our present landscape by precipitating material from solution and so laying down the salt beds with which Werner was so familiar in Silesia. In current theory most of these beds are indeed sedimentary rocks, but that cannot account for many other rocks that we call "igneous". The opposite view ("Plutonism"), that fire, not water, was a major geological agent, was associated with James Hutton (whose local Edinburgh hills are of exactly that kind). The controversy was a futile one, and in due course exclusive rights to either contender could not be granted (especially when glaciation came

PERILS FOR THE PLANET

to offer a third possibility). But by then (the mid 19th century) no one doubted that water, in certain circumstances, *could* have a devastating effect on the surface of the planet. Such would be the case in what came to be called catastrophic flooding.

Great floods have occurred through history and before written records began. There was, for example, a huge inundation in Mesopotamia that left in its wake a layer of sediment 8 to 10 feet thick. This layer was discovered in 1929 by Sir Leonard Woolley,[5] who thought it was a relic of the Noachian Flood, although this has been dismissed by later scholars on several grounds, including date (*c.* 4000 BC).[6] More recently many cataclysmic floods have been recorded,[7] often from alluvial rivers such as the Amazon and the Mississippi. The largest flood recorded in the last 1,000 years was in 1870, from the Yangtze river. Melting snow from much of western China drains into the Yangtze and immense power is generated as the swollen torrent passes through the deep Qutang Gorge in limestone country; on emerging from the gorge in 1870 the river discharged 10^5 cubic metres of flood water every second.[8] "Cataclysmic" is the only word to describe the result. The power of water to ravage the Earth can never be ignored. However, as a tailpiece, it is interesting to note we are encouraged not to fear a recurrence of flooding on the scale of Noah's Flood for the simple reason that such a disaster was expressly excluded in the covenant made between God and humanity.[9]

Volcanoes

Turning in true Plutonist fashion from water to fire as a geological agent, we can recognize another obvious threat to life on Earth as the action of volcanoes.[10] In Europe these are mostly long extinct (e.g. Arthur's Seat in Edinburgh), but the Mediterranean lands harbour two spectacularly active volcanoes, and several others which are less prominent. Eruptions of Vesuvius in the 18th and 19th centuries did immense damage, but none is remembered so well as the catastrophe of AD 79 in which the nearby towns of Herculaneum and Pompeii were destroyed by hot mud and ashes. In Sicily Mount Etna has erupted at least once in every century since the 14th, often more frequently, and has claimed many lives this century. When visited in 1828 by Charles Lyell (1797–1875) the volcano and its environs displayed evidence of such age that Lyell was able to conceive more readily of an immensely long history for the Earth. Beyond Europe volcanic activity has been evident this century in North and South America and of course the Pacific area. On 14 January 1993, an unexpected eruption of Galeras

Volcano, in Colombia, claimed the lives of several researchers in volcanology, including Professor Geoffrey Brown of the Open University.[11]

Some indication of the power of volcanoes can be gained from a visit to a remarkable example in New Zealand, Mount Tarawera (Plate 4a). Situated on a volcanic belt that includes the active and off-shore volcano White Island, Tarawera erupted on 10 June 1886, causing much loss of life, obliteration of a village and transformation of the landscape. A new lake was created (Rotomahana), and 1.3 km^3 of basaltic rock ejected. Something of the scale of events may be inferred from a sight of the craters in the 8 km-long rift. This was the worst eruption in New Zealand's recorded history (the previous one at the same site about 800 years ago emitting six times as much solid material).[12]

There have been many worse volcanic eruptions than the 1886 event at Tarawera, though that was bad enough. Often, as here, the main effects are not the fissures visible only to climbers or from aircraft. They arise rather from the deposition of ash and scoria and the explosions produced when white-hot rock encounters water (sometimes causing new craters which may then be flooded to become new lakes). Accumulation of mud and ash, rather than lava, was the chief cause of the historic disaster at Pompeii. A further hazard on other occasions may be the non-explosive ejection of magma streams which flow relentlessly down the mountain-side, destroying all vegetation in their path. Lava from the 1794 eruption of Vesuvius is said to have flowed over 20 km^2 (5,000 acres) of vineyards.

A further volcanic threat to the biosphere in general is illustrated by the extraordinary event of the eruption of Lakagigar, Iceland, commencing in June 1783 and continuing, on and off, for another eight months.[13] This was the largest eruption in historic times, producing 100 craters and an unimaginable 2.8 cubic miles (12.5 km^3) of ash. At first the lava was ejected literally in fountains, escaping along two river-beds. So fast was the production of lava (2,200m^3 per second for the first 50 days) that its rate of flow at the mouth exceeded that of water over the Niagara Falls.

At first the only damage was to property, but throughout the summer all growth was stunted and a bluish haze hung over the whole country. That year 50 per cent of cattle, 79 per cent of sheep 71 per cent of horses and 25 per cent of the human population (10,000) were killed, undoubtedly as a result of volcanic gas release. It is calculated that 1.3×10^7 tons of sulphur dioxide and 2×10^6 tons of carbon dioxide were released by the eruption. Since analysis of lava indicates 320 ppm fluorine content, it is possible that many of the fatalities were due to fluoridosis from fluorides also emitted.

PERILS FOR THE PLANET

Long-term dangers to the health of populations near active volcanoes are still being studied.[14]

However, it was not only Iceland that was affected. The gas cloud spread to most of Europe, and beyond. The following winter (1783/4) was exceptionally severe over the whole continent. Benjamin Franklin (1706–90) described it thus:

> During several of the summer months of 1783, when the effect of the sun's rays to heat the earth in these northern regions should have been greatest, there existed a constant fog over all Europe, and a great part of North America. This fog was of a permanent nature; it was dry, and the rays of the sun seemed to have little effect in dissipating it, as they easily do a moist fog, arising from water. They were indeed rendered so faint in passing through it, that when collected in the focus of a burning glass, they would scarce kindle brown paper. Of course their summer effect in heating the earth was exceedingly diminished.
> Hence the surface was early frozen.
> Hence the first snows remained on it unmelted, and received continual additions.
> Hence the air was more chilled, and the winds more severely cold.
> Hence perhaps the winter of 1783-4 was more severe than any that had happened for many years.[15]

Franklin went on to add that "the cause of this universal fog is not yet ascertained", but wondered whether it was "the vast quantity of smoke, long continuing to issue during the summer from *Hecla* in Iceland, and that other volcano that arose out of the sea near that island". He was probably right, in which case to the other awesome effects of volcanic activity must be added that of prolonged and damaging climatic change.

Earthquakes

Areas with a history of volcanic activity may also be unusually liable to earthquake tremors. Examples include Iceland, countries of the western Pacific, New Zealand, and Washington State, USA. However, it is now believed that other types of earthquakes can occur that have no direct connection with volcanic activity.

Records of historic earthquakes go back many centuries for Japan and China. Biblical reference to earthquakes is frequent.[16] In Old Testament

times Earth tremors may have been associated with the experience of Moses at Mount Sinai,[17] the destruction of Sodom and Gomorrah[18] and, with considerable plausibility, the fall of Jericho.[19] In fact the Old Testament now offers researchers a record of earthquakes over a period of 4,000 years.[20] In the New Testament they are explicitly mentioned in connection with the Crucifixion[21] and the liberation of Paul and Silas from prison at Philippi.[22] Other literature since classical times has countless allusions to earth tremors of varying magnitudes.[23]

In relatively recent times southern Europe has experienced several devastating earthquakes (see Plate 7a,b), as summarized in the Table 4.1.[24]

Table 4.1 Major earthquakes in southern Europe.

Date	Location	Fatalities
1 November 1755	Lisbon, Portugal	50,000–70,000
21 March 1829	Alicante, Spain	840
28 December 1908	Messina, Italy	120,000
27 December 1939	Erzincan, Turkey	23,000
6 May 1976	Friuli, Italy	965
23 November 1980	Campania, Italy	>3000

One need hardly add that, in addition to the fatalities, the toll of human suffering from injury and destruction of property was immense; in the last example cited (Campania) the number left homeless was 250,000. Further north in Europe this hazard becomes far less, and minor damage to property has been the worst effect of small tremors occasionally experienced in Britain and neighbouring countries.

In the Americas historical records are naturally much briefer than in China or Europe, although there are references to two in the 17th century and four in the 18th. At the end of 1811 and the beginning of 1812 ("the year of earthquakes") a succession of major shocks struck near New Madrid, Missouri, and shortly afterwards in California. Earthquakes continued to strike the Californian seaboard through the 19th century, culminating in the disaster at San Francisco in 1906, when 700 were killed by falling masonry or the subsequent inferno that raged through the city. Most recently came a series of earthquakes near the notorious San Andreas fault in June 1992. These were the largest in S. California for 40 years, with a magnitude of 7.5 on the Richter scale. So great were the changes that they may have advanced the date of the next major earthquake in the southern part of the fault-line by 10–20 years.[25]

PERILS FOR THE PLANET

Further north Alaska received a succession of shocks in the 20th century, of which the worst was on Good Friday, 1964. In addition to property damage estimated at $300 million and the loss of 131 lives, geological change included a rise of up to 10 metres of the Pacific shore-line. In Central and South America the greatest human toll appears to have been exacted in the cases listed in Table 4.2.[26]

Table 4.2 Major earthquakes in Central and South America.

Date	Location	Fatalities
21 March 1861	Mendoza, Argentina	18,000
25 January 1939	Chillán, Chile	30,000
15 January 1944	San Juan, rgentina	5000
5 August 1949	Ambato, Ecuador	6000
31 May 1970	Ancash, Peru	40,000
23 December 1972	Managua, Nicaragua	10,000
4 February 1976	Guatemala	22,000
19 September 1985	Michoacán, Mexico	9500

On 30 September 1993 India suffered a devastating earthquake in the region of Latur, with perhaps 10,000 fatalities. Many of the casualties resulted from the poor construction of buildings which were unable to withstand even relatively mild shocks.

None of these disasters approaches those recorded for the 830,000 fatalities at Shenshi, China (1556), the 300,000 at Calcutta (1737) or the 250,000 at Tangshan, China (1976). Few statistics could illustrate more powerfully the perils to which this fragile planet is subject from forces unleashed within itself.

Comets

Unlike floods, volcanoes and earthquakes, some hazards facing the Earth originate from far out in space. Two of these come from phenomena recognized from antiquity, though the extent to which they are dangerous to the Earth is only now being evaluated. The first of these is the possibility of collision with a comet.

From the earliest records we know that comets were commonly presumed to portend disaster, and astrological literature is full of references to such matters. The famous Bayeux Tapestry shows a comet (Halley's) commonly believed to portend the death of the last Saxon King of England, Harold II, in 1066. Even biblical events may have been linked to cometary

appearances, most notably of all the famous Star of Bethlehem, which Colin Humphreys has suggested was a comet in Capricornus known to have blazed forth in 5 BC.[27]

It was only after Newton had shown how the motion of comets fitted into his scheme of universal gravitation, and that their paths were probably elongated ellipses, that accurate prediction of cometary trajectories became possible. Halley was the first person to perform this task satisfactorily, predicting in 1705 a return in 1758 of the comet he had himself observed in 1682: Halley's Comet. Thereafter there was much speculation as to how comets might interact physically with the Earth. Whiston, for example, thought that comets could be held responsible for, in turn, the diurnal rotation of this planet, the Flood of Noah and the final dissolution of the Earth. The notion of a cometary *collision* does not seem to have exercised astronomers for the simple reason that no comets were known until our own day whose calculated paths suggested anything like a near approach to Earth. That, of course, did not deter a few novelists from such speculations, most notably H. G. Wells, whose *In the days of the comet* (1906) predicted a moral cleansing of Earth's inhabitants as they breathed mysterious green vapours from the heavenly visitant.[28]

Recent calculations have indicated a high probability that the inert core of an extinct comet will some day collide with a body in the solar system such as the Earth or Venus. It was once thought that the Tunguska crater in Siberia might have resulted from an impact with a comet nucleus 40 m diameter,[29] but an alternative explanation now seems more likely (see below). More plausible is the hypothesis[30] that the Swift-Tuttle comet may strike the Earth on 14 August 2126; the chance is as high as 1 in 10^4.

Meteorites

From the dawn of history human beings have been aware of showers of "shooting stars", sometimes leading to recoverable meteorites. In the ancient world meteorites were revered as sent by the gods, and for millennia they were the only source of metallic iron, being fashioned into knives, axes and so on.[31] The visible displays of shooting stars have been variously taken as symbols of mystery,[32] portents of some imminent catastrophe[33] or even firebrands hurled by the angels against too inquisitive spirits.[34] Their origin in the atmosphere was so generally taken for granted that it is said that in the 18th century French astronomers threw meteoritic stones out of their museums. Towards the end of that century various writers suggested

a cosmic origin for shooting stars, though it was not until 1866 that Schiaparelli showed that they were swarms of particles moving round the Sun in well-defined orbits, often coinciding with those of comets. They are now recognized as debris orbiting the Sun and often products of cometary breakdown.[35] When the particles are small they ignite through friction in the atmosphere and are burnt up completely as showers of "shooting stars". Slightly larger bodies may partially survive their passage through air, and land as "meteoric stones" or "meteorites". It is only when they are considerably larger ("bolides") that they pose a threat to the Earth.

In 1908 a remarkable event happened in Siberia. Over the Tunguska river a huge fireball was reported, accompanied by an explosion heard 1,000 km away. Although no conventional crater was discovered, the forest was flattened over an area of 70 km in diameter. Various theories were proposed for this extraordinary event, the more bizarre including a black hole of anti-matter or a nuclear-powered alien spacecraft. More probable was the comet theory (see above), though it has recently been proposed that the episode might have been caused by a meteorite, perhaps 30 m in diameter, fragmented well above the ground by aerodynamic forces.[36]

One meteoric impact that did leave a recognizable crater was about 50,000 years ago near Flagstaff, Arizona (the Barringer Meteor Crater). This has a diameter of about 1.22 km and a depth of about 180 m; large amounts of meteoric iron were found in its vicinity. It is estimated that the bolide must have had a mass of about 10^8 kg.[37]

Altogether some 120 meteorite impact craters have been identified on Earth (to say nothing of those on the moon). It has been suggested that about 2,000 small objects such as asteroids, with a diameter of 1 km or more, are in Earth-crossing orbits. Any one of these might each cause 25 per cent human mortality by creating dust-storms that would exclude sunlight for months or years; the individual's chance of death from this cause would be $c.\ 5 \times 10^{-7}$ (comparable to the risk of death in an air-crash). However, if the objects were at least 10 km in diameter, collision would probably extinguish 90 per cent of all species.[38] It is possibly one such object that contributed to the extinction of the dinosaurs.[39] This was first proposed in 1980 by L. W. Alvarez and his colleagues,[40] and depended in part on higher than normal concentrations of iridium at known sites marking the boundary between Cretaceous and Tertiary ages of the Earth – the ages of dinosaurs and mammals respectively. Of over 50 such sites later examined iridium enrichment was found at all but two.[41] The asteroid size was estimated at about 10 km in diameter.[42] A further suggestion was that cessation of photo-

synthesis could have been due not only to prolonged obscuring of the Sun by dust but also to poisoning of marine plankton, thus leading to a break in the ocean food-chain and substantial increase in atmospheric carbon dioxide concentrations for many millennia.[43] However, it has been well said that "no one isolated cause can explain the complex phenomenon of mass extinction".[44] The dinosaurs seem, for other reasons, to have been born losers. Humanity would do well to bear that in mind.

That does not exhaust the possible effects that meteorites and asteroids can have on our planet, or enquiries into their constitution.[45] Since the 1870s claims have been made, on and off, that meteorites contain traces of fossil material, suggesting the presence of non-terrestrial life and a possibility, however remote, of infection from space. A proposal that meteorites might have come from the Moon[46] led to elaborate quarantine precautions at the NASA Lunar Recovery Mission to the Moon. But no biogenetic materials were identified in the lunar samples recovered.[47] The presence of organic compounds (as amino-acids) in meteorites had been claimed for some years, though they could have been formed from purely inorganic material by reactions involving CO, H_2 and NH_3.[48] Analogues of such reactions were subsequently discovered on Earth.[49] However, amino-acids produced from living organisms should be optically active. Analysis of organic compounds recovered from a large (500 kg) meteorite which fell in 1969 at Murchison, Australia, did not yield conclusive evidence for optical activity.[50] It does not now appear that a danger to the present inhabitants of this planet resides in the importation of alien forms of life through meteoric invasion. Other perils are far more likely.

Radiation

The Earth is under constant bombardment from outer space. In 1911 it was shown that some background radiation detected on Earth originates beyond the limits of the atmosphere. By the 1930s it became clear that the "rays" were actually charged particles. They can tell us much about the universe and its probable origin. They have deep penetrating power and induce a complex series of reactions with our own atmosphere. Partly from this effect, but chiefly from other radiation sources, come several kinds of true electromagnetic radiation, including radio waves, X-rays and ultra-violet rays. The former are much used in astronomical research ("radio telescopes"), but the last two can have adverse effects on life, of which the most obvious example is the incidence of skin cancer, particularly after over-exposure to rays from

the sun. However, a remarkable and possibly unique feature of our planet is the existence of a layer of ozone (O_3) in the upper atmosphere which has the effect of filtering off a great proportion of such lethal radiation. Without it life could probably not exist, at least not in its present forms. It is for this reason that potential destruction of the ozone layer by human activity is viewed today with such alarm (see also pp. 63–4).

Solar heating

The greenhouse effect is so well known that little need be said at this point. Earth's atmosphere has a mean concentration of about 0.03 per cent of carbon dioxide. A "carbon cycle" normally regulates this to within quite fine limits (see p. 109). The overall effect of this stationary concentration is to maintain Earth's mean surface temperature at 15°C instead of the −18°C predicted otherwise. Life therefore becomes possible. There is thus a well-adjusted atmospheric temperature, just as in a well-constructed greenhouse. This process is independent of human activity and is a "natural greenhouse effect". If, however, the amount significantly increases, the effect is to permit solar rays to heat the planet as usual but not to allow excess heat to escape. The effects of over-production of carbon dioxide by human agency is properly described as an "enhanced greenhouse effect" and will be considered later (pp. 53, 114). Other gases than CO_2 are also involved, but this is considered to be the most important natural factor.[51]

In nature carbon dioxide results from biological processes as respiration and fermentation. This is well within the limits of the carbon cycle to contain. Additional injection of CO_2 into the atmosphere may result from conflagrations like forest fires and from exceptionally violent volcanic emissions. The overall effect then may be a slow warming-up of the Earth, a process that would eventually continue until life became extinct or unless some new balancing mechanism intervened. It has to be said, however, that on present evidence human activity is far more likely to prove a major contributor to a global warming.

There is also another consideration. The Sun is getting hotter, perhaps 30 per cent hotter than when the Earth was formed 4,500 million years ago, though it has been predicted that it will take another 5,000 million years to be transformed into a red giant star. However, a much more imminent peril has now been suggested. Such solar heating could lead in the relatively short term to a vast increase in rainfall, breaking down silicate rocks which are capable under these conditions of removing CO_2 from the atmosphere by

a reaction that is essentially

$$CO_2 + SiO_3^{--} \rightarrow CO_3^{--} + SiO_2.$$

Thus more CO_2 is absorbed from the air. This would certainly minimize the greenhouse effect, but it would also reduce the CO_2 level below the minimum for photosynthesis, so life would perish not from heat but from famine. A recent author suggests a mere 1,500 million years for this to occur.[52]

All of these natural perils have been identified for the planet. We must therefore ask: what kind of response is appropriate? There are two levels at which that question may be answered.

Technological responses

In terms of technology alone there are two possible approaches. The first of these is *fatalism*. Following in the footsteps of the Greek atomists we may well say there is little we can do about any of these cosmic phenomena. So the sensible thing is to sit down and do nothing. After all, the chances of a dire cosmic catastrophe in our own life-times are not great, so "let us eat, drink and be merry". But, as with the rich fool in the parable, our calculations over time may be severely wrong. Moreover, such a *laissez-faire* philosophy is a complete abrogation of our responsibilities to the future human race (probably including our own descendants). Even the Old Testament stressed our solidarity with our own future race. And for those who profess to follow Christ such irresponsibility is unthinkable. The Puritan founders of English science would have been horrified by such callous disregard of the mandate to study *and manipulate* nature "for the good of man's estate".

There is therefore only one viable alternative, and that is *a determined, but limited, application of technology*. One thesis of these chapters is that we need not less but more, and better, scientific research. Later (Chapter 9) we shall see some likely scenarios for the Earth. Meanwhile it is worth mentioning a few possible courses of action. Some proposals seem ludicrously far-fetched. Others, however, appear to be quite realistic. It must be stressed that we are here concerned only with responsive measures to *natural* threats to the planet, not proactive measures to minimize the additional dangers imposed by human beings.

One realistic proposal is the development of predictive geology. The purpose of Geoffrey Brown (killed at Galeras, p. 38) and his colleagues was to use gravity measurements in order to give some measure of warning,

TECHNOLOGICAL RESPONSES

especially to those living near active volcanoes. In a similar manner prediction of earthquakes has come a long way since the days of astrological superstition.[53] Apart from long-term studies in seismology generally it is now possible to predict very approximate dates of the next shocks in areas like China and California which have been subjected to repeated earthquakes over a very long period. Thus an almost linear sequence of earthquakes at Parkfield, California suggests the next event will be in 1993, the year of writing this book. It will be interesting to know if this is borne out before the publication date.[54] And of course methods have been developed for recognizing immediate harbingers of earthquakes. These include measured changes in the physical parameters of rocks, observation of uplift or tilt in the ground, evolution of radon gas, and fracturing of underground pipes. Yet there remain grave doubts as to how effective such predictions can be. In the case of Tokyo, extremely vulnerable to earthquake damage, an official and costly "early warning system" has been described as "myth sanctioned by government"; the period of warning, expected to be as long as two days, may in fact be no more than nine seconds.[55] The authorities have been advised to move government offices outside the city.

To minimize loss and damage when disaster does strike science and technology can contribute rather more than the advice seen on a New Zealand church notice-board: "In the event of an earthquake the congregation should get under the pews in order to avoid objects falling from the roof." In Wellington, for example, an earthquake in 1848 destroyed most of the city's brick buildings, so brick was replaced by timber. Today this is still the commonest mode of construction for dwelling houses in New Zealand, Japan and parts of the USA. One of the largest wooden buildings in the world, the Government Building in Wellington (1876), was faced with kauri wood treated to simulate stone; even this had its 22 chimneys later removed to minimize danger from falling masonry. With the advent of steel framing some brick construction recommenced in the city, one of the first buildings to conform to new earthquake requirements being the Prudential Assurance Co. offices of 1935. Since then far more sophisticated methods of construction have been developed,[56] including a built-in flexibility using modern polymers, applicable even to high-rise buildings.

Turning from the twin menaces of volcanoes and earthquakes we find rather more daring proposals to counter the dangers that threaten from beyond the Earth. They include deflection of near-Earth asteroids by shooting heavy objects at them and using high kinetic energy impact to change their trajectories into hyperbolic orbits (taking them for ever away from the Earth). For cosmic intruders greater than 1km in diameter it has been seri-

ously suggested that only nuclear explosions would be practicable.[57] Or again the undesirable warming up of the planet might be minimized by using giant mirrors to reflect away the Sun's heat.[58] A recent Japanese project intends to reduce the greenhouse effect by trapping carbon dioxide from power station flues and either transporting it to great depths in the ocean (when water pressure should hold it in place) or else hydrogenating it to form methanol. The problem is that such grandiose schemes themselves are energy-intensive and thus involve enormous consumption of fuel.[59]

Clearly the boundary between practicalities and science fiction is a blurred one. But that should not stop us from seriously considering how we may make the best of our present predicament. For those who feel such steps to be imprudent, impious or even blasphemous it is well to state that there is a divine mandate for technology ("Fill the Earth and subdue it"[60]), and that this should indeed be a partnership between humanity and the Creator. Let the point be illustrated by a *Punch* cartoon[61] of 1934:

"It's wonderful what the hand of man can do to a piece of earth, with the aid of Divine Providence, Wilkes."

"You should 'ave seen this piece, Sir, when Divine Providence 'ad it all to itself."

Theological responses

For all the challenges that natural disasters may bring to science and technology (or to common sense for that matter), the fact remains that they also constitute a problem for theology. If they are truly "acts of God" all kinds of difficult questions are raised, and most acutely in the minds of those most directly affected, for whom academic theology may well be an irrelevance. Without in any sense diminishing the validity of scientific descriptions of such events, may one not also ask whether they represent a judgement of God, and if so, how does this squares with his alleged love and mercy?

The problem is not a new one. Christ himself was faced with precisely this issue over a recent fall of the Tower of Siloam (perhaps through an earthquake tremor); he explicitly denied that the 18 persons killed were more guilty than others in Jerusalem who survived.[62] There was no direct connection between a natural disaster and individual human wickedness. Long before this the book of Job had dealt with the wider problem of human suffering (from natural and other causes). The proposed solution lay in a revelation of the power, sovereignty and majesty of God. Through the final four chapters Job is presented with a description of the natural world unparalleled in ancient literature. As he glimpses the awesome might of the Creator he can only confess his own ignorance and insignificance.[63] In purely pastoral terms many a simple soul has found strength by discovering that "the Lord answered Job *out of the storm*"[64]. As an encouragement to scientific research few biblical passages can match the challenge to consider the facts of astronomy, meteorology and natural history posed by those chapters of Job. Most relevantly today one writer has argued that this passage in Job is "one of the most far-reaching defences ever written of wilderness, of nature free from the hand of man", adding that "wild nature, then, has been a way to recognize God and to talk about who he is – even, as in Job, a way for God to talk about who he is".[65] This turning of a natural disaster into a natural theology is not only sound exegesis of a neglected part of the Old Testament. It is also a clue to a first understanding of how terrestrial or cosmic catastrophes can be viewed from the perspective of today, a perspective that may include the insights of both science and theology.

In a most sensitive analysis of the problem of disasters like earthquakes and volcanic eruptions Austin Farrer stresses that God works through "natural" laws and then brings good out of apparent evils:

> If an earthquake shakes down a city, an urgent practical problem arises – how to rescue, feed, house and console the survivors, rehabi-

litate the injured, and commend the dead to the mercy of God; less immediately, how to reconstruct in a way which will minimize the effects of another such disaster. But no theological problem arises. The will of God expressed in this event is his will for the physical elements in the earth's crust or under it: his will that they should go on being themselves and acting in accordance with their natures.[66]

He goes on to speak of volcanic eruptions, adding:

It is not, then, that the humanly inconvenient by-products of volcanic fire are cushioned or diverted; it is not that all harms to man are prevented. It is that the creative work of God never ceases, that there is always something his Providence does, even for the most tragically stricken.[67]

Finally, we hear from John Wesley (1703–91), who lived through tumultuous times at home and abroad, well aware of the main issues of 18th-century natural philosophy. For him there were more important things to consider.

Allowing there are natural causes for all of these, they are still under the direction of the Lord of nature. Nay, what is nature itself but the act of God? Or God's method of acting in the material world? True philosophy . . . ascribes all to God.

Speaking of the devastating earthquake at Lisbon of 1755 (when it will be recalled over 50,000 people were killed), and speculating on the possibility of further "natural" disasters (including the return of Halley's Comet in 1758), he argues:

Need we not fear, though the Earth be moved, and the hills be carried into the midst of the sea: no, not though the heavens being on fire are dissolved, and the very elements melt with fervent heat. It is enough that the Lord of Hosts is with us, the God of Love is our everlasting refuge.[68]

Getting even nearer home, he included his own earthly life in a pending, general dissolution. Putting into his own language the words of a 17th-century Silesian monk, he taught his people to sing:

What though my flesh and heart decay,
Thee will I love till endless day.[69]

That indeed is a philosophy adequate for all living on our fragile, vulnerable, endangered planet, whether in the 18th or the 20th century or at any other time in its chequered, tumultuous history.

CHAPTER 5

"Hurt not the Earth"

Visions of Apocalypse

The book of Revelation, the final book of the New Testament, must seem an unlikely source of information regarding the welfare of this planet. It is couched in vivid, almost bizarre imagery, totally unfamiliar to modern man, being expressed in the language and thought-forms of first-century Jewish apocalyptic writing. An alternative title for the book is appropriately "The Apocalypse", and its interpretation has been a matter of intense controversy all down the centuries. It has been a rich source of material for the craziest prophets of doom on one hand and for intellectual giants like Isaac Newton on the other. Yet in the midst of a series of purple passages presaging doom to an impenitent world comes this remarkable announcement, the restraining voice of God to an avenging messenger ("angel"):

Hurt not the earth, neither the sea, nor the trees.[1]

Taking "the earth" to mean "the dry land" the passage could almost have been a proof-text for a 20th-century manual of environmental action. Indeed the reference to "trees" has baffled generations of commentators until our own day, when the importance of fast-disappearing forests has now become so painfully obvious. To us moderns "trees" are a most appropriate symbol of environmental concern.[2] In the ancient world they were objects of worship[3] (though denounced as such in the Old Testament[4]); John's Jewish readers would have recognized them as legitimate objects for human use[5] and enjoyment[6] as well as joyous witnesses to God's creative power.[7] Their destruction was "bad news" whether for Israel,[8] her enemies[9] or even a solitary prophet;[10] it was often a symbol of judgement.[11] On some trees there was even a "preservation order",[12] while the Old Testament prophet Habakkuk

"HURT NOT THE EARTH"

condemned the Babylonian king Nebuchadnezzar in trenchant terms:

> You have cut down the forests of Lebanon; now you will be cut down. You killed its animals; now animals will terrify you.[13]

The Babylonian devastation of the Lebanese cedar forests was well known and deeply resented.

So to readers in the second century AD as well as to ourselves the command to "hurt not the trees" meant much more than a minor restriction in arboriculture; it portended the magnitude of the calamity to follow, once the order had been withdrawn.

Even a superficial inspection of the passage in Revelation discloses something more like a sequence of *natural* disasters than one caused directly by human beings. Nevertheless, the agents of destruction are clearly not to be taken in a literal sense and are obviously intended to show these horrors as a consequence in some way of human (sinful) activity.[14] Hence it would be foolish to "naturalize" their meaning too strongly.

When the restraining command is revoked the impending disasters are seen to include:[15]

(a) massive conflagration (one-third trees and grass consumed)
(b) wholesale destruction of marine life
(c) wholesale pollution of rivers
(d) partial blackout of Sun, Moon and stars
(e) painful and deadly disease
(f) devastating warfare.

Even for those scholars who take such passages with due seriousness problems abound. Given the plethora of obviously poetic imagery how far should any phrase be given a literal construction? Were the messages ever intended to apply to the end of the age or rather to the tumultuous Roman world a century after Christ? However, despite all the obscurity two things are surely crystal clear. The first is the writer's claim for a divine rôle in Earth history; God is not just a passive observer, indifferent to suffering, injustice or any other kind of evil. He acts decisively in history and will do so till the end-time. Secondly, while many of the disasters depicted could be from "natural" causes, each of them could be a result of human activity (in each case permitted by God). It is hard to avoid the rueful reflection that history might have been very different if human beings had only understood that their abuse of the world's resources could well lead to the kind of judgements grimly portrayed in the book of Revelation. And in this chapter we turn from natural disasters to those inflicted by ourselves, from external foes to the Earth to those from within our own ranks.

VISIONS OF APOCALYPSE

As David Attenborough has implied, (p. 35) there is now a widespread awareness that this fragile Earth, for so long subject to perils from natural causes, is now in even greater danger from the activities of its human inhabitants. Consider simply those calamities presaged in Revelation.

The possibility of *massive destruction of trees and grass* has become a reality in the immense programmes of deforestation undertaken in Africa, south east Asia and (most spectacularly of all) the Amazon Basin in South America.[16] Tropical rain-forests a year or two ago were estimated to cover some 9 million km^2; the current rate of clearance may well be 110,000km^2 per annum, at which rate they would have completely disappeared within a century even if the pace were not accelerating (which in fact it is).[17] The consequences for the global environment are well known: an incalculable loss of native fauna and flora (perhaps 10,000 species per annum), dramatic change in local climates, and an increase in global CO_2 (through burning) without any compensating decrease by photosynthesis in tree leaves. We are thus faced with global warming through an enhanced greenhouse effect,[18] with perils to every kind of life on this planet. Since 1900 there has been an estimated rise in air temperature of 0.5°C, and this may reach 1.5°C by 2030 and 3°C by 2060 (leading to overall sea rises of respectively 20 and 35cm).[19]

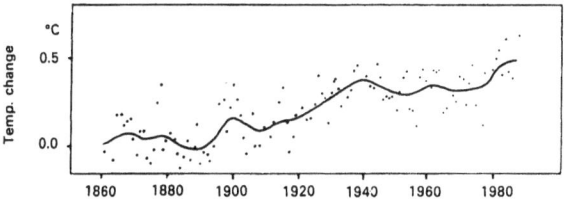

Figure 5.1 Change in global surface temperatures since 1860: a graph[20] derived from data by James et al., *Nature*, 1986, 322.

Turning from land to sea we are also involved in the *wholesale destruction of marine life*. Partly this has come about by the dumping of all kinds of unwanted material, as untreated sewage, chemical waste and nuclear waste. It has been well said that "the oceans have become the sinks of the world".[21] Since the days of the *Torrey Canyon* disaster (March 1967) the public has become used to the spectacle of tanker accidents which involve spillage of perhaps a million gallons of oil and subsequent slaughter of bird and fish life on a massive scale. Injury to marine life can also affect human beings. A classic case was a strange disease, often leading to insanity and death, first encountered in 1953 at Minemata Bay, Japan. It was shown that the 89

casualties had over 100ppm of mercury in their bodies, obtained through eating fish contaminated with methyl-mercury ($(CH_3)_2Hg$) from a local chemical plant. Later over a million cans of tuna fish were withdrawn in the USA after samples were similarly shown to contain mercury. And human complicity in the destruction of marine life is most familiar in the phenomenon of over-harvesting the oceans. This applies equally to over-fishing in European coastal waters and the dangerous depletion of whale stocks worldwide (so much so that in 1986 the International Whaling Commission called for a pause to all commercial whaling).[22]

Closely related to the destruction of marine life is our *wholesale pollution of rivers*. Historically by far the greatest contributor was untreated domestic sewage, a cause of successive waves of cholera, typhus and typhoid in the rapidly expanding towns of Victorian England, where drinking water was drawn from the rivers. This situation still exists in many places in the Two-Thirds World, the rivers of India being especially bad examples. In modern times manufacturing industry has rendered many rivers unfit for domestic use because of toxins, undesirable trace elements or an excess of nitrates through agricultural seepage. Survival of fish life is often at risk through the shortage of dissolved oxygen, removed by aerobic bacteria from waste organic matter. Chemical works are by no means the sole – or even chief – offenders. Here is a description of an output to the river Thames in the late 19th century:

> Through these secret channels rolled the refuse of London, in a black murky flood, here and there changing its colour, as chemical dye-works, sugar-bakers, tallow-melters, and slaughterers added their tributary streams to this pestiferous rolling river.[23]

Fortunately things have rather improved since then, at least for London, but the potential threat remains, and elsewhere in the world river pollution is still a major problem.

The reference to a *partial blackout of Sun, Moon and stars* might have meant more to readers a few generations ago. For much of Britain the industrial cities suffered from a perpetual darkness through the most appalling smoke pollution. The legendary fogs and smogs of London[24] are remembered by many, but thanks to Clean Air Acts or their equivalent most industrialized countries no longer have this grim experience. However, the fact that atmospheric pollution is now less visible (especially as coal has been replaced by oil and petrol) does not mean that it is less dangerous; the combination of carcinogens and carbon monoxide in diesel exhaust can be at least as lethal

VISIONS OF APOCALYPSE

FARADAY GIVING HIS CARD TO FATHER THAMES;
And we hope the Dirty Fellow will consult the learned Professor.

Figure 5.2 Cartoon from *Punch* relating to Michael Faraday's trip down the River Thames (1855) where pollution was so bad that the river was 'an opaque brown fluid', a piece of card becoming invisible before it had sunk an inch below the surface.[25]

as the smoky discharge of a steam engine. The awful possibility remains, moreover, of a "nuclear winter" following the advent of nuclear war (p. 84), in which case the biblical description is rather mild.

Possibilities of *insect-borne plagues* may seem reduced by advances in modern medicine, but the irony is that the panic banning of insecticides in the 1960s and 1970s has actually enhanced the survival prospects of many disease-carrying insects (such as mosquitoes), and in that sense we have our-

selves to blame. If the "insects" should be taken in a purely figurative sense, then the number of wasting diseases for which human behaviour is at least partly responsible is highly significant, from lung cancer to AIDS.

Finally there loomed before those early Christian readers the awesome prospect of *devastating warfare*. Not a few commentators in modern times have written of a nuclear Armageddon, and there is little doubt that such an event would pose the greatest threat to this planet since at least the extinction of the dinosaurs, and possibly in all its chequered history.

In 1966 the historian Lynn White Jr addressed the American Association for the Advancement of Science on "The historical roots of our ecologic crisis". His conclusions are now seen as over-simplistic or even wrong, but his intention was surely commendable. We *must* discover how we have got into our present mess. In his lecture White surveyed "the population explosion, the carcinoma of planless urbanism, the new geological deposits of sewage and garbage" and observed "surely no other creature than man ever managed to foul its nest in such short order".[26] In the subsequent chapters we shall try to find a valid explanation.

Science and environmental problems

It is first important to stress that the problems are far from being merely contemporary. We must not exaggerate the modernity of the present crisis. Thus about one third of the world"s natural forest cover has been removed over the last 8,000 years. In Britain the forests of alder, birch, oak and Scots pine that once covered all but the very highest mountains have been removed over the last few thousand years by grazing of sheep and other animals; where any replacement has taken place it has usually been by coniferous trees planted by the Forestry Commission. Man has been around in the Scottish Highlands for at least 4,000 years.

Certain cases of environmental abuse have been recognized as such for a considerable period. Thus in the 1830s the Irish chemical manufacturer James Muspratt (1793–1866) was subject to a series of prosecutions for polluting the air near his Merseyside works with hydrogen chloride gas. Instructed to find some means of absorbing it before discharge he announced that "all the waters of Ballyshannon could not condense the acid that I produce".[27] Given a technique recently invented, this was probably incorrect.

Shortly after this (in 1858) the Manchester chemist R. Angus Smith (1817–84) was studying the weathering of public buildings. In terms that

SCIENCE AND ENVIRONMENTAL PROBLEMS

sound almost contemporary today he wrote:

> It has often been observed that the stones and bricks of buildings, especially under projecting parts, crumble more readily in large towns where much coal is burnt, than elsewhere. . . . I was led to attribute this effect to the slow but constant action of the acid rain.[28]

Interestingly, he assessed the evil as "not of the highest magnitude" but rather as worthy of observation "first as a fact, and next as affecting the value of property". His findings were greatly extended in his later book *Air and rain – the beginnings of a chemical climatology*.[29]

Another modern term, "biosphere", actually originated in 1875 with a book on Alpine geology by Eduard Suess (1831–1914);[30] the concept was developed in the early 20th century by the Russian mineralogist Vladimir Vernadsky (1863–1945).[31] Meanwhile, in 1896, the Swedish chemist Svante Arrhenius (1859–1927), using measurements of infra-red radiation at night, calculated that for each doubling of the CO_2 concentration in the atmosphere there would be a mean global rise in temperature of at least 5°C.[32] He had discovered the enhanced greenhouse effect.

There can be no doubt that in the late 20th century the problems are immensely greater than they were 100 years ago. The critics of science and technology are quick to lay the blame at their door, and in three senses they are right. In the first place it is the application of scientific knowledge that has given us *the wherewithal with which to pollute*. Science-based technology has facilitated the rapid growth of transport systems, with the concomitant increase in energy consumption; it has produced the new materials for industry whose production may lead to undesirable by-products; it has produced new liquid fuels which are fine in a tank but lethal in the ocean; it has given us nuclear reactions with the dreadful possibilities of a Nagasaki or a Chernobyl; and it has launched a project concerned with the human genome which just might, in the wrong hands, lead to unthinkable acts of genetic engineering. Yet it has to be said that to many of the potential problems listed above science can reasonably be expected to proffer an appropriate solution.

Secondly, the application of science to medicine and to general environmental care has helped to promote an immense *population explosion*, with dramatically decreased infant mortality rates and lengthened life expectations. It is this phenomenon, accompanied by processes of urbanization, that has been a major cause of air and water pollution without any additional help from science-based technology. Indeed it will be argued that science alone can provide solutions to precisely those problems.

Thirdly, science-based technology has led to *a far greater public awareness* of pollution, thanks to better communication and publicity. Inter-personal communication by telephone, fax or E-mail has been nothing less than revolutionary in its social effects. Through TV and radio the public has become aware of disasters like that of the *Torrey Canyon* within minutes of their occurrence, of the sheer scale and potential of nuclear energy, of the almost visible acceleration of cosmic changes in our world. It has been argued that TV coverage of disasters can induce in viewers remote from the event a feeling of "disaster impact" even with consequent psychological and physical symptoms.[33] There can be no return to the days of blissful public ignorance. The nettle of our planet's destiny *has* to be grasped. Yet so complex are the issues involved that sometimes science can be used on both sides of the argument.[34] This is no new phenomenon, but merely underscores the rôle of science in public affairs and the necessity for applying it with rigour and fairness.

The special case of the chemical industry

Most maligned of all is the chemical industry (which outside eastern Europe is usually in the private sector). It is routinely portrayed as the arch-enemy of the environment, but occasionally as its friend, depending on perspective.[35] So great is the antipathy in some circles that generally unpleasant substances are called "chemicals" even though they may be of purely natural origin.[36] It has been indicted in at least three ways.

Uncontrolled pollution

Certainly the industry did not have a very distinguished record in its early days, particularly that part of it concerned with the making of alkali.[37] Alkali (in the form of soda, or sodium carbonate) was in great demand for the manufacture of glass and soap as well as many other substances. From the early 19th century it was possible to produce it by the Leblanc Process, in which salt was treated with sulphuric acid and the resultant "salt-cake" was then roasted with lime and coke. Soda could be leached out of the product with water and then obtained pure on crystallization.[38] In England the industry became concentrated on Tyneside (with ample coal supplies; Plate 6) or Merseyside (near the Cheshire salt deposits).

The environmental problem came with the disposal of by-products.[39] From the second (roasting) stage came a solid material rich in calcium sul-

THE SPECIAL CASE OF THE CHEMICAL INDUSTRY

phide which on exposure to the acid gases of the atmosphere would slowly yield the foul-smelling and highly toxic gas hydrogen sulphide. To this day it may be detected in and around some of the waste-tips on Tyneside. Of more immediate importance was the gas hydrogen chloride, of which two molecules were released into the atmosphere in the first stage for each molecule of soda eventually produced. It is a water-soluble gas with a strongly acidic nature; its aqueous solution is hydrochloric acid. Rain through which this gas has passed has therefore a highly corrosive effect on metal and a very deleterious effect on all forms of life. It clearly constituted a vast disposal problem. Alkali workers could be recognized at a glance because they only ate the softest of food as the acid gas had corroded away all their teeth. For miles around the factory the vegetation was either stunted or non-existent, railings were corroded and there was a general air of apocalyptic dereliction. When, as usually happened, the hydrogen chloride was mixed with smoke from coal-fired furnaces it was even worse. Murray's *Guide to Walker* on Tyneside (1864) described it as "black and overpoweringly hideous", and when its citizens averred "there's no place like Walker" they spoke truer than they knew. The postmistress took care to visit the nearby township of Byker only once a week. So bad were conditions at Haverton Hill, Billingham that it used to be said "even the birds cough".

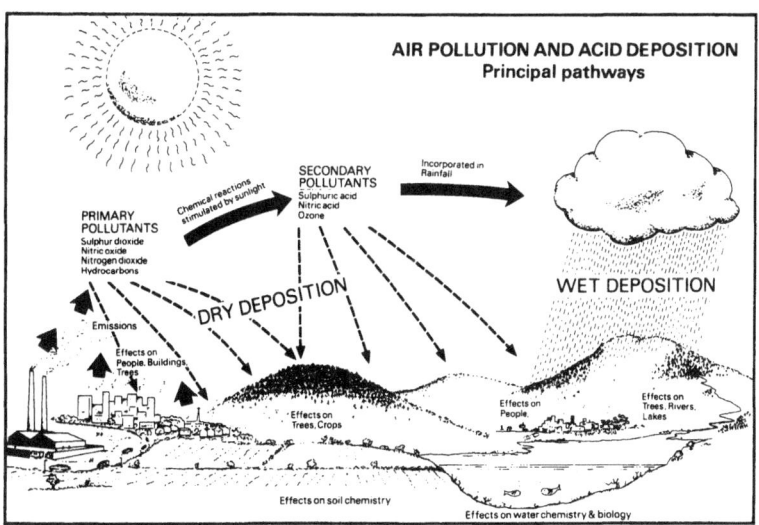

Figure 5.3 Principal pathways leading to acid deposition.[40]

"HURT NOT THE EARTH"

These were the kinds of circumstances that led to the prosecution of James Muspratt. His solution was to remove his works to a less densely populated area near St Helens in the hope that complaints would be minimized. Others, such as Tennant on the Clyde, built very tall chimneys, one of them 420 feet high. It is debatable how far this was a genuine attempt to diffuse the gases more efficiently into the atmosphere or to conceal from the population the enormity of what was being done. A lasting solution to the problem was discovered by William Gossage in 1836 when he passed the effluent gases from his works through a disused windmill filled with brushwood with water streaming down it. This absorbed much of the offending hydrogen chloride before it reached the air and has formed the basis of effective pollution-control ever since. Muspratt unfortunately was unable, or unwilling, to use it. Since that time the problems of "acid rain" have been more associated with SO_2 from combustion of sulphur-containing coal than with hydrogen chloride, and therefore less a direct responsibility of the chemical industry.[41]

Undesirable side-effects

For some 30 years the industry has been under fire for releasing materials thought to be beneficial at the time but subsequently shown to have had undesirable – sometimes disastrous – side-effects. For human beings this is most obviously the case with certain drugs. Pills consisting of mercury dispersed in lard, much used by the Victorians, once fell into this category. The most notorious examples in modern times are thalidomide and opren. Similar opprobrium has fallen on some of the food additives once widely used but now largely withdrawn on account of toxic side-effects. They range from the carcinogenic food colourant "butter yellow" (4-dimethylaminoazobenzene) to mildly suspect sweeteners like saccharin and the cyclamates. However, for all the human tragedy involved, their effects on the global environment were small.

This is not true of the employment of tetraethyllead as a petrol additive. Effects of high-level exposure to fumes from leaded petrol combustion are incontestably bad, especially for the young; those from low-level exposure are rather more problematic.[42] But "leading" the environment is on balance a most undesirable procedure, even though it has been happening since Roman times.

Neither can global effects be denied to the large-scale use of pesticides, chemicals designed to eliminate or at least control such agricultural unde-

sirables as weevils, caterpillars and woodlice (insecticides) or weeds of various kinds (herbicides). The strategy was first seriously challenged by Rachel Carson in her book *Silent spring* (1962; Plate 5a).[43] Since then pesticide use has become the target of a major environmental crusade[44] (as well as a subject for careful chemical analysis[45]). Many pesticides in common use 25 years ago contained chlorine and the problem appeared when organochlorine residues were found in dead or dying wildlife in the 1960s. Insecticides were firmly incriminated. Examples include:

DDT (1,1-bis(4-chlorophenyl)-2,2,2-trichloroethane)
DDD (1,1-bis(4-chlorophenyl)-2,2-dichloroethane)
BHC (γ benzene hexachloride)
Aldrin ⎫
Endrin ⎬ complex compounds with even longer names.
Dieldrin ⎭

The case of DDT was the first to come to light. Discovered in 1874 it was shown to have insecticidal properties only in 1942. For the rest of the Second World War it was extensively used in delousing powders to prevent the spread of typhus and against mosquito larvae to combat malaria. Without question it saved many lives among the jungle combatants during the final years of the war in the Far East. Not surprisingly it found subsequent use in peacetime as an agricultural chemical and in household sprays. Then its danger to wildlife became slowly apparent. Its baneful effects were widespread and devastating. Not only were many song-birds apparently being poisoned by organochlorine residues, but their eggshells were shown to be considerably thinner (and weaker) in the presence of DDE (a metabolic product of DDT). The scenario of a "silent spring", with bird-song but a past memory, was sufficiently emotive to rouse great public concern. This was intensified by the fear that toxic residues had entered the food-chain and could thus endanger the human species also. The problem, as we now know, is that of *bioaccumulation*, in which the concentrations of DDT and other pesticides are built up in the fat of certain fish and insects to levels up to 100,000 times that of the initial dosage. This, combined with resistance to complete biological breakdown, poses a serious environmental hazard, not least by the possible action by DDT and its relatives as weak oestrogen imitators. As such they may tend to reduce male fertility. However, the aetiology of pesticide-induced human illness is still imperfectly understood.[46]

There are, of course, many other general questions. The mechanisms of absorption into food-chains are only partially understood, as is the extent to which pests can adapt to such insecticides, so rendering their primary

"HURT NOT THE EARTH"

Table 5.1 DDT and its history.[47]

History	
Originally synthesized in Zeidler, Germany	1874
Remained laboratory curiosity until Paul Mueller discovered insecticidal properties	1939
Nobel prize (medicine) awarded to Mueller	1948
Mass introduction into agriculture and public health programs	1949 onward
Development of trace analytical techniques; recognition of resistance	1950–60
Recognition of residue; ecological and physiological properties; and their meanings	1960–70
State and federal legislation severely restricted use	1969–70
Use eliminated in United States and advanced countries; use limited in Third World countries	1970–80

Pertinent physical and chemical properties

- very soluble in organic solvents, fats and oil
- solubility in water at 22°C is 1.2 parts per billion
- vapour pressure very low (1.7×10^{-7} mm 20°), but forms distillate from moist surfaces; forms transportable aerosols that are relatively stable
- "Steam distils" from water, moist soils and animal hair
- Originally thought to be very stable in soil and in biological media, as well as photchemically stable. Metabolic pathway studies, photochemical degradations, and soil losses indicate exaggeration of early estimates on stability. Nevertheless, DDT is a relatively stable and persistent pesticide.
- Environmental burden estimated as 1×10^9 lb

function ineffective. Since it has been argued that only 1 per cent of the chemicals ever reach their intended victims, methods of targeting become matters of considerable practical importance.

Other insecticides do not contain chlorine but may be even more toxic to human beings, most notably organophosphorus compounds like parathion. Certain herbicides are extremely dangerous to animals and man (such as paraquat), and others have a similar environmental effect to the insecticides mentioned above, notably the chlorine-containing selective weed-killer 2,4-D (2,4-dichlorophenoxyacetic acid) and its relatives. The latter are carcinogenic and suspected also to have teratogenic properties.

THE SPECIAL CASE OF THE CHEMICAL INDUSTRY

Similar in action to DDT, though without insecticidal properties, is a group of compounds known as polychlorinated biphenyls (PCBs). More toxic, and harder to degrade, than DDT they have long been used in electrical capacitors and transformers. Dumping of such equipment poses a considerable hazard, yet it had not by 1976 been the subject for any official protest. For historical reasons DDT had acquired a rather special, symbolic significance, though far less threatening than PCBs. One writer claimed in 1976 that "DDT has never been recorded as having poisoned human beings" (a somewhat questionable observation today). But he went on to quote the Head of the American Environmental Defense Fund as saying:

> If the environmentalists win on DDT, they will achieve, and probably retain in other environmental issues, a level of authority they never had before.[48]

Another group of chemicals that have received abuse from certain environmentalist groups are the nitrogenous fertilizers that have been in regular agricultural use since the days of Liebig. Opposition has often been on aesthetic and ideological rather than scientific grounds: such aids are "unnatural" and should be shunned in favour of so-called "organic" farming. These objections are touched on elsewhere (pp. 76–7). They have been given greater substance by discoveries of high concentrations of nitrates in rivers and in domestic water-supplies. They have been leached by rain from land that has received excessive amounts of added nitrate in the form of artificial fertilizers.

To complete this litany of woe we should note the adverse effects on the whole environment of a group of chemicals known as chlorofluorocarbons (or CFCs).[49] These quite simple compounds were first made in the 1930s and have many desirable features. Although gases at normal temperatures and pressures, they may be readily liquefied under moderate pressure, are chemically inert, apparently non-toxic and completely non-inflammable. They are thus ideal for use as aerosols for all kinds of spraying-devices, fire-extinguishers and in the production of foams. Also, they make excellent heat-transfer materials for refrigerators, freezers and air-conditioning plant. Unfortunately they have one serious disadvantage.

For some years it had been suspected that, despite their chemical stability, CFCs might possibly behave rather differently when exposed to high-energy radiation. This could occur at stratospheric altitudes with ultraviolet rays and the chlorine atom which was split off could then interact with ozone known to be present. In the simplest possible terms something like this could happen:

$$CF_2Cl_2 \xrightarrow{\text{u.v. radiation}} CF_2Cl\cdot + Cl\cdot$$
$$\text{then } Cl\cdot + O_3 \rightarrow ClO\cdot + O_2$$
$$\text{and } ClO\cdot + O \rightarrow Cl\cdot + O_2$$

(the dot represents an unpaired electron; the oxygen atom in the last line results from a reversible decomposition of ozone: $O_3 \rightleftharpoons O + O_2$).

In fact the reaction cycle is much more complex than that, but it is clear that the effect of the Cl· atoms is to remove ozone molecules from the stratosphere, and *to go on doing so almost indefinitely*, since for every chlorine used up another is regenerated. Thus this unique protective canopy around our planet, the ozone layer, may be destroyed.[50] Although this had been suspected since the early 1970s, it was not until the early 1980s that evidence from the *Nimbus* 7 satellite suggested a progressive drop of 2–8 per cent in global atmospheric ozone levels. The first evidence for a "hole" in the ozone layer was obtained by the British Antarctic Survey in 1985.[51] Extensive studies two years later by an international expedition confirmed suspicions of CFC involvement but also suggested the culpability of other industrial products, including bromine.[52] In 1993 the first maps of ClO levels in the Antarctic *and* Arctic winter stratospheres were obtained, using satellite-borne equipment.[53] On the basis of this information, substantial ozone loss was to be expected in the Arctic spring of 1993.

To all the criticisms heaped upon it for manufacturing such products the industry's response has been varied, though it is improving since the massive cover-up following the disaster at Bhopal. There have, of course, been legislative responses, though these have often been too little or too late. The first, and probably the most famous, was the Alkali Act passed by the British Parliament in 1863.

This first Alkali Act decreed that no less than 95 per cent of effluent hydrogen chloride should be absorbed. It established an inspectorate (the first inspector being Angus Smith) with a right to enter factory premises, to monitor the process and to report defaulters. For years it was the only legislation (other than the Salmon Acts) created to protect private property. Eleven years later it was extended to cover other noxious gases. To be sure the Alkali Acts were a somewhat pragmatic response to demands from the landed aristocracy. But they also symbolized a new respect for chemical analysis, being the first Acts on the statute book, other than those relating to coinage, to enshrine such respect in actual legislation. Since then, of course, the Clean Air Act of 1956 has vastly supplemented the provisions of its predecessors and generated an immediate industrial response.[54]

THE SPECIAL CASE OF THE CHEMICAL INDUSTRY

The Atmosphere

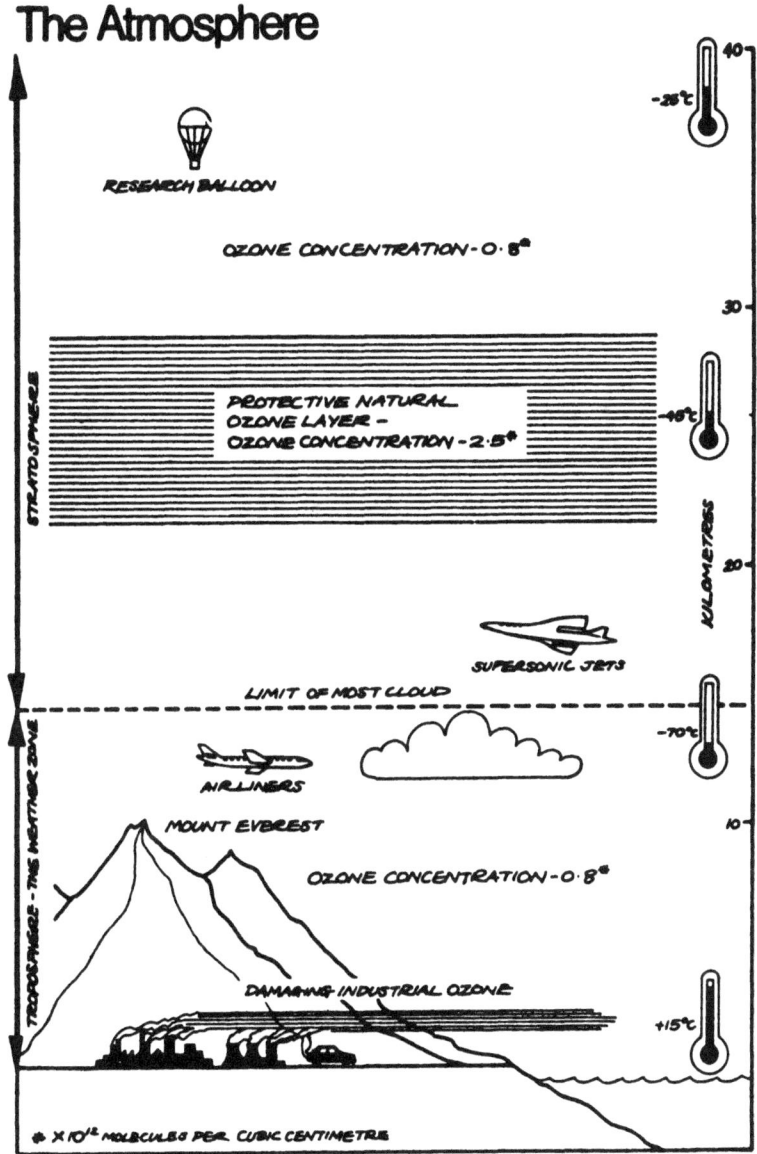

Figure 5.4 A cross-section of the Earth's atmosphere.[55]

"HURT NOT THE EARTH"

Government action has included the banning of some substances, one of the first being DDT which since the 1970s has been disallowed in most western countries. In the USA CFCs have been prohibited from use in aerosols by the Environmental Protection Agency in 1978; they will be outlawed by the year 2000 in the EEC (1989). Health and safety regulations in many western countries are leading to the disappearance of hitherto familiar chemicals such as carbon tetrachloride. But there is much to be done, especially in the way of international co-operation.

Unexpected accidents

The chemical industry has by its very nature been subject to fairly dramatic accidents. When something goes wrong it has the habit of triggering off a far larger incident. This has always been so since large-scale chemical manufacture commenced in the early 19th century. One example from that early period must suffice. A Newcastle banker, Hew Singers, set himself up as a vinegar manufacturer at Gateshead, on the south bank of the Tyne. In 1854 a fire at a nearby mill engulfed both his premises and those of an adjacent warehouse containing 1,000 tons of sulphur and saltpetre. The huge explosion that resulted destroyed much property on both banks of the river; many similar incidents have been recorded from that period.[56]

In more recent times most people recall the disaster at Flixborough, Lincolnshire, in 1974, when a tanker of cyclobutane exploded with the loss of 28 lives. Ten years later in Mexico City a similar but much larger explosion took place of about 80,000 barrels of liquefied natural gas, leading to 452 deaths and several thousand injuries.

In 1976 a serious explosion occurred, at Seveso, Italy, in a chemical plant manufacturing pesticides, associated with Hoffman La Roche. On 10 July a safety-valve jammed so permitting a build-up of pressure until, eventually, a huge explosion released into the night air up to 500 kilos of toxic vapour, chiefly trichlorophenol but also the dioxin TCDD. Four days elapsed before the factory authorities admitted that the cloud of gas was toxic, another 10 before analysis was complete, and yet another four before large-scale evacuation of the area was commenced. There is little doubt that some sort of a "cover-up" took place, and reliable records are hard to obtain. There was, however, much illness among the nearby populace and, in due course, a higher number of birth defects than usual.

The world's worst chemical disaster took place at Bhopal, India, in 1984. The firm, a subsidiary of Union Carbide, was producing an insecticide known as Sevin (N-methyl-α-naphthyl carbamate). A reagent used to syn-

thesize similar carbamates is methyl isocyanate ($CH_3N=C=O$), and it was this substance that was poured out into the atmosphere as a tank of it exploded on 2 December 1984. Highly poisonous and much denser than air, it formed a lethal blanket that enveloped about 200,000 victims asleep in their beds in the immediate neighbourhood of the plant. This time the scale of the disaster was truly catastrophic; quite apart from thousands injured there were several thousand fatalities and a legacy of bitter litigation that may well exceed the life-times of the stricken survivors. There is little doubt that the immediate cause was leakage of water into the tank, though quite how that happened no one is sure; explanations range from the bizarre ("Sikh terrorism") to the probable (faulty equipment). Because sales of Sevin were falling dramatically, various cost-cutting procedures were being implemented; the refrigeration plant was switched off to save money (at low temperatures the reaction of the water is much slower), other equipment had been shut down, and it was known that temperature and pressure gauges were notoriously unreliable, making recognition of abnormal situations a matter of luck rather than judgement.

The problems of nuclear technology

Associated in the popular mind with chemical production is the nuclear industry (and with good reason for much of that industry is concerned with chemical reactions). However, it is probably this application of science more than any other that causes public alarm, particularly when any kind of accident is reported. In Britain there has been continuing concern over the "leaks" of radioactive material into the sea or atmosphere from the nuclear reprocessing plant at Sellafield on the Cumbrian coast, and the adjacent Calder Hall power station. The most serious leakage, on 10–11 October 1957, came from a fire at what was then known as the Windscale reactor. It led to a full-scale government enquiry.[57] The most significant radionuclide emitted was radioactive iodine (^{131}I) which, though its half-life is relatively short (eight days), is liable to be absorbed into the thyroid gland. It enters the body through local produce, especially milk. Restrictions were introduced on distribution of locally produced milk which, 26 years later, were assessed as having halved the collective dose to the people of Cumbria.[58] Since then there have been constant anxieties about the higher than normal incidence of leukaemia in the vicinity of the plant, but it is only fair to say that a causal connection has not, as yet, been established.

"HURT NOT THE EARTH"

In 1979 a serious accident happened at a nuclear reactor at Three Mile Island in the USA. Heat is normally transferred from a reactor core by a water circulation system. At Three Mile Island heat was further removed from this primary cooling system by a secondary system. Just before the accident the latter system shut down because of circulation-pump failure. As a result the primary system and the reactor core began to heat up. Emergency water supplies should then have come into action but, because of an extraordinary series of technical malfunctions and operator errors, they did not do so. The top of the reactor core, once uncovered by water, got rapidly hotter. The fuel rods became deformed and the reactor casing (made of zirconium) reacted with water or steam to yield the potentially explosive hydrogen gas. Had there been a major explosion the spillage of radioactive material would have been catastrophic for the immediate area. As it was, the reactor was brought under control and the radiation leakage was largely confined to the reactor containment building and was externally so small that any increase in cancer cases would have been statistically undetectable.[59] However, public anxiety was considerably heightened, steps were taken to minimize the possibility of operator error by greatly improved instrument consoles at the plant in question, and wider consideration was given to the design and construction of the vital pressure vessels. There, despite pressures from the anti-nuclear lobby, matters might have rested in the public mind had it not been for the largest nuclear accident of all.

On 28 April 1986 reports began to appear in Sweden of abnormally high levels of background radiation. Anxieties mounted in the West and, after some delay, the Soviet authorities admitted a major disaster at number 4 reactor of their nuclear power station at Chernobyl, not far from Kiev. Details were not readily forthcoming, but it was obvious that something extremely serious had happened.

The reactor was of a type known as RBMK, widely used in the former USSR. Like many others it used graphite rods as the moderator in the core, but unlike any in the UK it operated at a much higher temperature (700°C), with boiling water pressure-tubes. For some reason a blockage developed in the water-circulation system, and there was a build-up of superheated steam which then reacted with either the graphite rods or the zirconium casing (or both) to produce hydrogen, which forced its way out and exploded on contact with air. The reactor core was left open, the graphite caught fire and uranium fission products began to volatilize into the atmosphere. The conflagration was far too hot for water extinction (as had been possible at Windscale) and was eventually smothered by using helicopters to dump

THE PROBLEMS OF NUCLEAR TECHNOLOGY

huge amounts of sand and boron compounds (the ^{10}B isotope very effectively absorbs neutrons).

The local effects of Chernobyl were devastating. Two workers were killed in the explosion, but thousands of people were exposed to massive doses of radiation, only 2,000 being evacuated fairly quickly, thousands more having to wait about 10 days. US intelligence estimated 2,000 fatalities, but there will be many more casualties from radiation sickness. As one commentator observed, for years to come "apparently random cases of thyroid, liver and bone cancer and leukaemia will shorten the lives of many people in Eastern Europe".[60] Further afield there may be a few additional cases of human cancer where the Chernobyl plume settled, but the more immediate effect in Britain was a ban on the sale of lamb and mutton from Scotland and northern England. The short-lived iodine isotope was less of a problem than radioactive caesium (^{137}Cs), for this has a half-life of 30 years and is readily absorbed from grass by sheep.

The Chernobyl disaster seems to have significantly altered the balance of public opinion over nuclear energy. There is now a far greater distrust of nuclear power, at least in western Europe. In no small measure is this due to demonstrations of the fallibility of scientists and engineers. Soviet claims for its safety, heavily publicized a few years previously, raised doubts about all prognostications by "experts". In a small way, perhaps, it helped to widen the gulf still further between the community of science and the general public. Before Chernobyl similar doubts were being vocally aired in Britain about the construction of new atomic power stations and about the disposal of nuclear waste. It must be said that much, though not all, public anxiety was an emotional rather than a rational response, but it was understandably increased by events at Chernobyl. It was fanned into flame in some quarters by those who wished to link nuclear power and nuclear weapons, usually on the grounds that reactors may be useful sources for military plutonium.

Renewed concern in the UK led to the production of a pamphlet from the Central Electricity Generating Board seeking to allay anxiety that a similar disaster might happen there.[61] In fact the UK reactors of the Magnox and AGR types use CO_2 as a coolant and work at considerably lower temperatures than the ill-fated example in the USSR; unlike that reactor they also have strong containment buildings and a back-up cooling system. Yet, when all the comforting platitudes have been uttered by the nuclear establishment, and all the simplistic generalizations of the anti-nuclear lobby have been corrected, there does remain a very small but nevertheless finite pos-

sibility that a greater disaster than Chernobyl might some day engulf this planet.[62]

In the case of Chernobyl the worst initial fears were not realized. These were of the so-called "China syndrome" in which the energy liberated by the fission-products is unable to escape quickly enough (because of smothering by sand etc.), and so the reactor core melts and forces its way into the earth's crust. It will then contaminate water-supplies and possibly cause huge subterranean explosions, with even more devastating effects on air and water. Though far-fetched, it is a remote possibility whose immediate consequences (hundreds of deaths) would be eclipsed by the appalling scale of the subsequent human suffering from diseases resulting from radiation exposure, most notably cancer.

Finally the question of radioactive waste disposal should be mentioned, though it has not been the cause of any disastrous accident. Related to this is the question of siting of new nuclear power stations (Plate 8). On such matters one of the crucial elements in the public "debate" (if it can be dignified by such a term) is a determination to avoid personal proximity to nuclear installations: "not in my back yard". One author, writing of the significance of the NIMBY syndrome within the history of nuclear power in Britain, suggests that an "assumption of faith and acquiescence in expert dependency is becoming increasingly fragile".[63] This may be unfortunately true, but it is equally certain that no worthwhile opinions on nuclear power can be expressed without a considerable measure of scientific competence. This dilemma is at the root of many of the problems facing a culture where technology is both rampant and potentially threatening.

However, as Peter Hodgson has convincingly shown, that dilemma can be resolved, at least over the question of nuclear power, by a Christian approach that combines genuine love for one's neighbour with a penetrating scientific analysis of the issues. He argues that the huge energy needs of the Two-Thirds World in the future (as opposed to those of the already comfortable West) can be met only by harnessing the energy of the atom. His words apply to far more than the nuclear issue:

> This life is for the Christian a brief time of trial, after which we shall be judged. We should at the same time live in the present, caring for present needs, but also in the future, because what happens then is largely determined by our choices today.[64]

To conclude: the rape of the environment may reflect a variety of attitudes, to personal comfort, to the creation of wealth, to the well-being of

others etc. Such attitudes inevitably exact their own toll on society. But they also have a tendency to generate subsequent calamities whose causal connection is not so obvious. It may be legitimate to view all such results as "the judgement of God", whether or not we think we can explain it naturalistically, – a working out of the "internal grammar" of the world. It is interesting that the divine injunction to "hurt not the earth" came after a period of famine, plague and internecine strife,[65] followed by natural disasters that induced equal terror in "princes, the generals, the rich, the mighty, and every slave and every free man".[66] One thing is certain: we are all in this together.

Chapter 6

Foes of the Earth

Is it fair to attribute all our difficulties to science and/or technology? The argument of this chapter is that such an attribution is so simplistic that it can fairly be described as naïve. At the very least science can offer some solutions as well as create some problems. To understand the true nature of our predicament we have to recognize the complex nature of humanity and to explore something of the hidden springs of action that motivate us all. It is when we do this that the plight of our planet begins to make some sense and a positive response becomes possible. This means a willingness not merely to think in scientific, historical or even sociological terms but to explore at a level that is fundamentally theological and personal. If the Earth really is a creation of a caring and intelligent God, this should not be at all surprising. We may then find "foes of the Earth" where we least expect them: within our own circle and society and (most painfully, perhaps) within ourselves. This chapter contends that such enemies to planetary welfare lurk in four different forms which relate to a profound failure to understand the laws by which the universe is governed, a determination to exploit the natural world for personal gain, a reckless aggressiveness to our fellow human beings, and an attitude that ignores or despises the non-human part of creation. Rather more baldly these attitudes may be labelled: human ignorance, human greed, human aggression and human arrogance.

Human ignorance

By this is meant an inadequate understanding of the natural world and its laws. It is a potent cause of environmental disaster. At a trivial level this may simply mean a premature jumping to conclusions on the basis of insufficient

HUMAN IGNORANCE

evidence. Thus several current ecological orthodoxies are now being questioned. One recent if bizarre example concerns the ozone layer. It has been argued that ozone depletion is a natural phenomenon since chlorine may be emitted from volcanic action etc. and our alarm is therefore misplaced. A "doomsday conspiracy" has even been suggested, with much profit to purveyors of both imminent doom and alternatives to CFCs.[1] However, the consensus view today is that man-made chlorine emissions contribute at least 80 per cent of the total. Again, quite different factors may affect the depth of the ozone hole, such as sunspot activity, for it appears to increase with the minimum of the 11-year solar cycle.[2] And involvement of sulphur oxides (as opposed to CFCs) may be plausibly connected with the natural volcanic emissions.[3] So what is the truth?

Or again, the greenhouse effect is far from uncontroversial; it is now being realized that a more significant cause of rise in Earth temperature may be increased energy output from the Sun.[4] And the possibility that global warming may release yet more CO_2 into the atmosphere complicates calculations still further.[5] There is still so much we do not know.

More serious is our ignorance of the nature of the Earth's self-compensating capability. To suppose that the notion of the Earth as a self-sustaining system is a prerequisite to sound ecological judgement is far too simple. Consider the following two situations. If the Earth does not have self-healing properties, Rachel Carson was quite right and DDT was an unacceptable intrusion and we therefore had to remove it. On the other hand, taking the Earth in a larger, holistic sense, and looking beyond the immediate problems, we might have expected long-term benefits by compensation. Thus Norman Borlaug (Nobel Peace Prize Winner) had some justification for attacking *Silent spring* as "vicious, hysterical propaganda".[6] The ban on DDT which Carson had urged actually removed a substance from the global environment that in 25 years had saved 1,000 million lives from exposure to the malaria parasite. It has since been urged that not even penicillin has saved so many lives as DDT.[7] And yet we have banned it!

The irony is that a self-regulating Earth was implied in the arguments used to justify the excesses of many early polluters. For some of them thought that if they used the air and oceans as sinks, noxious by-products would be well taken care of (as when carrion remove a stinking carcass). Yet influential chemists have had to admit that "Nature was not as self-cleansing as we had believed."[8] The question at issue is therefore the extent and the manner to which self-regulation may apply, and, indeed, whether there may not be a limit beyond which self-regulation ceases to be feasible.

Two important illustrations of the deadly effects of partial knowledge are well known examples from history, each originating in the 19th century. They concern responses – mainly by chemists – to potentially the biggest environmental disasters in modern times. Their ulterior cause was not greed but simple ignorance; their immediate cause was not irresponsible science or industry but an unprecedented increase in population. In Europe the population is estimated to have risen from 100 million to 200 million in the century from 1700 to 1800. As a result civilization was facing old problems on a dramatically increased scale. They relate to, first, the aetiology of water-borne diseases and, secondly, the fundamental requirements of crop nutrition.

A form of pollution that had nothing to do with the chemical industry was that arising from the twin processes of population growth and urbanization in the 19th century. In London, for instance, the population rose from 1.1 million to 6.6 million, whereas the overall national increase was only by a factor of three. With a huge increase in urban population came much greater problems of sanitation and sewage disposal. There might be seepage into domestic wells; or water supplied by the water companies would be drawn from rivers into which untreated sewage had flowed (in London's case to the amount of 31 billion gallons per annum). Water-borne diseases were rife, and it was only a matter of time before some devastating pandemic might be expected. There were, of course, responses from sanitarian reformers like Chadwick and from engineers like Bazalgette. But little was known of the cause of such diseases and, as often as not, they were associated with some kind of miasma hovering over the putrid rivers.

Pressures for reform became increasingly urgent with major cholera outbreaks in 1831, 1848 and 1853, and the typhoid epidemics of 1837, 1847 and 1855. The warm summer of 1858 brought with it London's "Great stink", in which the Thames was shrouded in a fetid mist, and when Faraday dropped his visiting card into the river, he found it to be invisible just below the surface. Meanwhile Snow had identified water supplies as a cause of cholera, Hassall had shown horrific microbes in water, and chemists were enlisted in the cause of pure water supplies by companies, government and reformists alike. The story is a long one, but from about 1868 water quality could be monitored chemically, particularly by the chemist Edward Frankland (1825–99). He believed his analyses of nitrogen in water gave an indication of previous sewage contamination and was able successfully to warn a multitude of intending users against such contaminated supplies, and also to pressurize the government into maintaining a constant watch on river pollution to the very end of the century. Later he turned to bacterio-

logical analysis, and shortly after his death the chlorination of domestic water supplies began (1905), with immense benefit to public health in London, including the virtual elimination of typhoid fever.[9]

The rôle of science in yielding insights into conditions necessary to public health has been criticized on a variety of grounds: it did not always speak with one voice, and appropriate technical action did not invariably follow, for example.[10] Yet this is to suppose a very Whiggish view of science, always right and always progressing. Anyone with real scientific experience knows this is simply untrue, and a series of mistakes or setbacks does not invalidate the general thesis – which needs to be strongly emphasized – that in the matter of water supplies in Victorian Britain science not only minimized pollution but saved countless lives in the process. Seen in that light the very fact that Frankland used his science to effect social changes (like pollution control) merely reinforces the point.

The other area in which science dispelled a fog of ignorance to the benefit of humanity generally was in the supply of food. It was no new problem. A review of famine and famine-related disease contained 588 references from Hesiod and the second book of Kings to the end of the Second World War.[11] Aware of the population explosion at the end of the 18th century, Malthus had gloomily looked forward to a day in which global demand outstripped supply (the population increasing in a geometric progression but subsistence increasing only in an arithmetic progression).[12] The question that haunted politicians and farmers alike was how to increase the productivity of the soil.

The scientific study of crop nutrition[13] had begun just before the nineteenth century and Davy's celebrated lectures in 1802 on "Agricultural chemistry" at the behest of the landowning proprietors of the Royal Institution in London brought it well into the public domain. A chair of Agriculture and Rural Economy had been established at Edinburgh University in 1790. A possible correlation between crop growth and soil composition began to be studied by Davy (in England) and Liebig (in Germany). Most of the agricultural societies of Britain appointed their own chemical consultant.[14] An agricultural experimental station was set up at Rothamsted in 1843 by J. B. Lawes and J. H. Gilbert. In the same year Lawes established a large factory to make superphosphate fertilizer, $Ca(H_2PO_4)_2$, and thereafter "artificial manures" became big business, adding still further to the demands for sulphuric acid.

The impact of fertilizers on European food production (and on landowners' profits) was soon considerable, but there were certain disadvantages.

Excessive reliance on artificial manures will lead to loss of organic humus and deterioration of the soil structure, with lower fertility and greater danger of erosion. There is also a possibility of exhaustion of natural deposits of raw materials, particularly the nitrate deposits of Chile. For this reason Sir William Crookes (1832–1919), addressing the British Association in 1898, warned that alternative sources of nitrogen must be urgently found or civilization would find starvation staring it in the face. By 1928, he estimated, the world demand for wheat would have risen from 2,070 to 3,260 million bushels. To meet this would require an average increase per acre of 150 per cent, practicable if each acre could receive 1.5 cwt of sodium nitrate, a world total of 12 million tons each year.[15]

In fact a solution to the problem emerged with the discovery of a method for the fixation of atmospheric nitrogen (the Haber synthesis of ammonia). This involves the direct synthesis of ammonia from its elements at high pressures (up to 200 atmospheres) and moderate temperatures (500°C), with a metal oxide catalyst:

$$N_2 + 3H_2 \longrightarrow 2NH_3$$

The ammonia can then be converted into soluble salts and applied direct to the land where it will be oxidized to nitrates. However, the extensive use of nitrates in the soil has led to seepage into rivers and a subsequent furore from those aware of the damage to human health inflicted by drinking water containing traces of such material. Despite all these problems the large-scale employment of artificial fertilizers continues, together with research into their effective use, though three main strategies may be recognized. One is to improve existing practice, with special attention paid to minimizing nutrient loss by leaching etc. Another is "integrated agriculture" which develops less intensive farming systems and so reduces the use of fertilizers. The third, "alternative agriculture", rejects even minimal application of artificial fertilizer. A protracted appraisal by the Norwegian firm Norsk Hydro of current agronomic practice has led to the conclusion that alternative agriculture is of questionable benefit to farmers, consumers and the environment, and is far too costly to offer a major route to mass food supplies in the future. The authors conclude that fertilizers will still be required for the foreseeable future to maintain soil productivity, though correct handling and application are essential. The best farming practice is not, however, static, but learns from past mistakes and develops as our understanding grows.[16]

Meanwhile science has aided food production in an entirely different sphere: agrochemicals. There still remains the age-old problem of crop ru-

HUMAN IGNORANCE

ination by a multitude of different pests, whether weeds, insects, fungi or systemic disease. From biblical times their diversity has been recognized: "blight and mildew",[17] root-attacking "worms",[18] the "canker-worm" and caterpillar,[19] and above all the ubiquitous and terrifying locust.[20] Usually represented as judgements from God, they did not of course receive any naturalistic explanation (not that the two levels of understanding are necessarily incompatible). The Babylonians and other ancient peoples used charms against plant diseases such as ergot. Other precautions like immersing pest-infected plants in milk and rainwater or pruning with knives coated with bear-fat might well have been effective against some diseases as fungi, though their rationale could hardly be described as scientific.[21] Ignorance of the material causes of plant disease remained almost complete until the 19th century.

In that century the dire prognostications of Malthus must have had a sinister air of reality, especially in the "hungry forties", when the Irish potato crop failed (1845 and subsequent years). It is said that a million people died of starvation, and 1.5 million emigrated. The cause was a fungus, *Phytophthora infestans* – potato blight. Efforts by the chemist Lyon Playfair to find a cure were unsuccessful, but a solution lay in a copper fungicide, known since 1807, but rediscovered by chance in a Bordeaux vineyard by Millardet in 1885; this was a spray of lime and copper sulphate, "Bordeaux mixture".[22] Science can make no claim to this discovery (though the ingredients are on any definition "chemicals"), but it has been actively involved in the later development of agrochemicals, currently being used worldwide to a value of about $20 billion.

Against the horror stories of pesticide pollution, and the propaganda of the organic farming lobby, there has to be set a global need that is expanding, not contracting. Even today it is estimated that pests destroy 50 per cent of the world's annual crops. In the Two-Thirds World, with little pesticide support, this figure is nearer 70 per cent. Yet this developing part of humanity needs to *double* its food production in the next 20 years if it is to avoid mass starvation. That means a sixfold increase in actual yield. Surely the knowledge given by science must be used constructively in that situation? It has been shown by the FAO that without pesticide use cotton crops (on which many poor countries depend) will drop by 50 per cent. In Ghana the yield of cocoa (its largest export) has been trebled by the use of insecticides that attack the capsid bug. And in Pakistan a similar strategy has increased the sugar crop by 30 per cent. Illustrations of this kind can be multiplied almost indefinitely.[23]

Yet we can never forget the other side of the picture. Some pesticides, in some circumstances, can do a great deal of environmental damage. In practice the great enemy is not the pesticide *per se* but our ignorance of its rôle and limitations. Much more scientific research is required, and for any one agrochemical the research & development costs may well reach $50 million.[24] There is now a wide awareness of methods of using pesticides, but with enhanced environmental safety.[25] Future developments in the industry might then include:

(a) replacement of broad spectrum killers by those with much more selective action;
(b) chemicals that are quickly biodegradable;
(c) those that act in very low dosages;
(d) improved methods of application (it has been said that in the early days 99 per cent failed to hit any recognizable target); and
(e) integrated pest management (IPM) programmes which would include biological and chemical measures, careful monitoring and introduction of pest-resistant crop strains.

Given such strategies a judicious assessment is as follows:

> The adoption of these methods will reduce the quantities of chemical pesticides added to the environment. However, it is likely that chemicals will remain the major weapon against pests until well into the twenty-first century.[26]

In response to the situations outlined above two things are surely obvious. If human ignorance is a root cause of our dilemmas, there must be an immense need for more education. The future generation must be aware of the conflicting demands of our environment, and as the issues are so complex this will require a sustained educational initiative. Books have been produced for what might be called "environmental fixes" with titles like *Design for a livable planet, 50 simple things kids can do to save the Earth* and *750 everyday ways you can help to clean up the Earth*. The brash popularization of such titles should not detract from their real worth in inducing environmental awareness in our youngest citizens.

And we desperately need not less science, but more and better science. That means a whole new attitude from many of us. The tendency of 18th- and 19th-century European culture has been to invest science with almost god-like powers, but some in the late 20th century regard it as diabolical for what they perceive it has done to the environment. It must surely be necessary now to move to a more mature understanding, with science as morally

neutral and the "guilt" for damage caused by its application to lie, not in some reified entity called "science", but rather in the hearts and minds of those who practise and apply it.

The point is often made that there is no such thing as entirely neutral science. Scientists, if not science itself, are motivated by a multitude of values, and these help to determine the way they construct their theories and indeed their whole world-views. It was in an exposition of this point that Peter Bowler came up with the surprising statement that "disputes over the 'facts' about pollution merely confirm that there are no truly objective facts to be had". However, he immediately qualified that remark by indicating the non-objectivity to lie, not in the experimental data, but in their perceived relevance. Concluding that "there is a real sense in which science is value-free", he observes:

> Measurements are made within the context of a theoretical approach to the question; change the theory and you change what counts as a relevant fact. If we accept that all science is based on theories that can be related to human values, then we can no longer use science to decide on the values we wish to adopt.[27]

That is well said. The contention of this book is that the most appropriate values required to save the planet are those rooted in the Christian faith. But these are not, of course, the exclusive property of those who call themselves Christians, and if they can include both environmental sensitivity and acute awareness of global human needs, we may get somewhere. First, however, we must expose three elemental human attitudes that Christian theology has long recognized as endemic in our species. What we now see is that they are threatening not only to ourselves and our neighbours but to planet Earth itself. However, much we dislike them (especially in other people), they are values that colour our understanding of science as much as our practice of technology.

Human greed

Were this to be put a little less bluntly it might be rephrased in terms rather of economic constraints or the needs of industry. But the facts of human cupidity, though stressed often enough in the Christian documents, are sufficiently well known to us all not to need corroboration. The chance of a quick buck is rarely rejected because it might cause infinitesimal harm to the

environment. Let the reader supply illustrations from his or her experience! On any scale, from the personal to the multinational, the issue can be simply expressed in the familiar phrase "economic gain by environmental loss".

It is easy to see this principle at work in all cases of exploitation, whether the victims be North Sea herrings, Antarctic whales, African elephants or South American rain-forests. Citing the murder in 1988 of ecologist Chico Mendes, Stewart Boyle and John Ardill are in no doubt as to the root cause: "poverty and greed lie behind the destruction of the Amazonian rain forest".[28] Where poverty moves over into greed is of course a crucial question. A culture at or below subsistence level can hardly be expected to have strong environmental priorities. But cases of specific hardship do not invalidate the basic general point, which is that human greed is often a sufficient explanation for a given act of ecological vandalism.

Such greed may be corporate rather than individual. A local authority may turn a blind eye to pollution by a firm known to make generous benefactions to its schools or hospitals. A government that depends for support on an influential lobby (e.g. the road-haulage industry) may well sanction abuses such as the destruction of nature reserves in order to create new and better motorways. Nations with large fishing fleets will often oppose limitations on fishing even when those are urged on grounds of marine ecology. One could continue endlessly with instances of corporate greed which have some kind of official legitimation. It is even more obvious in private institutions.

One is prompted to wonder how many of our current difficulties have been a result of simple human avarice on the part of the owners and manufacturers. By way of illustration we shall return to the enormous pollution caused in the early days of the alkali industry. Some individuals unquestionably tried to maximize their profit and gave little thought to any ecological effects of their processes. After comparing the horrors of Widnes and Runcorn to those of Sodom and Gomorrah one author added that the Merseyside towns "have, however, this advantage, they are by no means *dead* cities of the plain. Great and busy industries are carried on day and night in both, and in each large fortunes have been and are still being made."[29] As a modern commentator observed, "even this writer could not put aside his Victorian values".[30]

In similar vein it was remarked of the Tyneside manufacturer Christian Allhusen that although "his prosperity affords occupation to hundreds of families; his wise expenditure of capital fosters invention", yet his main goal was that of "personal enrichment". Daringly for his time, the writer regretted Allhusen's failure to provide any "permanent benefaction" to the people

of Tyneside, any "acts of benevolence which are prompted by those elementary virtues of sympathy, compassion and goodwill".[31] As has been more recently written, Allhusen "was a business man first and last... he held with Doctor Johnson that a man is never so innocently employed as when he is making money".[32] Not surprisingly he died a millionaire (Plate 5b).

On the other hand some manufacturers made important advances in pollution limitation and resolutely declined to take personal profit by patenting them. The most famous example is John Glover of Tyneside, who discovered a method for preventing loss to the atmosphere of the noxious oxides of nitrogen used in the manufacture of sulphuric acid (the so-called Glover Tower). This not only protected the environment but also saved a great deal of money, yet Glover made no secret of the process and freely shared his discovery with rival manufacturers.[33] The notable alkali manufacturer John Lomas, calling rather surprisingly for an extension and stricter enforcement of the Alkali Acts, had these cautionary words for his fellow entrepreneurs:

> The injudicious attempt is often made to prove that the alkali trade, as at present carried on, is no nuisance at all, and this in face of all the devastation so apparent in the neighbourhood of the works. A far wiser plan would be for manufacturers to acknowledge the danger, and reduce the evil to a minimum by the adoption of every practical means of condensation.[34]

In a similar spirit John Morrison's Presidential Address to the Tyne Chemical Society called for "further and enlightened legislation", adding these remarkable words:

> To an ordinarily simple-minded individual, it seems neither unreasonable nor unfair that the manufacturer should be pressed to keep his smells and his miscellaneous nuisances to himself. And most men must agree that however little else some of us may be heir to, we have all at least a divine inheritance – if not a prescriptive right – in air and water undefiled. If then the manufacturer – as the embodiment of power – rob the poor man – as the embodiment of weakness – of his oxygen; or dilute that oxygen with deleterious gases and vapours; or if he practically force him to make use of water which he has knowingly contaminated, the injury applies to what is of more value than silver – health.[35]

Thus the universally irresponsible chemical manufacturer! Nor could it be

truthfully said that the chemical manufacturers were the only exploiters. Sometimes, they were the victims. Speaking of the gains to be had from litigation Walter Weldon observed:

> In all countries to which my experience extends, I have noticed that farmers have a tendency to exploit any chemical work in their neighbourhood rather than to exploit their land.[36]

Twenty years earlier (1862) the Merseyside manufacturer John Hutchinson had testified that:

> It was notorious that every lazy farmer got his rent, or a large portion of it, frequently from the alkali manufacturers; and an alkali manufacturer would always rather pay a trifle than be annoyed and pestered in the conduct of his business.[37]

A further complication was that many alkali manufacturers were in constant financial trouble over litigation and so hardly able to make the very improvements that would have solved the problem. We shall never have a full picture, of course, but one writer has probably got it roughly right in the following assessment:

> Few alkali manufacturers were single-minded profit-maximizers of the kind economic theorists hold so dear, but, equally, few were altruistic enough to compensate their victims without some form of external prompting.[38]

Given the unchangeability of human nature we should not find this judgement surprising, nor the observation that human greed is at the root of much environmental damage. But it is by no means the only cause, as anyone with a knowledge of modern history will know all too well.

Human aggression

The devastating effect of warfare on the environment is so obvious today that it hardly needs stating. Yet for centuries the Earth has suffered from the effects of "man's inhumanity to man" in an endless succession of squabbles, raids, skirmishes, battles, declared wars and of course the totality of modern warfare. In ancient times the wholesale pillage of the land, with crop-burning and deliberate fouling of the waters by the conquering armies, is usually given less prominence than the immeasurable human suffering that

accompanied such acts of military vandalism. In so-called modern history a new peak of ferocity and brutality, and on a much greater scale than before, was reached in the Thirty Years War (1618–48). So vast was the devastation that it is estimated that at least one-third of the population of central Europe died as a direct or indirect result.[39] That war and all the subsequent horrors were as nothing compared with later conflicts in which scientific knowledge was actively employed. The First World War was marked by chemical expertise (particularly in Germany) in the manufacture of high explosives, and by the use of chlorine as a weapon in the trench warfare. The gas that had hitherto been used to save lives by water purification was now ruthlessly employed to maim and kill. With some justice the conflict was quickly referred to as "the chemists' war".[40] In Britain the Chemical Defence Establishment was established at Porton Down in 1916. The combined effects of detonating 238,000 tons of TNT[41] and 378,000 tons of ammonium nitrate,[42] together with a weekly release of over 100 tons of chlorine, are still a matter of living memory for some. More recent environmental damage was caused in the Vietnam War when, between 1962 and 1972, the USA attempted to flush the enemy out of forest cover by a programme of mass defoliation, involving some 17 million gallons of herbicide, mostly "Agent Orange", a paraffin-based solution of 2,4,5-T. Some 10 per cent of the country was defoliated, with incidental damage to wildlife but also to humans. In fact "Agent Orange" contained measurable quantities of the deadly substance dioxin. Many subsequent birth deformities and other health defects have been attributed to this chemical mixture.

More recently biological agents have joined the arsenal of modern warfare. By the Geneva Protocol of 1925 all signatory nations were bound not to be the first to use either chemical or biological weapons. But that did not, of course, prevent research into such substances for use in retaliation, or into possible antidotes.

Apart from continuing the research at Porton Down, during the Second World War the British government authorized experiments with microorganisms on one Scottish island, Gruinard. This has been off-limits to the general public for half a century (until 1991) because of the presence of anthrax bacilli introduced in the programme of military research. Fears of biological warfare during the recent war with Iraq were not realized, but immense environmental damage resulted from the deliberate ignition of oil-wells by the retreating Iraqi army.

All of this pales into insignificance beside the ultimate horror of a nuclear conflict. It has been calculated that if a major onslaught were mounted on

America's strategic targets alone, between 16 and 35 million deaths would ensue.[43] Given an escalation to full-scale war, with retaliation on secondary military and industrial targets, the number of *immediate* casualties must surely be of the order of several hundred million. Appalling though this version of Armageddon must be, it is but the prelude to something unthinkably worse: the nuclear winter.

To submit such a prospect to scientific analysis, and to obtain the most accurate predictions possible, a fully international Scientific Committee on Problems of the Environment (SCOPE) was set up to study "the environmental effects of nuclear war". Under the chairmanship of Sir Frederick Warner it has published a massive two-volume report which offers a consensus view of some 300 scientists from Western and Eastern bloc countries and from the Two-Thirds World.[44]

The principal focus of the report is on the changes that the Earth's climate would undergo. These would be induced chiefly by the unparalleled conflagration that followed the explosions. Quite apart from the production of toxic chemicals in the atmosphere, the inferno would lead to immense quantities of carbon dioxide, whose long-term "greenhouse effect" in raising the mean Earth temperature has already been discussed. This, however, is likely to be far less important than the release of elementary carbon from incomplete combustions of organic matter, especially plastics. It is estimated that at least 30 million tonnes of carbon dust would be produced in urban combustion, forming an immense cloud that, in the Northern Hemisphere at least, would block out the Sun for an indefinite period, causing the temperature on Earth to plummet by, in some cases, many tens of degrees. A sophisticated modelling technique enabled several teams of scientists to quantify the effect of this "black sky". Figure 6.1 shows the predicted change in surface air temperature from the normal annual mean 40 days after the event between 12° and 90° N latitude.[45]

The term "nuclear winter", despite its imprecision, is marvellously appropriate for such a scenario. Its effect on agriculture can only be described as devastating, for the ecosystems involved are very sensitive to even small temperature variations. A consequence is that Africa, for example, would suffer catastrophic famine, with perhaps 100 to 450 million people dying of starvation even though no nuclear weapon had struck the continent. All told the global casualties could be up to several thousand million people. Only a small minority of Earth's inhabitants would emerge to a future nearly as horrific as the immediate past. The bar chart in Figure 6.2[46] represents the vulnerability of the human population to loss of food production.

1a Nicholas Copernicus: the man who took the Earth from the centre of the universe

1b Science and religion: Copernicus' Tower in the walls of the Cathedral precinct, Frauenberg, Poland, where the astronomer reputedly made his observations; to the right is the west front of the Cathedral where he worked as a canon.

2a Thomas Burnet (c. 1635–1715): Master of Charterhouse and author of *The sacred theory of the Earth*.

2b Caricature of the Scottish geologist James Hutton (1726–97).

3a Sir Charles Lyell (1797–1875), one of the 19th century's most influential geologists and pioneer of the doctrine of uniformitarianism.

3b Lord Kelvin, formerly Sir William Thomson (1824–1907), pioneer on thermodynamic methods for determining the age of the Earth.

4a The crater formed on Mount Tarawera, New Zealand, by the eruption on 10 June, 1886.

4b "The Hot Springs of Mother Earth" *(Ngu Puia o-te-Papa):* intense thermal activity in the Waimangu Valley, New Zealand.

5a Rachel Carson (1907–64): author of *The sea around us* (1951) and *Silent Spring* (1962). Eventually Editor-in-Chief of the US Fish and Wildlife Service, she became a pioneer of environmental concern.

5b Christian Allhusen (1806–1890), highly successful entrepreneur in the Victorian chemical industry.

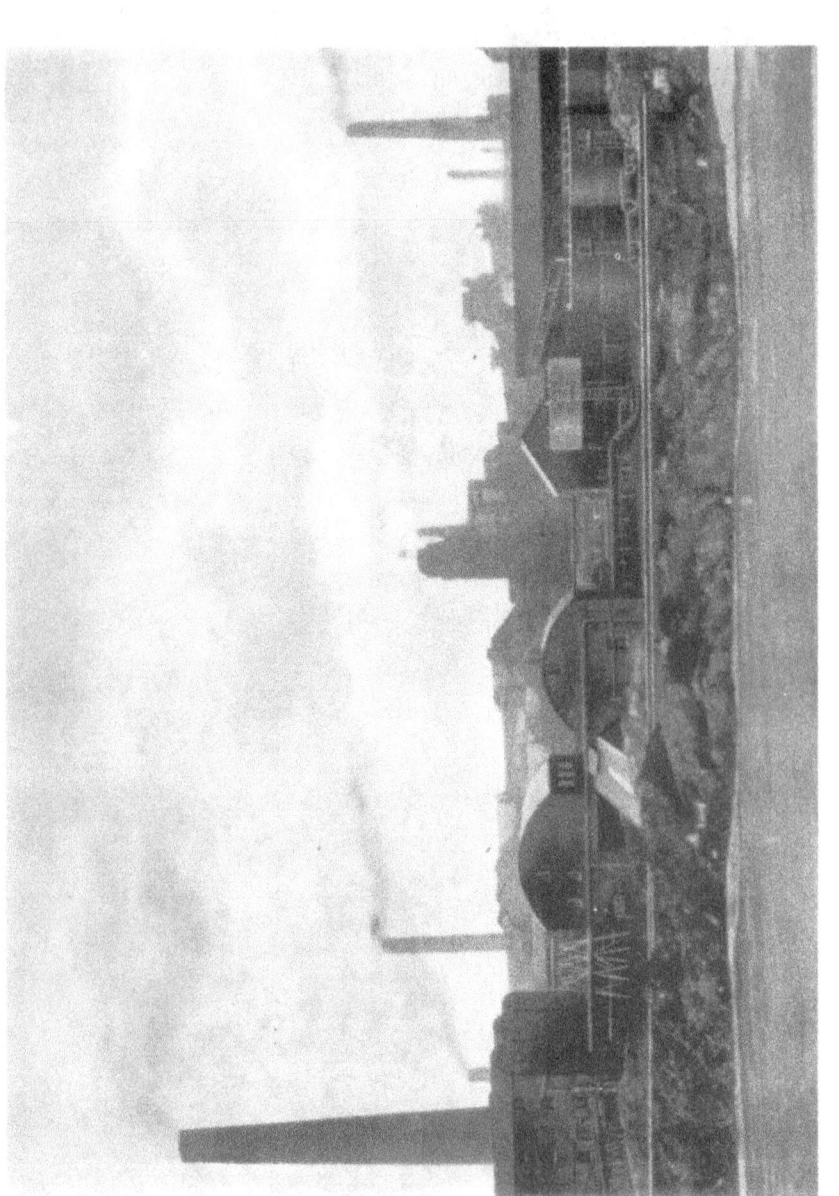

6 Chemical pollution on a large scale: Allhusen's Chemical Works, Gateshead-on-Tyne

7 Earthquake damage at Campania, Italy on 23 November 1980. The buildings are clearly not designed for earthquake resistance.

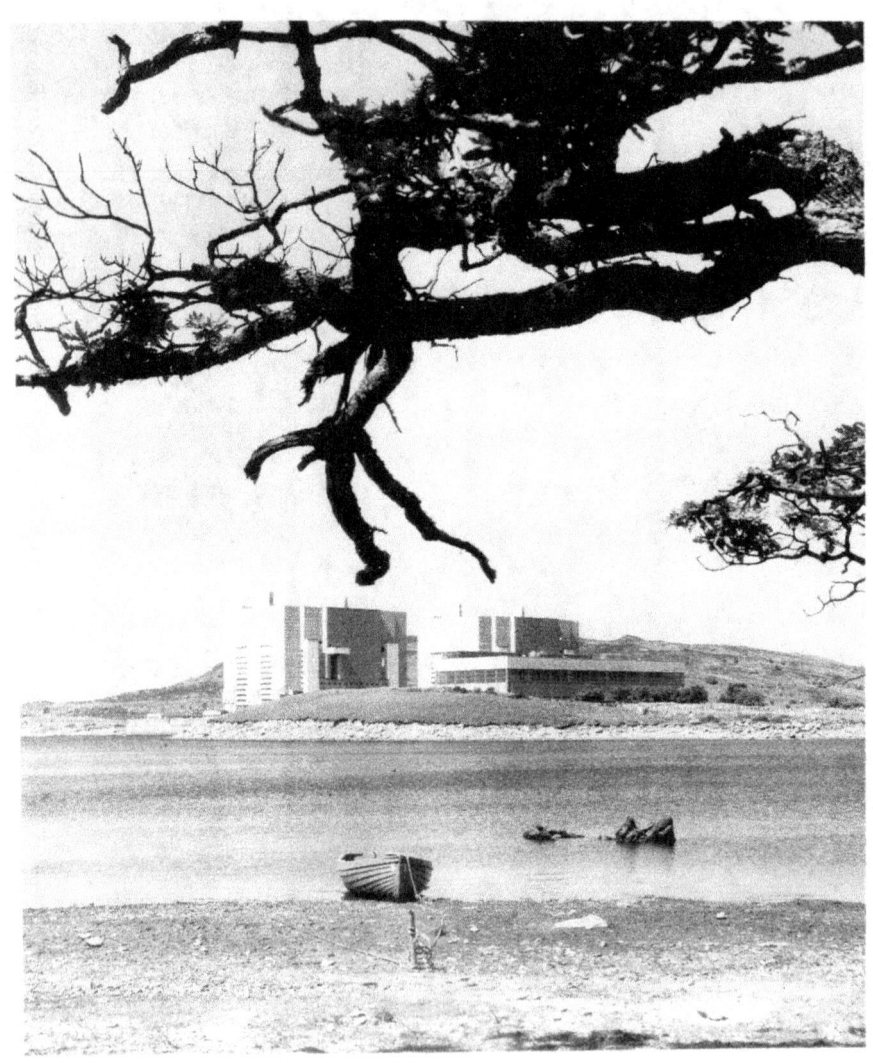

8 Nuclear power and rural tranquillity: utopian dream or practical possibility? Trawsfynydd Nuclear Power Station, North Wales.

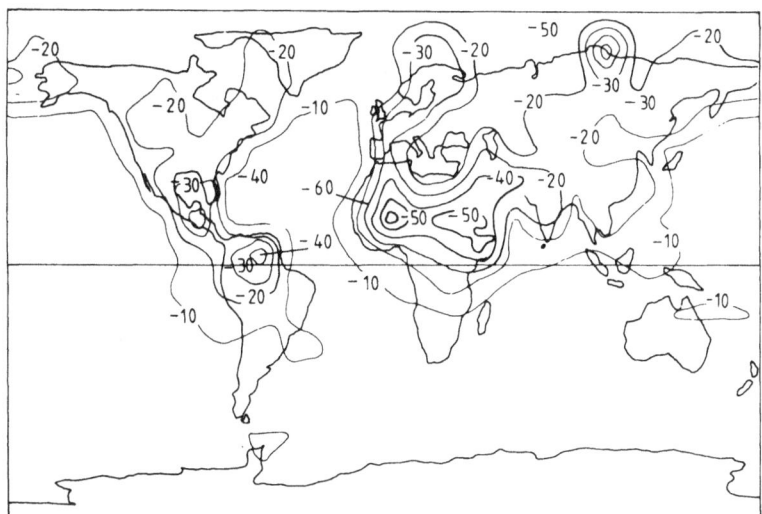

Figure 6.1 The change in surface air temperatures from the normal universal mean, 40 days after a nuclear induced conflagration in the Northern Hemisphere.

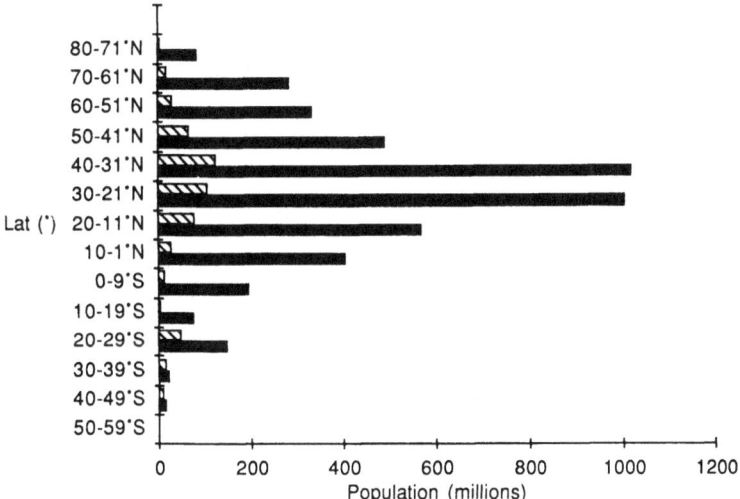

Figure 6.2 Vulnerability of human population to loss of food production if occurring when food stores are at a minimum. The solid bars represent the current populations at different latitudes and the striped bars the optimum number of survivors after one year.

One commentator suggested, with masterly understatement:

> It is possible that, in the aftermath of a major nuclear war, the global environment and human and social systems could collapse to an extent that might preclude recovery to post war conditions.[47]

In some desperation another writer exclaimed "the politicians and the military don't know what they are doing!"[48] If so, it is a manifestation of that other foe to the Earth, human ignorance. At the very least it points to an acute need for scientific education amongst those who make momentous decisions of this kind. It also points to the potential benefits of an underlying Christian ethic which enjoins love to one's neighbour and respect for God's world.

Just one single act of human aggression could pose to this "global environment" the largest threat of which humanity is capable. Maybe we can learn our lessons. But if ignorance could be dispelled, greed exposed and aggression inhibited, there remains arguably the most formidable foe of all. To that enemy we now turn.

Human arrogance

In an essay on "our human environment", John Stott quotes an incident told by Gavin Maxwell in which a Church of Scotland minister brutally shoots two otter cubs at play by the water's edge.[49] Defending himself from a spectator's shock and anger he justifies his action by paraphrasing Genesis: "The Lord gave man control of the beasts of the field."

The story symbolizes the brutal, unattractive face of that attitude which ascribes to man an absolute right to dominion over all the Earth, and then legitimates it by appeal to Scripture. Arrogance is not too strong a word.

It was this attitude that provided the basis for the famous thesis of Lynn White in 1966/7. Speaking in the aftermath of *Silent spring* and at the height of the anti-science movement of the 1960s, he argued that much of our present ills stem from the use (or misuse) of science and technology. This, in turn, is "at least partly to be explained . . . as a realization of the Christian dogma of man's transcendence of, and rightful mastery over, nature". The magnitude of our current environmental predicament arises, he argues, from the fusion of science and technology a century or so ago. "If so, Christianity bears a huge burden of guilt."

There are really two questions here, one theological and one historical. The former addresses the issue of whether unbridled dominion has any rôle

in an acceptable theology of creation. Alternatively, should one, as White advocates, revert to the naturalism of Francis of Assisi, where animate and inanimate objects are seen as "brothers" to be cherished rather than objects to be manipulated? The matter has been much discussed ever since White's paper: one thinks of Peacocke, Moltmann, Torrance and many others. We shall return to it later. Meanwhile there is the other problem, which is essentially historical: *has any form of Christian theology actually favoured a "dominion" view of nature and thus been responsible for the environmental crisis of today?*

To answer that question adequately demands all the available apparatus of historical enquiry, and this process has hardly begun. But let us at least try to unravel the threads. Perhaps the first thing to note is that some of the "heroes" of modern science went out of their way to stress the theological validity of the whole scientific enterprise. Thus Francis Bacon wrote:

> Man by the Fall fell at the same time from his state of innocence and from his dominion over created things. Both these losses can even in this life be partially repaired; the former by religion and faith, the latter by arts [= technology] and sciences.[50]

Subsequent Calvinist and Puritan literature is full of references to man as God's vice-gerent, with authority to control the natural world. That is not, however, to suggest unlimited licence to do as one likes. Indeed Bacon himself announced the twin objectives in manipulating nature: "for the glory of God and the relief of man's estate".

Evidence for a biblical justification for extreme "dominionism" is hard to find in subsequent writers. Maxwell's otter-killing minister is fortunately a rare example. What we do discover, however, is a great number of Christian men and women of science, especially today, who explicitly assert both the superior place of humanity in the chain of being and our responsibility of stewardship. Nor is this anything new. John Calvin wrote in 1554:

> The Earth was given to man, with this condition, that he should occupy himself in its cultivation. . . . The custody of the garden was given in charge to Adam, to show that we possess the things that God has committed to our hands, on the condition, that being content with a frugal and moderate use of them, we should take care of what shall remain. . . . Let everyone regard himself as the steward of God in all things which he possesses. Then will he neither conduct himself dissolutely, nor corrupt by abuse those things which God requires to be preserved.[51]

FOES OF THE EARTH

In similar vein an influential author of the 18th century, Rev. William Derham, FRS, assured his readers

> That these things are the gifts of God, they are so many talents entrusted with us by the infinite Lord of the world, a stewardship, a trust reposed in us; for which we must give an account at the day when our Lord shall call.[52]

To infer from these and many other similar passages that the Church – or even part of it – taught unrestrained plunder of Earth's resources is to fall into the most elementary trap of selective reading.

There is plenty of other evidence which, at very least, goes far in exonerating the Christian Church for our ecologic crisis.[53] Consider, for example, the rape of the forest on the Mediterranean seaboard in the pre-Christian era; the fetid pollution of many rivers in the Indian sub-continent; the endangered species in Buddhist lands; the appalling air-pollution in innercity Tokyo. In none of these has Christianity been at all involved.

There is further reason to reject the White thesis as unhistorical. If it were correct, one would never expect to find reverence for nature combined with a powerful desire to control and use it. Yet there are many cases where this was true. Consider, for instance, the English chemist Humphry Davy. A friend of Wordsworth, Coleridge and the other Romantic poets, he was not afraid to write verses himself. He once wrote:

> O most magnificent and noble Nature,
> Have I not worshipped thee with such a love
> As never mortal man before displayed?
> Adored thee in thy majesty of visible creation,
> And searched into thy hidden and mysterious ways,
> As poet, philosopher and sage?[54]

Then one day, lying on a rock on his beloved Cornish coast, he experienced nature with a new sensitivity:

> Today, for the first time, I have a distinct sympathy with nature.
> ... Everything was alive, and myself part of a series of visible impressions; I should have felt pain in tearing a leaf from one of the trees.[55]

Yet this same young man was shortly afterwards to praise chemistry for enabling man to control nature:

> By means of this science [chemistry] man had employed almost all

the substances in nature either for the satisfaction of his wants or the gratification of his luxuries. . . . He is to a certain extent ruler of all the elements that surround him; and he is capable of using not only common substances according to his will and inclinations, but likewise of subjecting to his purposes the ethereal principles of heat and light. By his inventions they are elicited from the atmosphere; and under his control they become, according to circumstances, instruments of comfort and enjoyment, or of terror and destruction.[56]

Davy sat lightly to Christian theology, but his combination of mystical reverence and confident utilitarianism calls in question the whole basis of the Lynn White thesis. It is a great over-simplification to posit "reverence" and "control" as mutually exclusive attitudes.

Finally it may be pointed out that the exercise of dominion over nature was encouraged more by Marxism than by Christianity, particularly by some of Marx's later followers. Benjamin Farrington, writing approvingly of Bacon's "interpretation of nature and man's dominion of it", asserts that "the real history of humanity can only be written in terms of man's conquest over his environment";[57] J. G. Crowther defines science as "the system of behaviour by which man acquires mastery of his environment";[58] and J. D. Bernal looks forward to a day when "it will no longer be a question of adapting man to the world but the world to man", though "to escape destruction by inevitable geological or cosmological cataclysms, some means of escape from the earth must be found".[59] How far these opinions actually affected attitudes in general is of course another matter.

It has taken some time to disentangle the threads of arrogant "dominionism" and Christian teaching so closely woven together by White, but fairness to the historical record demands it. But a more important question awaits us. Turning from history to theology we must ask whether a cavalier, exploitative attitude to the Earth can have any theological justification, and if not, what are the alternatives.

One really has to start with that famous passage from Genesis 1:

> And God said, Let us make man in our image, after our likeness: and let them have dominion over the fish of the sea, and over the fowl of the air, and over the cattle, and over all the earth, and over every creeping thing that creepeth upon the earth. So God created man in his own image, in the image of God created he him; male and female created he them. And God blessed them, and God said

unto them, Be fruitful, and multiply, and replenish the earth, and subdue it: and have dominion over the fish of the sea, and over the fowl of the air, and over every living thing that moveth upon the earth.[60]

Or in a modern translation:

Then God said, "Let us make man in our image, in our likeness, and let them rule over the fish of the sea and the birds of the air, over the livestock, over all the Earth, and over all the creatures that move along the ground."

So God created man
 in his own image,
in the image of God
 he created him;
male and female
 he created them.

God blessed them and said to them, "Be fruitful and increase in number; fill the Earth and subdue it. Rule over the fish of the sea and the birds of the air and over every living creature that moves on the ground."[61]

An extreme reaction has been voiced by Ian McHarg, who refers to "this ghastly, calamitous text", adding that "in its insistence upon dominion and subjugation of nature . . . God's affirmation about man's dominion was a declaration of war on nature".[62] Ringing words, but hardly a solution to the problem. For "ghastly" or not, the text is there and cries out for understanding. Its primary meaning (that man is placed in charge of nature) is perfectly clear, and is supported by other biblical passages as Psalm 8, and stressed even more strongly in the post-diluvian covenant of Genesis 9. As Hugh Montefiore put it,

Man has dominion over all nature. This clear teaching of the Bible has been endorsed by centuries of Christian tradition.[63]

That, of course, is precisely why some object to it. However, Norman Young has remarked that

It is certainly true that he [man] is given a place of ascendancy, but only by a feat of desperate exegesis can this be interpreted as receiving the right ruthlessly to exploit for his own advantage. The

words "subdue" and "have dominion" are strong, but within the biblical narrative they can add up to exploitation only if God's dominion over man is similarly seen to amount to exploitation, for the Bible pictures man standing in the same relation to the rest of creation as God stands to him.[64]

Moreover, to over-emphasize the subjugation of nature is another example of extremely selective reading, *even of these three verses*. The command to "replenish" the Earth means to fill it, the verb having some notion of *fulfilment* (as when Rebekah's water-pot was filled at the well[65] or when Ezekiel saw that the glory of the Lord filled the temple[66]). It is not limited to multiplying the human population. But there is more. Montefiore puts it bluntly again: "Man is made in the image of God, and the beasts are not."[67] The man and woman were created in the image of a God whose created universe the (probably priestly) author repeatedly described as "very good" and orderly ("after its kind"). At a lesser level man is to partake in God's creative activity, and that is not destructive or warlike. As Alan Richardson observed, "the doctrine of the *imago Dei* is closely connected with the doctrine of *dominium*; the former shows us what man *is*, the latter shows us what is his function".[68]

But is even that enough? What of the Earth itself? To be sure the author of Genesis 1 has no truck with a semi-divine universe. It is thoroughly de-deified, even to the extent of relegating that notable ancient divinity the Sun to the fourth day. But it is still "very good", in the same way as a poem or a symphony. You don't need to worship it to appreciate it. It has *intrinsic* value, conferred by God, not man.[69] Moltmann points out that the Creation stories climax in the seventh day of rest, with all creation living together in harmony.[70] This concept of "fellowship" with the rest of creation can be developed in the light of the Servanthood of Christ, so that to "subdue the Earth" can be read as "free the Earth through fellowship with it". One might add that in the same way to "replenish" the Earth could include in its meaning "to maintain its excellence by conservation".

Some theologians have gone further than this, suggesting a *sacramental view* of the Earth, which sees the whole of nature as both symbol and instrument of God's activity and presence (as in a Catholic view of the Eucharist).[71] Such a view, founded upon the Incarnation, inspires reverence and respect for the material Earth and its biosphere.

However, it may be observed that a genuinely sacramental view of nature does not of necessity have the effect suggested. An instructive example is the 16th-century chemist and medical reformer Oswald Croll (*c.* 1550–1609), who reinterpreted Paracelsian philosophy in the light of Calvinist

theology. Owen Hannaway has argued convincingly that "Croll's view of the Word signified throughout nature makes the whole of nature sacramental", adding that "From Croll's standpoint all the specific powers of nature as signs of the Word become potentially sacramental to the elect." However, the "elect" consisted of all believers in Christ and "cut across the denominational boundaries of institutional Christianity".[72] That being so one might have expected a high view of the Earth that militated against any kind of chemical exploitation. Instead we find this:

> Nature therefore, as it is now, gives us nothing that is pure in the world, but hath mixed all things with many impurities, that as by the spur of necessity, it might often put us in mind that we should begin to learn the knowledge of Chymistry from our cradles, that so long as we are shut out of Paradise into the suburbs of this world, we ought to till and manure the EARTH, to wit, the whole frame of the world by admiration, searching into, and knowledge of both the Visible and Invisible Earth, and that we should labour to get our bread, and other necessary things for this present life, as Nature's Labourers, not lazily but in the sweat of our brows . . . lest . . . by doing nothing we should learn to do naughtily.[73]

Thus nature is impure and needs to be manipulated if we are to live. As Hannaway remarks, "Croll has effectively removed chemistry and the manual arts from a soteriological context and placed them in the more familiar field of Calvinist ethics."[74] Yet in the primacy given to the non-verbal signs of the Word in nature, in his view of the Eucharist and in much else Croll's theology was truly sacramental.

The theory that a fully sacramental theology of nature is a prerequisite to reverence for nature needs some careful qualification. A powerful incentive may be generated by merely seeing the world as a *symbol*. Thus even in the Bible an apparently sacramental form of language and ritual may conceal a simple piece of symbolism and nothing more. Take, for example, the Old Testament story in which David, though parched with thirst in his battle with the Philistines, is brought water from the well of Bethlehem, at great peril to the agents of that mission. He refuses to drink it, and pours it away, with the question: "Is it not the blood of the men who went at the risk of their lives?"[75] Though the language (reminiscent of the Eucharist) and the action sound sacramental, the "water" stands purely symbolically for the "blood", and there is no suggestion that it was otherwise regarded; but the symbolism was so powerful that it was sufficient to determine a course of

action in which self-gratification gave place to reverence. Much the same may be true in our modern context.

Whatever may be our views on these matters it is clear that a well-articulated theology of nature is needed by our postmodern generation. That then requires a church which will proclaim it in intelligible terms as part of its larger proclamation of the Gospel.

That prolific Victorian author Charles Kingsley knew how to write for children. He concludes a delightful introduction to natural history called "The Glen" with this ascription of the proper status of nature, including our own planet Earth:

> Hear with the ears, not of your body but of your spirit, men and all rational beings, plants and animals, ay, the very stones beneath your feet, the clouds above your head, the planets and the suns away in farthest space singing, eternally,
> "Thou art worthy, O Lord, to receive glory and honour and power, for Thou hast created all things, and for Thy pleasure they were and are created."[76]

An attitude like that encourages scientific enquiry as divine vocation. It would dispel like the morning sun the mists of ignorance about the natural world; and it leaves no room at all for greed, aggression and arrogance.

Chapter 7

"Mother Earth?"

The present chapter and the next are concerned with a concept of such simplicity and familiarity that to regard it as in any sense a major issue could seem pedantic and churlish. Yet in fact the simple phrase "Mother Earth" conceals a multitude of ideas, from primitive superstition to sophisticated science. It is not too much to say that the practical outworking of some of these notions can be of the greatest importance for the destiny of the whole human race and of the Earth it inhabits. Indeed it will be argued that defective thinking in this area can be so dangerous that it might well be characterized as a further "foe of the Earth", to be added to the four encountered in the previous chapter.

Consider two documents. They indicate both the vast timespan in which this concept has held sway over the human mind and also the immense change that it has undergone over many millennia. The first is a cuneiform tablet from ancient Mesopotamia, dated perhaps 2000 BC; it illustrates a very primitive view of the cosmos, and a prominent feature is the figure of woman, probably suckling a child, with other children in evidence, even embryos as well. She is the archetypal symbol of fertility and reproduction, known by a variety of names but all with the meaning "Mother Earth".[1] We shall soon meet her again.

The other document[2] seems to come from a different world. It is a handout from a Royal Society soirée held in London on 17–18 June 1987 (Fig. 7.1). It is about a theory called "Gaia", a Greek word whose simple English equivalent is "Mother Earth". But whereas it is admitted on all sides that the most appropriate designation of the Mesopotamian cosmology is "myth", the theory publicized in, of all places, the rooms of the Royal Society must surely be located within the sacrosanct framework of modern science. The extent to which that conclusion is justified will be discussed in

The Gaia hypothesis
by Andrew J. Watson, Andrew J. Lovelock and James E. Lovelock

In the early seventies, the Gaia Hypothesis was proposed to explain the paradox of the long term survival of life on Earth. Life has existed for at least 3.8 billion years, there being evidence for biological activity in the earliest sedimentary rocks. It has thrived despite many factors which might have altered conditions away from the rather narrow ranges which mainstream life can tolerate. For example, the brightness of the Sun has increased by perhaps 25%, numerous impacts of large asteroids must have occurred and major changes in atmospheric composition have taken place. The Gaia Hypothesis suggested that life on Earth was able to actively regulate the global environment so as to maintain conditions comfortable for life.

There is evidence to show that living organisms greatly influence the global environment. For example, the anomalously low carbon dioxide pressure in the atmosphere, which is biologically induced, makes for a colder planet because of a reduced atmospheric "greenhouse" effect. But how might the biota achieve active, "gaian" regulation of the temperature?

In fact, such regulation appears to follow from two reasonable assumptions:

1. The biota are consistently influencing planetary temperature, so that the more active is life on Earth, the colder the planet tends to be. (The argument in fact works just as well if life tends to make the planet warmer – the direction in which the temperature is "pushed" is immaterial.)

2. Life is most active at moderate temperatures and will not grow if the planet is too cold (say, below freezing) or too hot.

These two assumptions translate into a "control feedback system" linking the activity of life to the planetary temperature and tending to regulate them both.

We have chosen to illustrate some of the properties of such a system using "Daisyworld", an imaginary planet on which light and dark coloured daisies influence the planetary temperature by absorbing varying amounts of sunlight. We believe however that a temperature control system is implied in what we already know about how life influences atmospheric carbon dioxide levels and how growth rates vary with temperature.

Figure 7.1 The Gaia hypothesis and Daisyworld.[2]

"MOTHER EARTH?"

the following chapter. Meanwhile it is sufficient to note this particular element of continuity between ancient legend and contemporary science, extending over a period of at least four thousand years. The idea may have something profoundly important to tell us about the Earth that we inhabit. First it is necessary to note something more of its origins.

The antiquity of "Mother Earth"

The modern mind may be slightly more at home with the phrase "Mother Nature", and there is no doubt that connections exist with "Mother Earth". Yet the latter seems to be of greater antiquity. In the opinion of Mircea Eliade "The image of the Earth-Mother, pregnant with every kind of embryo, preceded the image of Nature." It arose from a projection of life on to the cosmos, thus sexualizing it, "the culmination and expression of an experience of mystical sympathy with the world". He adds

> It is not a matter of making objective or scientific observation but of arriving at an appraisal of the world around us in terms of life, of anthropocosmic destiny, embracing sexuality, fecundity, death and rebirth.[3]

Such a process of sexualization in (or of) Nature has quite recently prompted the movement known as ecofeminism, though its origin is far from recent. On this view the essentially feminine Earth was replaced by a machine at the scientific revolution, and the constraints on "her" violation were removed.[4] Attempts have been made to fuse such ideas into a wider feminist Christian theology.[5] This enterprise has provided helpful insights into an integrated ecology, together with some curious conclusions about the Genesis account of Eve, represented as being not really about a "Fall" but a coming to maturity of the human race.

One of the earliest identifiable locations for the appearance of "Mother Earth" is Mesopotamia, that fertile land between the rivers Tigris and Euphrates and now including much of modern Iraq. Her début was in about 2000 BC or earlier and has been well described by the Assyriologist Thorkild Jacobsen. He argues that the universe was seen not only as a living, sexualized organism but also as a cosmic state, with a hierarchy of powerful gods. A typically Mesopotamian view of Earth was as the third of the gods, yielding in importance only to the god of the sky (Anu) and the god of the storm (Enlil). Originally known as Ki, the Earth-god later received

THE ANTIQUITY OF "MOTHER EARTH"

a succession of names which conveyed her supreme rôle as "Mother Earth", of which Ninhursaga is the most specific. According to one myth her union with the fourth deity Enki, god of the unpredictable flowing waters, led to the birth of the plants. In another story the Earth-Mother is raped by Enlil, the outcome being the Moon-god and three infernal brothers.[6] And in these and a multitude of other references she is seen as the bountiful source of all fertility, not least when the seemingly reluctant land miraculously yields the harvests that give her grateful children enough and to spare for all that year and until the wondrous cycle shall begin yet again.

These ideas were not common currency through all the ancient Middle East. The Egyptians, with their god-king Pharaoh firmly in charge of society and (it was hoped) nature as well, and acting under the eye of the all-powerful Sun-god Ra, knew nothing of a female divinity responsible for operations on and in the Earth. Even less addicted to this idea were the people of Israel, whose whole universe had been purged of divinity and even sentience. Procreative energy for them stemmed from God, not "Mother Earth". And to Abraham, that wandering pilgrim in Mesopotamia, came the revelation of the name of God as El Shaddai, the God Almighty who cared for his children.[7] In his Parenthood they, and the Christians who followed them, were to find undreamt-of security.

With the coming of the Greek civilizations some of the Mesopotamian notions of "Mother Earth" began to appear in transmuted forms.[8] Expressing also a belief in a procreative activity of the gods, albeit long ago, the Greek poet Pindar, in about 500 BC, opens his sixth Nemean ode with these words:

> Of one race, one only, are men and gods;
> both of one mother's womb we draw our breath.[9]

The name of that mother was Gaia, the Earth. She appears to be a reincarnation of the Mesopotamian Ninhursaga. In the subsequent development of Greek proto-scientific ideas, however, she plays little part, "Mother Earth having remained the dark preserve of the mythologists".[10] Yet, as we shall see, it was not quite as simple as that.

In Roman literature "Mother Earth" appears more than once. For example, Virgil makes one of his heroes worship before "Earth, first of the gods".[11] The Romans must often have enjoyed the story of how Junius Brutus visited the Delphic Oracle to enquire which of three candidates (including himself) should succeed the banished king Tarquin. The answer given was "he who should first kiss his mother", upon which the quick-thinking applicant

promptly threw himself on the ground with the words "Thus, then, I kiss thee, mother Earth!" He reputedly got the job.[12] In one of his odes from the first century BC the Roman poet Horace, commenting on the defeat of giants (whose agonized writhings led to eruptions of Etna), proclaimed that "Earth groans and mourns her offspring hurled by the thunderbolt to pale Orcus [the nether world]".[13] Of course all passages of this kind can be dismissed as mere poetic conceits, but the fact that such sentiments were expressed at all shows at least some measure of common usage.

In the early centuries of the Christian Church the Fathers occasionally touched upon related subjects. Thus Eusebius (4th century AD) writes of nature (not the Earth) as a universal mother, yet she herself is subject to God's laws and commands; he denies the possibility of spontaneous causation.[14] He, and many others, were concerned to demonstrate the superiority of the biblical traditions to those of Greek origin, where a totally impersonal, even materialistic, interpretation of nature was seen as a considerable danger. Also heirs to the Greek legacy of powers inherent in nature itself were the 10th-century Muslim philosophers al-Farabi and Ibn Sina (Avicenna). Their solution was a life-giving force with origins beyond the material world itself, manifesting itself as animal, vegetative and mineral souls, each being a different aspect of one World Soul.[15] This is perhaps the nearest that Islamic philosophy got to the Earth-Mother.

As for subsequent literature, there are countless allusions to these ancient ideas. Two illustrations must suffice, both from Spenser's *Faerie Queene* (1590). An unfortunate knight derived strength by contact with Mother Earth; he was killed by the simple expedient of holding him up in the air until exhausted (as had been the fate in Greek mythology of Antaeus, son of Neptune and the Earth-goddess). His final reflections were understandably lugubrious:

> He then remembred well, that had bene sayd,
> How th'Earth his mother was, and first him bore;
> She eke so often, as his life decayd,
> Did life with usury to him restore,
> And raysed him up much stronger than before,
> So soone as he unto her wombe did fall.[16]

The same idea is present in Spenser's condemnation of mining as sacrilegious abuse of Earth, described here, however, as "grandmother":

> Then gan a cursed hand the quiet wombe
> Of his great grandmother with steele to wound,

And the hid treasures in her sacred tombe
With sacriledge to dig.[17]

Real life, however, is much more than philosophy and poetry. Before we dismiss all this as baseless myth we need to enter the world of ordinary human activity. There we shall discover not only a ubiquitous and deeply held belief in "Mother Earth" but also – surprisingly – a great deal of empirical evidence that appears to justify it.

Empirical justification

Persisting right through the Middle Ages and even later was a long tradition of minerals growing in the Earth, so giving eloquent testimony to the fertility of the Earth-mother. It is, in fact, a very common-sense deduction. Carefully till a piece of stony ground and remove as many stones as you can see; next week, after a shower or two, an abundance of stones will be visible, for all the world as though they had grown there like potatoes. Small wonder, then, that ordinary people believed that minerals were conceived, born and nourished in the bowels of the Earth (a phrase still used today but full of ancient meaning). Thus we find that in Roman times the galena (lead sulphide) mines in Spain were allowed to "rest" for a period, during which time the mineral was "reborn"; then in due course mining operations could begin again.[18] Sixteen centuries later Francis Bacon quotes a report that a kind of iron buried in Cyprus "vegetates therein in some manner so that these same pieces become much bigger".[19] Struck by the fact that rubies *gradually* change colour, another 17th-century writer suggested "just as the infant is fed on blood in the belly of its mother so is the ruby formed and fed".[20]

A widespread belief throughout the Middle Ages was that metals contained the seeds of their own development,[21] while some saw their transmutation into one another as a real process taking place within the womb of "Mother Earth". There were all kinds of speculation as to how subterranean transformations occurred, including changes to the "mix" of the Aristotelian elements earth, air, fire and water (or of the later Paracelsian "principles", salt, sulphur and mercury). As each metal was linked to a planet, the influence of these heavenly bodies was also sometimes supposed to be at work.

Behind this riot of speculation lay a vast mass of empirical data, not all of it corrupted by folk-lore or mythology. This is all the more surprising to

"MOTHER EARTH?"

modern minds when it is seen to have been particularly associated with what was generally known as "alchemy".[22] This came to Europe in about 1200, having previously passed from the Greeks to the Arabs. In fact it is a term with multiple meanings, from which we may extract three. An alchemist was concerned with one or two (rarely three) of the following:

(a) Extraction and refining of metals; alchemy was thus a predecessor of metallurgy, and often had a semi-quantitative basis with the use of balances for the processes of metal assay.

(b) Attempts to achieve transmutation of metals into one another (usually to gold) and the search for the requisite "philosopher's stone", together with a pursuit of other chimeras such as the universal solvent and the elixir of life.

(c) Fraudulent attempts to imitate the imagined transmutations of the previous adepts and, by quite sophisticated conjuring tricks, to get rich as quickly as possible.

It may be said that the first class deluded no one, the second deluded themselves and the last deluded everyone else (or tried to). Understandably modern chemists prefer to trace their intellectual ancestry through the first class alone. Yet it was in fact a combination of the efforts of the first two groups that laid such a broad foundation of empirical knowledge that chemistry remains permanently in their debt. And from alchemical practice over perhaps 1,000 years there slowly came to light experimental data that seemed at the time to confirm in great detail the concept of "Mother Earth". The essential nature of this evidence has been put very simply by Eliade:

> Like the metallurgist who transforms embryos (i.e. ores) into metals by accelerating the growth already begun inside the Earth-Mother, the alchemist dreams of prolonging this acceleration and crowning it by the final transmutation of all "base" metals into the "noble" metal which is gold.[23]

The argument can be put as two propositions and two conclusions:

Proposition (a) "Mother Earth" generates metals in her womb;
Proposition (b) Metallurgical alchemists imitate those methods successfully.

Therefore we can draw:

Conclusion (c) Speculative alchemists ought to be successful by imitating the methods of their metallurgical colleagues;
Conclusion (d) From (b) and (c) (if successful) the validity of (a) is established.

EMPIRICAL JUSTIFICATION

In practice the extension of "Mother Earth's" techniques in metallurgical practice proved outstandingly successful, while its further application to alchemical transmutation often seemed at the time to be on the brink of success. Only thus can we explain the centuries-long persistence of what we now know to be an unattainable goal (at least by the means available), and then in the teeth of clerical opposition, widespread suspicion, general unpopularity and considerable danger to life and limb.

Studying alchemical literature is an immense and unbelievably formidable enterprise. Quite apart from the size of the corpus, it is suffused with mystic imagery and often deliberately arcane for reasons of security. Yet certain generalizations may be made about its effectiveness and its techniques.

Certainly no alchemist ever established that he (or she, for there were several notable women alchemists) created gold from anything else. Nor were the other mystical goals attained. However, they did discover some extremely important substances (such as two of the three mineral acids, many salts, phosphorus, benzoic acid etc.) and were able to extract and refine a range of metals including copper, tin, lead, mercury and silver. All this was done on the basis of certain powerful techniques that they devised in imitation of "Mother Earth".

Knowing that the temperature rises as one descends into the bowels of the Earth, and recognizing that this is where some of the most prized minerals were to be found, they developed new methods for applying heat in their processes. Thus from Greek times we find characteristic alchemical techniques. The hall-mark of alchemical practice is distillation, using retorts [alembics] leading to receivers [aludels], and also apparatus obviously used for fractional distillation. With these techniques they obtained pure mercury, sulphuric and nitric acids, acetic acid, ethanol (alcohol[24]), ether, ethyl nitrate and much else. With sublimation apparatus they prepared benzoic and succinic acids and ammonium chloride.

None of this would have been possible without efficient heating. This was so important that one 17th-century practitioner, J. R. Glauber (1604–70), entitled a major textbook *New philosophical furnaces* (1651). Designs varied enormously but all were to the same end: to replicate as far as possible the conditions of mineral-generation in the Earth, or even to surpass them. To quote Eliade again,

> The artisan takes the place of the Earth-Mother and it is his task to accelerate and perfect the growth of the ore. The furnaces are, as it were, a new matrix, an artificial uterus where the ore completes its gestation.[25]

"MOTHER EARTH?"

Figure 7.2 Imitating "Mother Earth" by transforming minerals by heat, in this case smelting lead ores in a furnace.[26] A, furnace; B, sticks of wood; C, litharge (lead oxide); D, plate; E, foreman.

For people with an allegiance to "Mother Earth" it is ironic that their smoky furnaces should have led to so much atmospheric pollution, to say nothing of the poisons liberated to the environment. Contemporary pictures of alchemical laboratories testify to these hazards and help to explain the alchemists' general unpopularity.

The biological analogies were never far away, and gentle heating on beds of rotting manure is frequently encountered. With furnaces always available it is not surprising that progress was made in the study of antimony, arsenic and their compounds, together with the extraction of metals from their ores by charcoal smelting.

There was a further batch of techniques prompted by the analogies with "Mother Earth", and these involved the frequent use of eggs in alchemical

experiments. Apart from the Earth itself there could have been no more potent symbol of fertility than an egg. Now, a remarkable thing about an egg is the large amount of combined sulphur present, which is why hydrogen sulphide – a decomposition product – smells of rotten eggs. But this gas has striking effects on metals and their compounds, turning white lead paint black, for instance. A particularly evil-smelling product from alchemical days was a solution of calcium polysulphides in water known (presumably on account of its powerful chemical action) as "divine water". On exposure to this vile concoction many metals are easily coated with thin layers of varying colours [sulphides], and it is not hard to believe that some kind of transmutation has actually taken place. Thus from eggs has come the expected generation of new materials. And all of this fits perfectly with the basic theory that "Mother Earth" does this kind of thing all the time and that alchemists have merely to learn from her. But even alchemy does not supply all the empirical evidence.

A living Earth is a natural deduction by primitive people from signs of volcanic activity, by earthquakes and by the rise and fall of waters. This happened to some extent in Europe, but in lands where the Earth is much more visibly active there may well be an incorrigible tendency to ascribe such activity to a personalized Earth. A recent example comes from New Zealand, where the Maoris have been deeply impressed – and understandably so – by spectacular phenomena in areas of high thermal activity. Thus to the boiling hot springs in the volcanic valley of Waimangu they have given the evocative name *Nga Puia o-te-Papa*, or Hot Springs of Mother Earth (Plate 4b).

By the 16th century the generative functions of the Earth were gradually transferred to the Aristotelian element earth as the prime among other elements. As late as 1703 the German originator of the phlogiston theory J. J. Becher (1635–81) could write: "earth is not only the mother, fount and origin of all but also the receptacle and end of all",[27] and by "earth" he meant not the planet but the Aristotelian element. Thus the notion of mineral generation was so powerful that it eventually outgrew the "Mother Earth" mythology.

At the hands of Paracelsus, Croll and others, the idea of metals germinating in the Earth became a doctrine in which the pattern of growth in any "seed" (metallic or otherwise) was determined by an *astra*, or spirit from the stars, inherent in each, and not by the matrix in which growth took place. Growth would then occur in the appropriate "element", and this could be air, water or fire as well as earth.[28] However, as early as 1556 Agricola had

denied the Paracelsian "principles", the alchemical linking of planets with metals, and the notion that metals contained the seeds of their own development.[29]

Gradually alchemy sunk into oblivion, the last practising alchemist often being said to have been Peter Woulfe, who died at the beginning of the 19th century. Long before then, however, the whole Aristotelian basis of transmutational alchemy had been discredited, as, of course, had the notion of "Mother Earth" as anything other than a pleasant metaphor. With the coming of modern science the terminology was largely laid to rest. This is entirely in accord with the deanimation and de-deification of the whole of nature (see pp. 15–18).

Return to myth?

Yet there have been two interesting developments that testify (if to nothing else) to the reluctance of the human race to abandon completely phrases and ideas vaguely recalled from its distant past. But to many it is exceedingly strange that towards the end of the 20th century not merely the phrase but also many of the associated ideas are reappearing, and not only in popular parlance (from which, of course, "Mother Earth" has never been completely absent).

The most obvious area in which a recrudescence of the Earth-Mother notion has been observed is that of the borderland between religion and environmental activism. Of course there always had been a tenuous thread of Earth celebration, at least since the times of St Francis of Assisi, who sang:

> Dear Mother Earth, who day by day
> Unfoldest blessings on our way
> O praise Him, Alleluia!
> The flowers and fruit that in thee grow,
> Let them His glory also show,
> Alleluia![30]

A recent anthology, *Earthsong*, compiled within a wide Christian perspective, includes several striking modern examples. What can best be described as a short environmental litany by Sister Rosita Shiosee begins with the invocation:

> In most aboriginal cultures of the Americas, the Earth is called "Mother", as she is the source of blessings,

RETURN TO MYTH?

and several times has the refrain

> We are listening, Mother Earth. Speak.[31]

A poem by Sue Lightfoot, "Gaia", has the lines

> The Earth is shouting.
> She was my mother,[32]

and one by Evelyn Holt, "The glory which is Earth", proclaims

> O Earth, living, breathing, thinking Earth
> On the day we treasure you
> As you have treasured us
> Humanness is born.[33]

These poems, consciously or not, reflect the values of a movement that stresses a kind of religious environmentalism. Often this is associated with that very heterogeneous group called New Age. One of its spokesmen, Sir George Trevelyan, displays a deep spirituality in his longing for the healing of the Earth: "Planet Earth, Gaia, has sent up her prayer to God and this will not go unheeded."[34] He is in no doubt as to the objectives of the Wrekin Trust, which he has founded:

> We must learn to think wholeness, to realise the reality of the Earth mother and that our exploitation of the animal kingdom and the rest of nature is piling up for us an enormous karmic debt.[35]

The last phrase suggests more than a touch of the occult, and this is borne out by conferences of the Trust, an advertisement for which contains the following small extract:

> Recent research likening the Earth to a living being with its subtle force fields, has discerned energy patterns which are focussed at specific locations within the landscape. Historical and archaeological evidence suggests that peoples of the past recognized and used this energy in their religious practices, erecting their monuments in accordance with underlying geomantic principles.[36]

To those attuned to biblical warnings against the occult this kind of message comes as a timely warning. It also presents a world-view totally incompatible with that of science for at least the last two centuries, and in most respects for far longer than that. It is, in fact, a return to the pre-Baconian organismic universe and offers another prospect of a post-scientific era. Whether this is to be desired is highly debatable.

"MOTHER EARTH?"

There have also been various attempts to harness "Mother Earth" to the environmental chariot without any (or much) semblance of religious aspiration. Thus a new cartoon series for children in the USA, "Captain Planet", has been heralded by its creator as follows:

> This is the story of Captain Planet. It starts out with the Earth Mother. We all know her. Her name is Gaia. She's taking a nap. All of a sudden she's woken up.[37]

Also in America there has emerged one of the most militant environmental groups called "Earth First!". Its symbol is a raised monkey-wrench and its motto "No compromise in defence of Mother Earth".[38]

The value of "Mother Earth" as a totem for some kinds of environmentalists must be considerable. The intriguing question is: which came first? Did the environmental concern spring from a flash of insight about an organismic universe and Earth? Or did the concern have other origins and a convenient symbol lie to hand in the vernacular vocabulary? Available evidence seems to point to the latter scenario.

All these examples might be regarded with some suspicion by scientists, but for the curious fact that it is within science itself that "Mother Earth" has recently reappeared. That was in the hypothesis known as "Gaia", to which we turn in the next chapter.

CHAPTER 8

Gaia

Self-regulating systems

The beginnings of feedback control

The transformation of the "Mother Earth" myth into something like a scientific hypothesis came about in a curious way. It began with a slow realization that the Earth was involved in a number of systems showing at least some degree of self-regulation or feedback.[1] Such systems had existed in artificial contrivances from antiquity; they included such devices as float valve regulators in Greek, Arabic and Chinese contrivances such as water clocks and oil lamps. Temperature regulators appeared in the 17th century, springing perhaps from the thermostatic furnaces of Cornelis Drebbel in Holland. At the same time pressure regulation became a practical possibility with the safety-valve for a pressure cooker described by Denis Papin in 1681. In the 18th century speed regulators were applied to windmills and (especially by James Watt) to the steam engine using a centrifugal governor.

Clearly self-regulation was a fruitful concept in engineering. It was carried over into economics, with Adam Smith's *Wealth of nations* (1776) advocating *laissez-faire* on the grounds that, left to itself, the economy would automatically readjust to an equilibrium state. If this was indeed the birth of modern liberalism, the techniques of the Industrial Revolution may have had a larger part to play in Western culture than is generally recognized. It may also have been the case that the self-regulating machines of the late 18th century triggered attempts to apply the same ideas to the physical world. If so they were fairly general and vague, at least at first. In 1774 Oliver Goldsmith published his *History of the Earth and animated nature*, in

which he stressed the activity of the Earth in volcanoes and earthquakes but also its overall stability. Roy Porter has written of the book:

> It is not yet "geology". But it conceptualized the Earth as a stable, self-regulating natural economy, in a way which was foreign to late seventeenth-century thought but which was to be so very influential in the formation of "geology".[2]

That conceptualization may be more clearly seen in the famous declaration of James Hutton in 1788 that the world is a kind of superorganism, caught up in a virtually endless cycle of decay and repair. It is not exactly alive, but is probably more than a machine:

> But is this world to be considered thus merely as a machine, to last no longer than the parts retain their present position, their proper forms and qualities? Or may it not also be considered as an organized body? Such as has a constitution in which the necessary decay of the machine is naturally repaired, in the exertion of those productive powers by which it has been formed?[3]

A rather similar view of an integrated science of Earth was found in the writings of the German traveller and writer Alexander von Humboldt (1779–1859), especially in his massive four-volume work *Kosmos*,[4] a colossal treatment of nature which he saw as an integrated whole.

Later on the concept of a "biosphere" emerged.[5] The word seems to have originated in a book on Alpine geology by Eduard Suess (1831–1914), published in 1875. He wrote of "eine selbstandige Biosphare",[6] which implied something of a larger self-regulating system that extended to living as well as non-living objects. His ideas were largely unnoticed at the time and even ignored in the 1981 sesquicentenary celebrations of his birth. However, they were taken up and developed in the early 20th century by two influential writers. One was the Russian mineralogist Vladimir Verdnasky (1863–1945), often regarded as the father of biogeochemistry.[7] The other was the unorthodox Roman Catholic palaeontologist and philosopher Teilhard de Chardin (1881–1955), whose own "Biosphere" was too anthropocentric to be termed ecological but became a living force in the cosmos that he imagined.[8]

By the late 19th century several examples had come to light of specific self-regulating systems in the natural world, two of special importance being the cycles involving carbon and nitrogen.

Carbon and nitrogen cycles

These are the mechanisms by which concentrations in the atmosphere of the gases carbon dioxide, oxygen and nitrogen remain virtually constant. Whatever we humans may do, or whatever natural events befall the world, it seems that self-regulation applies. If we were not so familiar with breathing an atmosphere that, despite local disturbances, always has an overall constancy of composition, we should find this phenomenon truly staggering. Two most elegant "cycles" of events ensure this constant composition: the carbon cycle and the nitrogen cycle. Each is basically very simple.

The *carbon cycle* is the name given to the whole system of processes by which the average concentration of CO_2 in the atmosphere is maintained within quite close limits at 0.03 per cent. The simplest representation (Figure 8.1) shows the gas fed into the air by respiration of animals and removed from it through absorption by plants during photosynthesis.

Figure 8.1

A slightly fuller statement is made in Figure 8.2. This includes a further means for removing carbon dioxide from the air, in the weathering of certain rocks (limestone and similar minerals) when solutions of the gas form soluble bicarbonates and carry them down to the sea. It is also released into the air from plant decomposition, and from a variety of non-biological processes including combustion and volcanic eruptions. The remarkable thing about the cycle is that these processes somehow balance out and the overall atmospheric concentration, though very small, remains constant.

We now know that matters are even more complicated than this. Carbon dioxide is not the only carbon-bearing intermediate, shuttling the element between various parts of the biosphere. Methane, CH_4, is a major product of some fermentation and digestion processes and is removed from the atmosphere by a number of reactions that until recently would have been thought most unlikely.

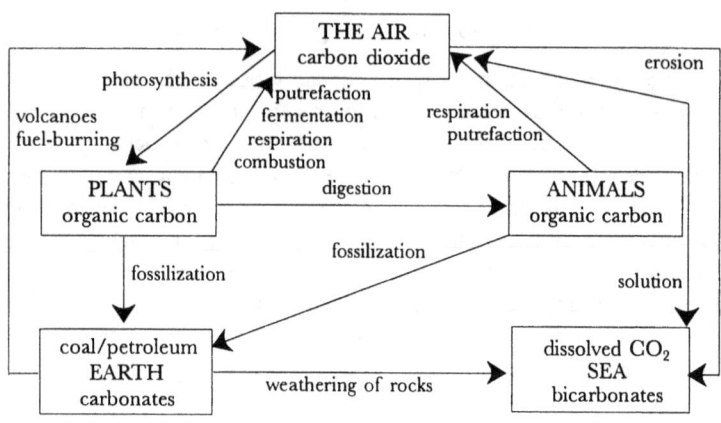

Figure 8.2

In the *nitrogen cycle* nitrogen atoms are transported between nitrogen-containing compounds in the soil and living organisms, of which nitrogen (like carbon) is an essential element. The basic form does not involve the air and is as shown in Figure 8.3.

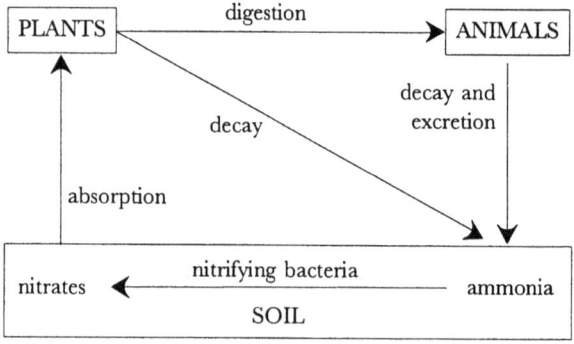

Figure 8.3

An end-product of nitrogen metabolism in animals is urea, $CO(NH_2)_2$, which is readily converted to ammonia (NH_3). In the soil are nitrifying bacteria which promote oxidation of ammonia into nitrates which are readily assimilable by plants (hence the use of nitrate fertilizers when natural ammonia supplies are inadequate). However, things are a lot more complex than this. Several processes reduce the amount of combined nitrogen in the

soil, of which the most important is the action of "denitrifying" bacteria, which convert ammonia into the very unreactive nitrogen gas (N_2) and release it into the air. Other impoverishing processes include the natural and man-made disposal of nitrogen waste directly to the rivers or sea.

Fortunately for life there are compensations. Although molecular nitrogen is notoriously unreactive it can be oxidized under the drastic conditions of a lightning flash, in which circumstance it is converted ultimately into nitrates like nitric acid. The sequence is:

$$N_2 \xrightarrow[O_2]{\text{lightning}} NO \xrightarrow[O_2]{\text{ordinary temp.}} NO_2 \xrightarrow[H_2O]{\text{ordinary temp.}} HNO_3$$

An industrial process has been developed to imitate the first stage, but it requires enormous expenditure of electric power. An additional mechanism exists for utilizing atmospheric nitrogen, and that is present in plants known as *Leguminosae*, which include peas, beans and clover. Through what are called "symbiotic bacteria" they are able to absorb molecular nitrogen directly and thus redress the effect of nitrogen release by other processes.

As a result of all these effects operating together the atmosphere contains a constant proportion of nitrogen, approximately 78 per cent. Amongst other effects this acts as a diluent of the highly reactive O_2, helps provide a stable climate and so on. A more complete account is given in Figure 8.4:

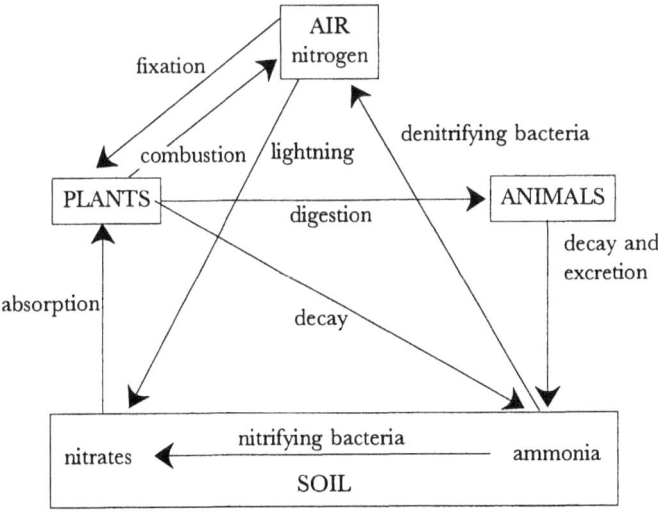

Figure 8.4

Many of the above facts were known for a long time, with pioneer work being done by J. B. Boussingault and others in the mid 19th century.[9] However, their incorporation into a cyclic scheme seems to have been left to the 20th century. One of the earliest schemes has been located in a textbook by Mellor, who also permits himself the following flight of rhetoric:

> Today a nitrogen atom may be throbbing in the cells of the meadow grass; tomorrow it may be pulsating through the tissues of a living animal. It may rise from decaying animal refuse and stream to the upper regions of the atmosphere where it may be yoked with oxygen in a flash of lightning and return as plant food to the soil in a torrent of rain.[10]

From about the 1930s such cycles were a standard part of elementary biology and chemistry teaching. Yet no-one (except theologians) appears to have asked *why* the system should have been so finely tuned, *why* there was this impression of stability and equilibrium.[11] It was just accepted that, somehow, there was a natural balance sheet, and expenditure (say of oxygen) was always exactly balanced by income. It was not until after the Second World War that speculations led to a wave of new interest in the problem.

The birth of Gaia

During the mid 1960s a scientist at the Jet Propulsion Laboratory in California, James Lovelock, was investigating the possibilities of life on Mars. He used the rather novel approach of analysing the planet's atmosphere (with the readily available technique of infrared spectroscopy), what he called a "top-down view" of the planet, as opposed to close-up examinations of landing sites etc. The theory was that life presumably depends in some way on the atmosphere, so if life were absent the only laws determining its composition would be those of physics and chemistry. In thermodynamic terms the atmosphere would be very close to equilibrium. On the other hand in the presence of life the atmosphere would be constantly involved in chemical reactions, and would hardly be in a state of equilibrium. The latter is the case on Earth, where both nitrogen and carbon dioxide are involved in cycles of transformation and in fact the carbon dioxide concentration in the air is relatively small. But investigations of Mars revealed a profoundly different situation. The atmosphere was rich in carbon dioxide, had no oxygen and was apparently very near equilibrium. Thus life, at least as we know it, was eliminated as a possibility on that planet.[12] Much the same situation

SELF-REGULATING SYSTEMS

obtains on the planet most like our own, our near-neighbour Venus. Some relevant parameters are included in Table 8.1.

Table 8.1 Planetary atmospheres.

Planet	Distance from sun (km × 10^6)	Mean temperature (°C)	Main components of atmosphere
Venus	108	474	CO_2 (96.5%), N_2 (3.5%), H_2SO_4 (trace)
Earth	149	16	N_2 (78%), O_2 (21%), CO_2 (0.03%)
Mars	227	−55	CO_2 (95%), N_2 (2.7%), CO_2 (0.13%)

Without life Earth is predicted as having an atmosphere of 1.9 per cent nitrogen, 98 per cent carbon dioxide and no oxygen at all. Its mean temperature would be in the range 240–350°C.[13]

If the vast differences between Earth's atmosphere and those of other planets were due to life, then some kind of feedback mechanism must operate between living and non-living entities, much as Hutton had proposed. Many chemists had known the separate pieces of these mechanisms since the 19th century. The carbon and nitrogen cycles are simply familiar examples of what must be an immeasurably more complex system of checks and balances. In seeking a name for this overall control system Lovelock happened to be speaking to his neighbour, the novelist William Golding. It was Golding who suggested that it be called Gaia, the old Greek name for "Mother Earth". And Gaia it has been known as ever since though, as we shall see, this has produced such formidable difficulties that an alternative term has now been canvassed by Lovelock, "geophysiology". There have been many attempts at precise definition (wherein lies a whole clutch of problems), but one of Lovelock's early attempts will suffice for the present: "A complex entity involving the Earth's biosphere, atmosphere, oceans and soil".[14]

More technically this can be put in the following way. Life and the global environment must be an integrated whole with systems of negative feedback leading to homoeostasis. This will occur despite the thermodynamic instability of Earth. More specifically we can say that the totality of life (biota) affects the physical environment to its advantage. The new emphasis is that the biota is not just a victim, but in part a conqueror of its environment. This stands in sharp contrast to past conventional wisdom, which portrayed living things as at the mercy of physical forces. In some sense the

physical part of the planet has lost its autonomy. Hence, wherever we find it, "planetary life can never be sparse".[15] Which brings us to our own Earth.

Regulation and repair

As we have seen, ours is a fragile planet, with multitudes of hazards from without and within its own structure. Yet despite these perils life on Earth has existed for perhaps 3.5 billion years. Of all the known planets within the solar system our own appears to be uniquely able to sustain life. To begin to answer the question "Why us?" we may take simply the question of temperature.

For life to have begun on Earth the temperature at that time must have exceeded 0°C, as otherwise the liquid water essential to life would have turned into ice. Today, nearly 4 billion years later, we know the mean temperature is about 16°C. During that period the Sun has been getting brighter and is now perhaps 30 per cent hotter than when life began. But that cannot be the sole factor governing Earth temperature, and at least two other regulators must be at work.

First there is the *influence of carbon dioxide*, CO_2 (greenhouse gas). Although it is now only 0.03 per cent of Earth's atmosphere, it must have been much higher when life began, perhaps 30 per cent. If a fall of that magnitude were not the case, it is estimated that Earth temperature would now be *c.* 250°C.[16] As we have seen, CO_2 is released into atmosphere by living things (through animal respiration, forest fires etc.). Also, it is removed from the atmosphere by plant respiration etc. These usual organic sources may be ignored for a moment, since they tend to balance out. On a grand scale we need also to consider two non-organic processes. A non-organic *source* for atmospheric CO_2 is volcanic activity, and evidence suggests this was particularly significant in the Earth's early history. Acting in the opposite direction is the weathering of silicate rocks, which thus acts as a *sink*:

$$SiO_3^{--} + CO_2 \longrightarrow CO_3^{--} + SiO_2$$

Like many other chemical processes it is greatly favoured by increased concentrations of one of the reagents. This process is accelerated by increased concentrations of CO_2 in the soil, and this can result from increased biological activity (either via the roots of plants or through microbiologically induced decay). The concentration of CO_2 in the soil may well be 40 times as high as it is in the atmosphere. Thus the greater the biological activity in the soil, the more CO_2 is removed from the air, and Earth's tendency to heat up will be diminished. Hence, on this view, life helps to regulate temperature.

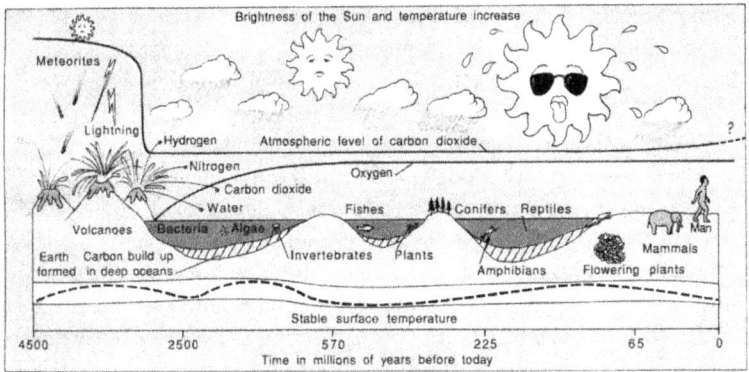

Figure 8.5 A summary of Earth history according to the Gaia hypothesis.[17]

Secondly, there is the *influence of cloud reflection*. The whiter a cloud, the more readily it will reflect away solar heat and thus minimize the heating-up process. It is known that clouds are formed from droplets of water that have themselves condensed round "cloud condensation nuclei" [CCN]. The more of these there are, the smaller will be the droplets and therefore the better the reflection. Now the main source of CCNs is probably acids (such as methane sulphonic acid, MSA) derived by oxidation from dimethyl sulphide $((CH_3)_2S)$.[18] This substance is chiefly generated from algal plankton in the ocean, always fairly near the surface.[19] Hence the greater the algal activity, the more CCNs are developed and therefore the smaller will be the rise in temperature. Nine-year records from Cape Grim (Tasmania) show that concentrations of CCN and MSA follow the same seasonal pattern.[20] Thus by an entirely different mechanism from the weathering of rocks biological activity can exert a significant effect on the Earth's temperature.

There is also another aspect of the Gaia hypothesis which does not merely apply to questions of *regulation*, as in the activity of biota leading to temperatures favourable to life. According to Gaia the Earth has also a capacity for *self-repair*. The Earth has been subject to the ravages of meteoric bombardment, and these may have caused the extinction of the dinosaurs. Such damage to the total biota may have been repaired by the emergence of *new* species to replace the old. If so the biota would continue, though in a changed form. It may be the end of the road for dinosaurs, humanity or some other species, but not for Gaia as a whole.

A simple but elegant illustration of the point Lovelock is trying to make has been in his fictional planet called "Daisyworld". Consider this imagi-

nary planet orbiting around an equally imaginary "Daisysun". Its only inhabitants are black and white daisies, and their wellbeing is affected only by temperature (all other necessities being freely available): they have a survival range of 5–40°C. The two species differ in one vital way:

White daisies deflect sunlight and so cool the planet;
Black daisies absorb sunlight and so heat the planet.

If we suppose the early Daisyworld was relatively "cool", the black daisies will have been favoured; as Daisysun warms up, the planet will therefore become colonized by black daisies. Above an optimum temperature, however, their growth will be restricted. The white daisies, with their capacity for slowing down temperature rises, will tend to take over. They flourish for a while, staving off the eventual rise to beyond 40°C, above which "flower power is not enough" and *all* daisies die. But they fought a good fight and, in a more complex biosphere, other life-forms would have been expected to continue the struggle.

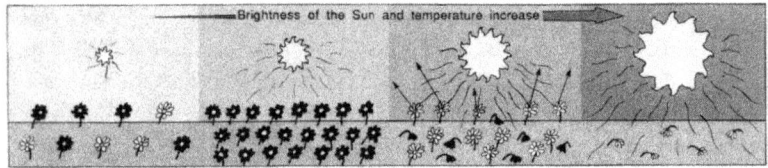

Figure 8.6 The course of events in an imaginary planet, "Daisyworld", showing the different fates of black and white daisies as their world gradually gets hotter; an illustration of the Gaia hypothesis.[21]

Gaia has been advocated enthusiastically by some scientists and repudiated by others; it has been welcomed by some theologians and attacked by others; it has received a mixed welcome from environmentalists, and from members of the New Age movement. So what are we to make of it, as perhaps the most scientific expression to date of "Mother Earth" philosophy? One reason for the confusion is a tendency to use "Gaia" in several different senses, and also for several different purposes. To clarify these may be the most helpful preliminary step towards a rational assessment.

The threefold meaning of Gaia

Examination of the Gaia literature seems to show an enormous semantic confusion, especially in the popular literature. It is not exaggerating to claim

THE THREEFOLD MEANING OF GAIA

that we are about to enter a linguistic jungle. There are, of course, many layers of meaning for a simple phrase like "Earth, our mother". Even when the more obviously mythological forms are excluded, and Gaia is taken merely within the context of scientific discourse, there is one obvious ambiguity at the start. "Gaia" is sometimes used as a hypothesis (like Avogadro's hypothesis, evolution, the second law of thermodynamics etc.), but sometimes as the subject of that hypothesis, i.e. the system that undertakes its own self-regulation and repair. Etymologically and historically it would make more sense to restrict it to the latter usage, but its shorthand application to the whole theory is hardly avoidable now. But that is the least of our problems, as may be seen by inspecting three definitions of the Gaia hypothesis, all of them from the pen of Lovelock himself:
(a) There is "a complex entity involving the Earth's biosphere, atmosphere, oceans and soil";[22]
(b) "The Gaia hypothesis supposes the Earth to be alive";[23]
(c) "Life on Earth was able to actively regulate the global environment so as to maintain conditions comfortable for life."[24]

Of these the first claims least and is also the most uncontroversial; for present purposes it may be called "the WEAK Form".[25] The second enunciation claims far more; this is obvious even if one may question the precise meaning of "alive"; it appears to be a literal interpretation of the original term "Gaia", for which reason it may be reasonably termed "the STRONG Form" of the theory. The third statement is a clear statement of purpose, intention, end, or goal of the natural process. To use Aristotelian terminology, it is dealing with *final* causes, and so it could be known as "the FINAL Form" of the Gaia theory. It appears to be thoroughly teleological in content, though Lovelock has inexplicably denied that he and his colleague Lynn Margulis "have ever proposed a teleological hypothesis".[26] We return to this question later (p. 123).

Thus understanding the Gaia hypothesis must involve differentiating it from the totality of "Mother Earth" biosphere that it presupposes. It also requires a sensitivity to the different shades of meaning that are attached to it by its authors and others. As if this were not enough one must also recognize that all this variety of usage is employed in many different contexts and therefore with a multitude of different purposes. These manifold uses of Gaia must now be examined.

GAIA

The manifold uses of Gaia

To speak or write of Gaia *in any sense* is to make a certain kind of statement. It may or may not conceal the "hidden agenda" beloved by historians and sociologists. More importantly, the contexts in which the statements are delivered can indicate the manner in which they should be understood. For an issue as confused as Gaia that is fairly important. Broadly speaking the statements may be rhetorical, political, scientific or theological, though often they may have more than one intention simultaneously.

As a rhetorical statement

The first and most trivial observation is that terms like "Gaia" can turn up in popular speech, juvenile fiction, sentimental poetry, journalistic ephemera and so on. Such allusions cannot be inferred to mean the Earth is seriously supposed to be maternal, sentient, purposive or whatever, any more than children's stories of Thomas the Tank Engine can be taken as evidence that the author believes steam locomotives to be alive. This is even more true of pre-Gaia references to "Mother Earth" which abounded in certain genres of popular writing.

Sometimes the rhetoric may have more serious intentions, especially in literature tinged with Romanticism. Employment of "Mother Earth" as a literary metaphor (though not specifically by name) may be found in a letter by Humphry Davy:

> That part of Almighty God which resides in the rocks and woods, in the blue and tranquil sea, in the clouds and moonbeams of the sky, is calling upon thee with a loud voice: religiously obey its commands and come and worship with me on the ancient altars of Cornwall.[27]

How far Davy intended to be taken literally, or how far this kind of writing was used to impress his friend Southey, must be a matter of some conjecture. The day when "Gaia" becomes a serious literary metaphor may not be far distant, in which event similar caution will be necessary. But in all these cases the chief purpose is to entertain. The next category is about those who wish to stimulate certain action.

THE MANIFOLD USES OF GAIA

As a political statement

The concept of "Mother Earth" offers itself to those who wish to argue for certain forms of Green politics. It has a certain emotive value and lends weight to the sentiments expressed. In a similar way some advertising agencies have begun to explore its potential ("Save money and Mother Earth"), particularly in promotions of "natural" foods and so-called eco-friendly detergents. I am not aware of an explicit use of the term "Gaia" in this connection, but it will probably come.

The main political movement enlisting Gaia to advance its cause is ecofeminism, a movement that unites feminist ideologies with ecological concern.[28] As one woman writer has argued:

> The priority of the female principle [in Gaia] may partly explain why the Gaian theory finds a sympathetic audience amongst feminist writers wishing to re-image our understanding of God and creation according to feminine characteristics.[29]

However, the most frequent encounters with Gaia are in the context of what purport to be statements of science.

As a scientific statement

The Gaia hypothesis makes a serious claim to be regarded as a scientific theory. But is it? Or is it "science made myth"?[30] Extreme caution is needed at this point. It is foolish to dismiss out of hand any theory that claims to be "scientific" simply on account of some *a priori* notion as to the exact nature of "science". That is because the concept of an absolute dividing line between "scientific" and "non-scientific" is wholly inconsistent with our modern understanding of the history and philosophy of science. This is even more pertinent when the theory in question is contemporary: it is slightly easier to make a judgement on issues further from us and frankly less "hot". Even then the advantage of hindsight can prove to be a snare, for we may then try to assess as "scientific" a theory on the grounds of whether or not it was "successful", while its actual success or failure may in fact be due to quite fortuitous events.

The case of Copernicanism is instructive. It could be said to have been "unscientific" on the grounds that it made little progress for over half a century, that its origins lay clearly in Hermetic philosophy as well as in a limited number of astronomical observations, and that it remained technically

unverifiable for nearly three centuries. Yet it was "scientific" in the sense that it purported to be about the physical universe, that it led to a revolution in astronomical thinking, that it made sense of many new observations (comets, supernovas, precession etc.) in a way that its predecessor could not, and that in the end it was triumphantly verified (by the discovery of stellar parallax).

That single case should warn against facile distinctions between "scientific hypotheses" and "religious myths"[31] which are really quite arbitrary. Perhaps the right question to ask about Gaia is not whether it is or is not strictly "scientific", but *in what senses* it may be legitimately said to be a part of modern science.

Taking first *the Weak Form* we cannot deny that it has had considerable predictive power and has generated much unquestioned scientific activity. Some of the successful predictions Lovelock claims are listed in Table 8.2.[32]

Table 8.2 Predictions from Gaia.

Prediction	Test and result
No life on Mars (1968)	confirmed by Viking Mission (1977)
Transfer of essential elements from ocean to land by compounds of organic origin (1971)	dimethyl sulphide and methyl iodide found (1973)
Climate regulation by CO_2 through biologically enhanced weathering of rocks (1981)	effects of micro-organisms on rock weathering confirmed (1989)

However, these and other claims have been challenged on a number of grounds. First there may be *alternative explanations*. Thus the acceleration of CO_2 production in soil (and thus the weathering of rocks) *could* be due to increased temperatures and rainfall; the survival of life against all odds *could* result from a capacity of micro-organisms to adapt to greatly varying external conditions; and the biosphere could be essentially a dissipative structure, out of thermodynamic equilibrium, but responsive to thermodynamic constraints.[33]

Then again attention has been drawn to the *difficulty and partial results of testing*. On this question of testing a supporter of Gaia, Andrew Watson, writes somewhat tendentiously that "the difference between a theory in science and an idea in philosophy or religion is that a scientific theory must be capable of being tested".[34] In that case some results are less than favourable to Gaia. Thus some tests on Antarctic ice indicate a *decrease* in the sulphur content in the atmosphere in the last 15,000 years, which would im-

ply that the regulative effects of plankton were not as suggested.[35] Furthermore, the Gaia hypothesis would have been less credible if life on Mars had existed, or if terrestrial fossil record (known to be discontinuous) were not to be matched by discontinuities in environmental record. Such falsification would, however, rely on negative evidence, and it has been strenuously argued that a fatal weakness of the Gaia case is that it is inherently impossible to falsify.[36] That, for followers of Popper at least, would be more significant than any claims that it might be verified.

Scientific theories can be of many different kinds, with different magnitudes of rigour etc. We may distinguish three stages in a scientific statement that purports to represent the natural world: metaphor, mechanism, mathematical model. The first of these Mary Hesse has called "conceptual models" which are "imaginative devices to be modified and fitted *ad hoc* to the data" since the relations between their terms are imaginary and arbitrary.[37] Examples include chemical atomism before 1860[38] and the biological doctrine of "family" before Darwin.[39] This seems to apply fully to the Weak Form of Lovelock's Gaia, for there is yet no way of knowing how the overall mechanism works. I conclude that the Gaia hypothesis may be properly described at present as a scientific theory, *but only in the form of a "conceptual model"*. It is on a par with a theory of atoms which no one can see or even weigh, and with a family of species where there is no means of understanding their evolution.

Turning now to the *Final Form*, one notes immediately how this adds to the Weak Form the purposive characteristic of life. It has been fiercely assailed on grounds of reimporting teleology into science. Despite Lovelock's denials it is hard to see how this charge can be resisted. According to Dawkins it is unscientific *because* it is teleological, requiring such illustrations as Daisyworld. Dawkins also expressed grave doubts as to whether or how evolution could lead to co-operative altruism on a global scale. What is important is whether or not the teleology is immanent in the world and therefore unconscious. Does it have the status of, say, Natural Selection? Or are we simply dealing with a harmless anthropomorphism? That will depend on the status accorded to the third version of the theory.

In the *Strong Form* of Gaia we really are concerned with that expression of "Mother Earth" inherent in the hypothesis. The organismic belief that the Earth really is "alive" is a pre-scientific hangover, and the hypothesis reverts to myth. It cannot even be metaphor, since no new characteristics of life are added to the model; Earth does not, for instance, reproduce itself.

Thus we may well conclude that in its Strong Form it is without scientific basis, in its Final Form it may be deemed scientific but only if the tel-

eology is immanent, but in its Weak Form it has genuine scientific value as a metaphor of great generality and (for many) charm. One other point is sufficiently striking to warrant a concluding comment. In many ways the Gaia hypothesis has certain features in common with the central hypothesis of Western alchemy, that transmutation is possible through reproduction of methods used in "Mother Earth". It is striking that in certain kinds of New Age thought there have been attempts to revive at one and the same time both alchemical and Gaian mysticism.

That might be mere coincidence were it not for certain striking morphological similarities between the two speculative systems. Thus each uses important terms in vastly different ways. One need look no further than the two key-words "Gaia" and "alchemy" (see p. 100). Each embodies powerful human myths of great antiquity, and each is culturally derived, with a strong metaphysical basis. Both Gaia and alchemy sought for an overall, all-embracing theory as well as consistency with empirical observation. Each had some predictive value, together with extremely useful spin-off benefits.

Yet on any rational basis today we know that alchemy was wildly in error, speculative in the extreme and with a fundamentally flawed ideological basis. While being scrupulous to avoid any hint of "guilt by association", one may be permitted to wonder whether the parallels are not too strong to be ignored in the case of Gaia.

It is also noteworthy that in New Age thinking the Weak Form of Gaia has very limited appeal,[40] possibly because of that movement's known distaste for science. On the other hand, the Strong and Final Forms, equivalent to mythological Earth Motherism, have deeply penetrated its philosophy. In so far as this is successful it poses a serious threat to all that we know of science, for it not only abandons the mechanistic universe but also undercuts the very biblical base on which the scientific enterprise has rested. Which brings us to a fourth context in which Gaia appears.

As a theological statement

The previous discussion has indicated that one cannot always demarcate clearly between scientific and other statements. These include those properly understood to be in the realm of theology. In fact there are several key theological issues in almost every form of "Mother Earthism", four of which call for special comment.

First and most obvious is the assumption of a *living Earth*, explicit in the Strong Form of Gaia theory. When pressed on this Lovelock was somewhat

vague, though he did say "The Gaia hypothesis supposes the Earth to be alive."[41] That is a matter in which theologians as well as scientists have an interest. Writing of the medieval incantation involving "the spirit of thy Mother Earth" (p. 98) Thorndike observes "The mention of mother earth in this charm perhaps indicates an ultimate pagan origin",[42] for such associations are not characteristic of Christian or Jewish thought. On such matters the biblical literature is silent, though the tendency is overwhelmingly against ascribing sentience to any part of nature other than man and perhaps the higher animals; the nearest one can get to an exception is probably in the inter-Testamental *Benedicite* ("O let the earth praise the Lord"). Some view Gaia with deep theological suspicion. Thus Tony Higton writes:

> Lovelock saw this theory in a purely scientific way. And some Christians may see it as describing the natural laws God has "written into" nature. But many will see in it a revival of pantheism.[43]

What must be clear is that it is clearly associated with a reversion to an organismic universe with all the hazards that that implies. In August 1987 a "Harmonic Conference" was held at Glastonbury, a supposed centre of mystical Earth energy. It sought healing for Planet Earth, now "in a precarious state as she enters the time of change at the threshold of the Aquarian Age"; Sir George Trevelyan added "God is in us and is the life in all things."[44] Gaia in nearly all its manifestations goes considerably further than the biblical doctrine of the immanence of God, though more will be said on that subject in the next chapter.

Then there is more than a slight suggestion of *teleology*. In the concept of a marvellously self-regulating world we may well see evidence of a Designer's hand. What is particularly interesting is that Gaia advocates are far from the first to perceive design in the composition and structure of our atmosphere, and that their precursors saw it in a strongly theological light. In the eighth Bridgewater Treatise, by William Prout, the author speaks of a "grand conservation principle" in the atmosphere. Even in 1834 he was aware of something strange about the air, but he presumed that the "conservation" was intended to prevent uneven distributions of gases, which would be deleterious to human and animal welfare (e.g. if all the local oxygen were used up in a large conflagration). He concluded that this benefit arises from the fact that the components of air are uncombined with each other and thus able to mix freely, so that "if a little more oxygen be consumed in one spot than in another; instantly the deficiency is supplied from the neighbourhood by diffusion".[45] Self-regulation in our environment was for Prout glowing testimony to design in the world.

A far more chemical interpretation was supplied later by that indefatigable Victorian writer, E. C. Brewer:

> Thus man and other animals supply the vegetable world with carbonic acid gas, its proper food; and the vegetable kingdom restores to the atmosphere that oxygen which has been taken out of it by the animal creation.

He concluded, rather primly, that "every breath we draw instructs us to admire the wisdom and goodness of that great Being who doeth all things well."[46]

But of course this kind of teleological argument begs the question: what is the Earth for? There have been many answers. In alchemical days Pallisy (1563) asserted "the Earth . . . exerts itself to bring something forth",[47] its ultimate aim being to make gold. Thus in a sense it existed for its own sake. With the Enlightenment the Earth was seen as existing for man, and natural theology made much of this. An extreme, if amusing, illustration was furnished by a German visitor to the British Association meeting in Birmingham in 1839. Writing of a *tour de force* performance by the Oxford Professor of Geology, William Buckland, before an admiring audience in Dudley Caverns, Christian Schönbein remarked:

> The immeasurable beds of iron-ore, coal, and limestone, which are to be found in the neighbourhood of Birmingham, lying beside or above one another, and to which man has only to help himself in order to procure for his use the most useful of all metals in a liberal measure, may not, he urged, be considered as mere accident. On the contrary, it in fact expresses the most clear design of Providence to make the inhabitants of the British Isles, by means of this gift, the most powerful and richest nation on the earth.[48]

Buckland then led the multitude out into the daylight singing "God save the Queen"!

Now, when teleology is located within the Gaia theory a profound difference is noted. Gone is an Earth made for man. In Lovelock's Gaia the converse is true: man (and the rest of the biota) exists for Earth. Humanity's own future may well be in doubt, but in the event of catastrophe Gaia would survive our departure. It would just be different.

Thus Lovelock has retained teleology but with inverted priorities. This means that he has also stood conventional natural theology on its head – the argument for God from a "designer universe" created with us in mind.

THE MANIFOLD USES OF GAIA

In fact both forms of teleology are grossly at variance with the biblical picture, according to which humanity does not exist for Earth any more than Earth exists for humanity. The Judaeo-Christian vision is of both Earth and man existing for God. On that basis one may well applaud the teleological implications of the Weak Form of Gaia. They are entirely consistent with the ascription:

> Thou art worthy, O Lord, to receive glory and honour and power, for Thou hast created all things, and for Thy pleasure they were and are created.[49]

When consideration is given to *the nature of man* some advocates of Gaia take off into the stratosphere of imaginative fiction. Thus Peter Russell writes of the possibility that humanity might become a global brain, servicing the rest of Gaia; alternatively, and worse, it might become "a form of planetary cancer".[50] Either way, as Pedler writes, Gaia "cares nothing for the continuance of the human race"[51] and acts with complete and a-moral indifference to it. This is another idea present in much New Age thought. Fashionable though it may be, even "politically correct", the downgrading of the human race is a far more serious consequence of the Strong Form of Gaia than it was of the doctrines of evolution. For this is about ultimate values and destiny, not origins and social behaviour. The Christian doctrine of the uniqueness of humanity, a species made in the image of God and accountable to him, is in danger of being lost without trace in a welter of speculative myth-making.

Finally the Gaia theory touches on the question of *providence*. It is of course possible that a demythologized Gaia might be yet another example of the care and planning of God, built into the fabric of the universe. However, it is hard to see the point of an Incarnation for and within humanity if the latter is merely an incidental part of a greater organism, Earth. As Moltmann has stressed, what is truly immanent in nature is not an Earth Mother but God the Holy Spirit.[52] The more this is stressed the more complete becomes the reduction of Gaia to something synonymous with a global system with negative feedback from living organisms. Only then does it become theologically neutral. With a recovery of belief in the providence of the triune God may come also an opening of the floodgates to reception of his love in Christ for human beings and the whole Earth.

CHAPTER 9

Surveying the prospects

A world perplexed: popular misgivings

A few years ago a roving radio reporter was conducting a "vox pop" exercise in an English street. She was enlisting popular views about the end of the world. This was just before the last Reagan/Gorbachev Summit, when there was widespread pessimism in the West about the Cold War. The following were the (unedited) opinions expressed:[1]
- It could come at any time.
- It will be the Third World War. It will be nuclear. That will be the end of the world. It won't be anything religious.
- It will come after 2000, you know, any time after then, I think.
- It will be disastrous. I don't think there will be any chance for a Noah's Ark this time.
- I think there's a toss-up, really, whether it's nuclear or one of the major astronomical disasters people talk about. I would hope when it comes, it will be sudden.
- One day the sun will go no further. That will be the end of it.
- I hope it won't be in my life-time, any way. I don't think God will destroy it. I think it will be humans. We will just get too powerful and we will destroy it in the end.
- I will just say, they will just press the button and there will be a bang. We will all be gone.
- No, it won't be nuclear, no. We will just be gone. I don't know. Like it says in the Bible.

An interesting feature of these "interviews" is the mix of scientific and biblical ideas, however vaguely understood, even in the late 20th century. They underline the necessity of an intelligent prognosis for Earth's future,

A WORLD PERPLEXED: POPULAR MISGIVINGS

to which we come in these final chapters. There seems little point in any examination of the Earth and its relation to God and humanity if one does not use the insights gained, if not to predict the future with confidence, at least to prepare to face it, and possibly to seek some measure of control over it.

The future of the Earth matters for at least two reasons. In the first place there are some circumstances in which the global destiny may lie in our own hands, in which case to ignore it must be reckless negligence. Secondly, our own personal destiny may depend, at least in part, on our response to challenges that are implicit in any consideration of environmental issues. Questions of our relationship to the Earth, of ethical and moral priorities, of our responsibilities to posterity and to God, of the whole *purpose* of existence on this planet – these and many others can raise for the individual a variety of hopes and fears, and may also initiate further enquiries into the Christian Gospel that offers answers to many of them.

Down the ages men and women have looked in many places for signs of the end, but always without success. They have contemplated social unrest, even revolution, and predicted a Golden Age round the corner, but always in vain. They have marvelled at the fragility of life on Earth, the delicately poised equilibria, the sensitivity of the ecosystem to even small changes, and have feared the end, though it has not arrived. Others have turned away from such thoughts, eating, drinking and making merry as though life – and Earth – went on for ever. Others again have delighted in the beauty of the world around them, wondered at the order and intricacy of nature, and marvelled at the continuing grace and patience of the Lord. But very rarely have people supposed the world would go on for ever. As Prospero suggested at the end of his entertainment:

> Our revels now are ended. These our actors,
> As I foretold you, were all spirits and
> Are melted into air, into thin air:
> And, like the baseless fabric of this vision,
> The cloud-capp'd towers, the gorgeous palaces,
> The solemn temples, the great globe itself,
> Yea, all which it inherit, shall dissolve
> And, like this insubstantial pageant faded,
> Leave not a rack behind.[2]

Since Shakespeare's time a great many more expressions of the same theme would have been expected. Two of the more zany ones are:

SURVEYING THE PROSPECTS

Though the ultimate state of the universe may be its vital and physical extinction, there is nothing in physics to interfere with the hypothesis that the penultimate state might be the millennium. The last expiring pulsation of the universe's life might be – I am so happy and perfect that I can stand it no longer.[3]

When the last sun shall have shed its last ray, I shall nevertheless soar over its ashes, and be what I am today, and will what I will today, my duty![4]

In truth it is easier to jest than to face squarely what seems to be so bleak a future. Yet face it we must, but this time with all the knowledge denied to our forefathers about the sciences and the environment. At this point it may be prudent to repeat advice commonly given at the end of the more horrific *Crimewatch* TV programmes: "Don't have nightmares!", for in truth some of the prospects are far from inviting. All of them have been met earlier in the book.[5] They may appropriately be called Doomwatch scenarios.

A world at risk: Doomwatch scenarios?

To the question "what future may we reasonably expect for our planet?" an informed answer will much depend on which factors are taken into account, and which are ignored. According to this decision one may reply on at least three naturalistic levels (with a fourth, theological, response to be considered later). We consider the three in turn.

Taking into account the laws of physics only

The possibility of entry into the Earth's biosphere of a large meteorite has already been mooted, and with it the possible elimination of some or all life. Similarly the chances over a vast timespan of collision with a comet are very much higher than the 1 in 10^4 predicted for an isolated encounter with the Swift-Tuttle comet in the year 2126.

If, against some considerable odds, the Earth is fortunate enough to avoid such an inter-stellar traffic accident, there remains an alternative scenario of baking alive. It is known that the Sun is getting warmer, and following a familiar pattern of stellar transformation. The Sun's energy, upon which all terrestrial life depends, comes from a transformation of hydrogen

A WORLD AT RISK: DOOMWATCH SCENARIOS?

into helium at the unimaginable rate of about 6×10^{14} g per second. As the hydrogen/helium ratio decreases the denser core will begin to contract and thus become much hotter. This, of course, means that the Earth will heat up and eventually (after about 1500 million years, perhaps) all the CO_2 will be driven off and life will have become extinct. In time the extra heat energy will cause the outer regions of the Sun to expand, though the surface temperature will be lower than now and the Sun will simply glow with a red heat; it will become a red giant, perhaps in 5,000 million years. But the expansion will be so great that it will devour the inner planets, including Earth, and our planet will be no more.

Perhaps that will be a foretaste of a day when all galaxies will be swallowed up in the Big Crunch. But there is another cosmic scenario, known since the mid-19th century. This is the "heat death" of the universe. We have seen how studies of thermodynamics enabled Kelvin to determine the age of the Earth. He also argued (on the basis of the Second Law of Thermodynamics) for an absolute scale of temperature and also for a "universal tendency in nature to the dissipation of mechanical energy",[6] leading to a heat death for the universe with the temperature just above absolute zero. Kelvin pointed to "a finite period of time to come" in which the Earth will be fit for human habitation. He was, of course, unaware of modern theories of stellar evolution, and also of nuclear reactions, so could not have known of the prior absorption of the Earth in the Sun. Were that in any way avoidable, and no-one knows how that could be, the alternative "heat death" would be even more inevitable.[7] It has been skittishly put: "if the oven won't get you, the freezer will!".

The predictions of physical science have a certain sense of inevitability, so much so that a recent writer refers to the horrifying thought that eschatology (the theology of the last days) could become "entirely a branch of physics"![8] However, physics, at least in its traditional sense, is not the only factor to consider. We may briefly look at another.

Taking into account theories of Gaia

Setting aside any question as to whether, and in what senses, Gaia can be properly called science we can hardly avoid its optimistic conclusion that Earth will survive numerous catastrophes as feedback mechanisms operate (with or without humankind), and the system's capacity for homoeostasis comes into play. Even taking Gaia only in the Weak sense suggests this conclusion, though it is far from inevitable.

A further fate for Earth proposed by some advocates of Gaia is a kind of absorption into the larger cosmos and the emergence of a new planetary consciousness: Gaiafield. Then it is argued that a new Supergaia will emerge from millions of individual galaxies, giving, ultimately, Brahman, "the perfect Cosmos".[9] The Eastern origin of this idea is obvious. Let readers decide for themselves.

Finally there has to be the possibility of a Gaian failure, terrible though that may be to contemplate. It is significant that even Lovelock admits a limit to the extent of homoeostasis in all negative feedback systems. Gaia is not, therefore, a recipient of guaranteed immortality.

From the more speculative flights of fancy of some Gaia enthusiasts it may be salutary to turn to the far more certain effects of our own activity.

Taking into account human activity

Much of this has been encountered before. We are on surer ground when we survey the impacts we humans are likely to have on our Earth. Our prodigal consumption of fossil fuels could increase the concentration of carbon dioxide in the air above its present 0.03 per cent, while the wholesale destruction of the tropical rain-forests will deprive nature of a mechanism for reducing that concentration. It is thus probable that an *enhanced greenhouse effect* will be created, with an accelerated rise in temperature that has nothing to do with the Sun's getting brighter. This hotter environment could significantly reduce the period of habitability of Earth.

Allied to our pouring CO_2 into the atmosphere is *hyper-pollution* by all manner of manufactured substances, with unpredictable effects on the biosphere. The effects of DDT and CFCs are beginning to be understood; one wonders what new polluter will be seen to have dire effects on the Earth.

Then there is the question of *resources*. Estimates vary, but a reasonable projection is that the supply of fossil fuels (coal and petroleum) will last 200 years at most; those forests and trees that can also yield energy by combustion are being felled at such a rate that replacement is impossible within one or two generations. Meanwhile the one energy source that is almost inexhaustible, nuclear energy, has had its own problems of pollution, and is hugely unpopular with some sections of the community. Its ban (as well as its misuse) could have catastrophic effects on humanity's future. In the same way indiscriminate banning of all "chemicals" would lead to a global shortage of food supplies and thus the elimination of much life. Banning DDT has, as we have seen, both desirable and disastrous effects on the environment.

If "resources" are not limited to those of immediate value to humanity, but may include all kinds of plant, bird and animal species, then it has to be admitted that many are now endangered and will certainly disappear unless decisive action is taken by us.

All these dangers are greatly exaggerated by the added effects of *war*, above all nuclear war: a vast increase in the use of fossil fuel and consequent CO_2 production, poisoning the biosphere with the toxic detritus of warfare, even extinction of species. The dire predictions of a "nuclear winter" have already been noted.

Against all these potential disasters, natural and manmade, there have to be Herculean efforts by concerned individuals, pressure-groups and governments. The next chapter will suggest modest hopes that these will materialize.

A world re-deified: return to pantheism?

There is one other way in which human action could bring irreparable damage to the planet and its inhabitants. Reference has been made to it several times already. We have seen how the old organismic universe was displaced in favour of a mechanistic one at the end of the Middle Ages. We have noted the survival of ideas about "Mother Earth" over many centuries and attempts to strengthen them today. And we have observed how one interpretation of the Gaia hypothesis can lead dangerously near the concept of an animistic Earth. It is, however, but a short step from an organismic to a divine universe, and many people today are finding such a prospect curiously attractive. In an age when nostalgia for a Golden Age in the past is big business we cannot be surprised if we discover within ourselves a resonance with all kinds of primal myths and legends. Yet recourse to pre-Christian notions of a divine universe is fraught with dangers for humanity and the Earth. There are at least two reasons: it is both an aberration of theology and an abandonment of science.

An aberration of theology

To suppose that the universe, or even just the Earth, is part of God, or even *is* God, is to contradict a thesis on which classical Christian theology has always insisted: the transcendence of God – his otherness from the world that he has created and that he continuously keeps in being. The Old Tes-

tament prophets and singers were in no doubt about the matter as they sought to protect Israel from the nature-worship endemic in the neighbouring peoples: the Phoenicians, the Philistines, the Babylonians, the Egyptians (to some extent), and many of the local Canaanite tribes. They needed to remember "the Lord who has made all things, who alone stretched out the heavens, who spread out the earth",[10] who controls the weather,[11] permits natural disasters[12] and gives harvests in abundance.[13] The great sea-monster that terrified Israel and its Canaanite neighbours was not an incarnation of God; it was one of his greatest creations[14] or merely one of his playthings.[15] As for the forest groves in which Canaanites and others worshipped, there was resolute resistance against all such practices and even the worship of images associated with them.[16]

By New Testament times animistic pantheism was less of a threat to the Israelite faith. The teaching and life of Jesus can leave us in no possible doubt as to the transcendence of the God whom he called "Father", encouraging his followers to do the same. It would take many chapters to elaborate just this aspect of the subject, but it would be far better to scan the pages of the Gospels and epistles in the New Testament. The case is crystal clear.

The current trend to a vague deification of the Earth flies in the face of nearly two millennia of Christian theology, even though it is sometimes advocated by people nominally within the Christian Church. Of course this argument may have little weight with those outside Christianity, but at least all should know what they are letting themselves in for. No one has put it more clearly or more cogently than C. S. Lewis, who saw, well before his time, something of the perils of civilization if it travelled far down this road. In his day he saw it in theosophy and in the worship of some imagined "life-force"; he felt that even the worship of a racial spirit encouraged in Nazi Germany was "only Pantheism truncated or whittled down to suit barbarians". Of pantheism itself he wrote:

> So far from being the final religious refinement, Pantheism is in fact the permanent natural bent of the human mind; the permanent ordinary level below which man sometimes sinks, under the influence of priestcraft and superstition, but above which his own unaided efforts can never raise him for very long. Platonism and Judaism, and Christianity (which has incorporated both) have proved the only things capable of resisting it. . . . Men are reluctant to pass over from the notion of an abstract and negative deity to the living God. I do not wonder. Here lies the deepest taproot of Pantheism and of the objection to the traditional imagery.

A WORLD RE-DEIFIED: RETURN TO PANTHEISM?

It was hated not, at bottom, because it pictured Him as man but because it pictured Him as king, or even as a warrior. The Pantheist's God does nothing, demands nothing. He is there if you wish for Him, like a book on a shelf. He will not pursue you. There is no danger that at any time heaven and earth should flee away at His glance.[17]

When it comes to matters of ecology there are those who feel that a pantheist approach to nature is the only way to save it. There is nothing new about this; the ideas may be found in Meister Eckhart (c. 1260–1327) and other medieval mystics. However, a subtle change has emerged from process theology, a view described as panentheism (meaning "the world-within-God"). This does not equate the world with God but rather asserts that it is part of God. Thus it would follow that while the first statement below is false, the last three are true:

	God = universe	(F)
	God > universe	(T)
	universe < God	(T)
or even	universe = God	(T).

One of the leading exponents of panentheism in an ecological context is Matthew Fox.[18] The merit of panentheism over crude pantheism is that it does take into account the biblical assertion that God is much more than the world he has made and also the doctrine of his immanence in the world (which complements statements as to his transcendence). And it might, in theory, predispose one to a greater reverence for the material Earth. A question that needs to be asked, however, is whether panentheism adequately represents the transcendent otherness of God or elevates creation to a position unjustified in Scripture. Attempts to justify it by the oft-quoted words of Paul (himself citing a Cretan poet) demonstrate the fragile foundations of the argument. It is perfectly possible to read them as a testimony to the sustaining power and love of a transcendent God: "God . . . is not far from each one of us. For in him we live and move and have our being." Indeed he prefaced these remarks by proclaiming that "the Lord of heaven and earth does not live in temples made with hands", and that he "gives all men life and breath and everything else". He continued by speaking of God as "Judge" who "*overlooked*" ignorance, *commands* people to repent, and *raised* Jesus from the dead.[19] And at no point in Scripture are we ever encouraged to view the Earth as coterminous with God (or part of him).

However, it is easy to suppose that pantheism and panentheism represent a more tangible danger to the Earth through their dire implications for sci-

ence than they do by their theological unorthodoxy (or otherwise). This is actually a mistake because, as we shall see, correct theology *does* matter when it comes to caring for the Earth. The irony is that the very Earth which their exponents hope to protect is actually endangered by pantheistic world-views.

An abandonment of science

A re-deification of the Earth is endemic in much thinking associated with New Age, postmodernism and other reactions to what their supporters perceive as a science-led abuse of the Earth. But let there be no mistake: their intention must be to put the clock back to a pre-scientific era. In that connection it is instructive to place side by side two accounts: one of England before the scientific revolution by the distinguished historian G. M. Trevelyan,[20] and the other of a mystical "encounter" with Pan by R. O. Crombie, a guru of the New Age movement:

The parallel between the two passages is striking; in the Crombie anecdote the scientific revolution might never have happened; the intention is clearly to revert to a previous, organismic world-view. And that, for today's world, is fraught with danger.

Early 17th century	*Late 20th century*
The idea of a regular law governing the universe was unfamiliar to the contemporaries of Francis Bacon. The fields around town and hamlet were filled, as soon as the day-labourers had left them, by goblins and will-o'-the-wisps; and the woods, as soon as the forester had closed the door of his hut, became the haunt of fairies; the ghosts could be heard gibbering all night under the yew-tree of the churchyard.[21]	He [Pan] stepped behind me and then walked into me so that we became one and I saw the surroundings through his eyes. At the same time, part of me – the recording, observing part – stood aside. The experience was not a form of possession but of identification. The moment he stepped into me, the woods became alive with myriads of beings – elementals, nymphs, dryads, fauns, elves, gnomes, fairies – far too numerous to catalogue . . . [22]

Given the facts of the present population explosion there are two stark alternatives: let nature take care of itself and Gaia be free to undergo self-regulation in her own way; or let us draw on the immense bank of scientific

knowledge to find new ways of sustaining life on the planet. The first option, to abandon a scientific world-view, is to solve nothing and at the same time to bring untold suffering on fellow-human beings; it is the law of the Victorian *laissez-faire* jungle. Do we really want infant mortality, mass hunger and epidemic diseases at 17th-century rates? We don't even have a 17th-century population. The second option has many risks but surely they are worth taking. How else can we feed the hungry, heal the sick, sustain in a degree of wellbeing the masses who will populate our vast cities? Someone has to be prepared to take responsibility. Meanwhile our analysis has one final element to consider, namely the proposition that in some sense the Earth is "a fallen world". This relates not chiefly to a possible uniqueness of the planet itself but even more pertinently to the human beings who populate it. On these matters theology has urgent things to say.

A world estranged: "the silent planet"?

In one of his space travel novels C. S. Lewis tells the story of a Cambridge linguist, Dr Ransom, who is transported to another planet (Malacandra) from which he can see his own Earth. What he discovers is that this Earth is a world *incommunicado* with the rest of creation. This is not a question of any kind of radio-communication failure but rather of moral isolation, for the Earth is insulated by the sin and corruption it uniquely supports. He is told by the ruler of Malacandra that Earth is "the world we do not know. It alone is outside the heaven, and no message comes from it."[23] It is "the silent planet". In such mythology may lie profound truth.

The story, and its sequel *Perelandra*, convey in powerful imaginative imagery something of the Christian understanding of what has happened to our world, how *we* have contaminated it and how *our* malfunctions have blighted its destiny. They touch on one of the least popular themes of Christianity, the issue of human sin. This is the reason, it is sometimes alleged, for the one proposition on which all human beings seem to be united, namely that the world is less perfect than it should be. People may differ on the nature of its malaise, on its causes and certainly on its cure. But there must be few today who would agree with that "cosmic Toryism" of the late 18th century that believed ours to be the best of all possible worlds. The facts of human suffering are sufficient refutation, whether on the grand scale of ethnic Holocausts or the individual scale of pain, fear, loneliness and frustration. Why this should be has been the subject of endless debates and

philosophical speculation on the origins of evil. They need no repetition here. Instead I propose to explore briefly three aspects of a Christian understanding of the dilemma facing humanity, of which the ecological aspects are the most obvious in the present context, but by no means the most urgent for the individual.

The plight of humanity

The magnitude of our own self-inflicted wounds is too obvious to require elaboration. Nor does it appear that the situation is much ameliorated by advances in science and technology; in some respects scientific progress has made matters worse in providing us with even more lethal means of self-destruction. Indeed, the Bible speaks consistently, not of an evolving super-race of human beings shortly to attain perfection, but of a humanity that is fallen, sinful, reaching only to a small degree its full creative potential. The most damning words of all are directed by Jesus Christ himself at a self-righteous religious establishment.[24] The omens for all of us are not good. Yet does this not accord with life as we experience it? One German theologian who had witnessed the atrocities of the Second World War knew all too well how the animals fail to plumb the human depths of "diabolic sadism". He wrote "only a man could have written the terrible sentence of Nietzsche, 'To watch suffering is sweet, to cause suffering is sweeter'".[25]

These terrible words unfortunately ring true, though most of us don't feel like that most of the time. This is always easier to see in others: in the mindless violence against the old and the weak, in the brutal murders of defenceless children, in the systematic elimination of sections of the human race with the "wrong" genes or culture, in the pillage of the Earth in the name of progress and so on.

So what hope is there for an Earth inhabited by us humans? Biblical theology is nothing if not frank, but it not only underscores the sense of moral outrage at evil in others and ourselves, but also proclaims a way out of the maze. That is through the saving acts of God in human history, consummated thus far in the incarnation, death and resurrection of Jesus Christ. For the deepest mystery of all, far exceeding the most intractable problems science has ever had to face, is that in Christ God himself identified with arrogant, self-important, power-crazed human beings; and in the Cross made open a way to their peace, with himself and with creation. In the famous words of St John lies the profoundest truth in the universe, yet their staggering simplicity conveys a welcome to the least sophisticated in society as well as to

the most learned: "For God so loved the world that he gave his only Son, that whoever believes on him shall not perish but have eternal life."[26]

But at the same time Christianity insists on a realistic appraisal of our human condition, never more directly than in the Genesis story of "the Fall".[27] Whether this be taken as a parable of all human life, or as a once-for-all historical event with far-reaching consequences for all Adam's descendants, it represents an attitude in which man and woman not merely seek for independence from God, but also question his Word and attempt to assume a Godlike authority over themselves and creation. The condition of "fallenness" involves, therefore, a mismatch between the actual and intended purpose for humanity, with the inevitable consequences of malfunction, confusion, fragmentation and even disintegration. The theological term "sin" applies to the whole global phenomenon of displacing God by man, not merely to individual lapses from the moral law. It would be surprising indeed if the Earth escaped any serious harm from this lamentable state of affairs.

Thorns and thistles

It is important to stress how easily we can project upon inanimate nature the troubles of men and women: in other words how easily we can equate "the Earth", or at least "the world", with the sum total of humanity. Although for many reasons that is obviously inadequate, parts of the physical world have often been seen as sharing in our "fallenness". Thus in earlier centuries the surface of the Earth was often considered as corrupted in some way, having lost the perfection of a primeval Golden Age. The very wildness, disorderliness and confusion of the normally inaccessible places of nature were seen as an offence. This was the sentiment behind Burnet's anxiety about the "confusion" he perceived in the Alps (pp. 22–3). In a similar way volcanic eruptions, earthquakes and floods were seen as evidence of a very imperfect Earth. So too were the production of weeds and poisonous plants, the existence of virulent pests, and the occurrence of plagues and epidemics. Frequently, of course, these phenomena were condemned because of their adverse effects on the human race. Mountainous features of the landscape in particular long remained to puzzle, challenge and haunt the imagination. The poet, Thomas Gray who so delighted in the beauties of the English Lake District (1769), was yet compelled to regard the mountains as "the reign of Chaos and old Night".[28] Speaking of the same part of Britain, as we saw in Chapter 3, Daniel Defoe objected:

SURVEYING THE PROSPECTS

> Nor were these hills high and formidable only, but they had a kind of inhospitable terror in them. Here were . . . no lead mines and veins of rich ore, as in the Peak, no coal-pits, as in the hills above Halifax, but all barren and wild – and no use or advantage either to man or beast.[29]

We probably smile at such naïveté and may be permitted to wonder whether our own welfare and comfort are of such importance as to warrant delivering to the Earth judgements of imperfection that we normally – and rightly – apply to ourselves. Anthropocentric appreciation of this kind has little part to play in yielding an understanding of the Earth.

But there is more to it than this. Theology has traditionally insisted that the Earth (and everything in it) has in some way been tainted by, and has thus shared in, the "fallenness" of humanity.[30] We human beings are therefore implicated in Earth's malaise. This is spelled out in the Genesis account of the Fall.[31] In agriculture there will now be thorns and thistles and man will reap his crops "by the sweat of his brow". Similarly woman shall know pain (as well as joy) in childbearing and there will be "enmity" between her descendants and at least part of creation. Man and woman are equally implicated and equally penalized; there is no sexism here. The important point is that creation, which must include the Earth, participates in the suffering of humanity. None put this more succinctly than the apostle Paul:

> We know that the whole creation has been groaning as in the pains of childbirth right up to the present time.[32]

The metaphor is taken directly from the experience of Eve and her daughters. But how could this be? In what way can we humans infect the Earth on which we live?

Consider first the historical and scientific evidence. Let us for the moment suppose that "the Fall" of humanity was a distinct historical event and not merely a continuing process of rebellion, disobedience, unbelief or whatever. After humanity underwent the profound moral and spiritual changes associated with that event, are there good scientific reasons for supposing that the Earth became fundamentally different or inferior? Is the imprint of human sin to be found in the rocks, the sea, the life patterns of organic nature that shares the planet with us? In all honesty the answer has to be "no". Long before man came on the scene (let alone before the Fall) the rocks yield evidence of catastrophic floods, earthquakes and volcanic eruptions. In any case volcanoes also exist on Jupiter, and no-one imagines that other planets have shared in the Earth's disgrace.

A WORLD ESTRANGED: "THE SILENT PLANET"?

We cannot, therefore, attribute physical phenomena like natural disasters simply and directly to human sin. However, it remains perfectly feasible for normal events in the physical (and biological) world to be invested with a new and dire significance for human beings who see themselves as godlike autonomous creatures, knowing better than God and certainly owing no allegiance to him. A "natural" disaster would pose a far greater threat to those who saw this life as all there is than to those with a real expectation of Heaven.

As we have seen repeatedly, physical disasters are not the only threats to the Earth and its inhabitants, for humanity itself has inflicted on the Earth some grievous wounds. The Gaian insight that man affects the world is in fact affirmed by Christian theology. We have already seen this many times over environmental pollution, over failure to engage in conservation and over a host of ecological disasters. And, as we noted in Chapter 6, we achieve this through our wanton exercise of ignorance, greed, aggressiveness and arrogance. Some of these, particularly the first and third, we share in a measure with other animals. But we display them more fully, in fact to an unprecedented degree, and with consequences unknown in the "animal world". At the *conceptual* level we fail to understand the Earth, priding ourselves at times on our very ignorance. At the *perceptual* level we often value the Earth wrongly, seeing it in terms of anthropocentric priorities, as an arena for parading our achievements or a resource to be plundered. At a *relational* level we may find ourselves victims of our sheer inability to relate adequately to our terrestrial environment, though our concepts and even our values may be correct. Tillich and others have argued that one major effect of sin has been a fundamental fragmentation of our world, most obviously including society and individual lives. How far this includes the physical cosmos is another matter. What is clear is that nature has been disrupted by human beings in the arrogant pursuit of certain specific power-goals, the essential unity of (say) the biosphere being ignored. At least to recognize this fragmentation of life as an expression of our fallenness must be one step in the right direction and in accord with the insights of ecology.

In response to human sin generally the Bible speaks of "judgement", an unpopular concept today if ever there was one. God is described as "Judge of all the Earth"[33] and he is pictured as storming the Earth,[34] forsaking the Earth,[35] and, in the very last verse of the Old Testament, smiting it with a curse.[36] At the very least such judgements may be seen as inevitable consequences of breaching the "internal grammar" of the world, just as putting one's finger in the fire is "judged" by getting it burnt. However, that deistic

position, helpful though it may be, does scant justice to the radical theism of both Testaments, in which God is seen actively involved in upholding and judging – his creation.

Thus by the most devastating abuses of the natural world, humanity has in our own times demonstrated more clearly than ever before its ability to corrupt the Earth and given new significance to the phrase "a fallen world". Yet it is possible that an even deeper meaning may be found.

Nature, red in tooth and claw

There are some aspects of life on Earth that cannot be reduced to the level of mere inconveniences to the human race, as may be many natural disasters. As we have seen in Chapter 4, earthquakes and similar catastrophes cannot be attributed to individual sin and, indeed, can be accommodated within a deeper understanding of the meaning of providence. However, the problem intensified as the apparent cruelty of "nature, red in tooth and claw" became ever more evident in the century of Darwin, with whole species succumbing to predators and the fittest surviving only after the bloodiest struggles. Was this, for them, "the best of all possible worlds"? Yet if animal death and suffering pose real difficulties for us, we are no longer in a position to attribute them to the Fall of man. The existence of carnivores before humanity is now undisputed; some fossil skeletons even contain the remains of other animals eaten as food. The fact becomes painfully clear that death is in a profound sense a natural phenomenon and there is no reason to imagine that even in the garden of Eden its presence was excluded; how else could the command "replenish the Earth" be fulfilled? In that case a deeper meaning would be given to those familiar words of Paul, "Since by man came death, by Man [Christ] came also the resurrection of the dead."[37] The death referred to would be not physical but spiritual, and the resurrection a matter not of indefinite survival on Earth but of eternal life in Heaven. The "king of terrors" has been banished – at least *in potentiam* – for the human race.

However, the prophetic vision of the wolf lying down with the lamb, of the lion eating straw like an ox, and the child at play by the adder's den[38] cannot be a mere reversal of the calamities occasioned by the Fall. As Berkhof remarks:

> In modern scientific thinking ... there is no place for the conception that an alteration and deterioration took place in man's physical nature, and in the biological world around him, as a conse-

quence of his culpability. According to our experience, death is inherent in all life. Strife and suffering belong to nature. Floods and earthquakes are part of the same reality to which majestic mountains and fertile valleys belong.[39]

In this sense, then, Polkinghorne may be right to argue that "physical evil had always existed but it had not been perceived *as evil* until humanity's appearance".[40] However, the word "always" may need some qualification. The possibility exists that in the remote depths of prehistory something happened to nature as a consequence of some act of cosmic disobedience.[41]

In the 1924 Bampton Lectures N. P. Williams spoke of a "pre-mundane Fall", before the creation of Earth, involving a hypothetical WorldSoul.[42] With masterly understatement Anthony Dyson observed "I assume that there can be in principle no historical evidence which could support" such a theory,[43] or (he might have added) could refute it. More plausible from the biblical stand-point was a suggestion that "sin . . . started with the angels", by some act of disobedience of which one of the results may have been "a disorganization of the material universe over which, according to a reasonable theory, the angels had charge".[44] There are certainly references to fallen angels in Scripture.[45] Of course those who decline to acknowledge any entities not in principle verifiable by science will refuse such explanations, as they should refuse much else. The rest of us would do well to keep an open mind on such difficult issues, but may care to note the following from C. S. Lewis:

> It seems to me, therefore, a reasonable supposition, that some mighty created power had already been at work for ill on the material universe, or the solar system, or, at least, the planet Earth, before ever man came on the scene: and that when man fell, someone had, indeed, tempted him. . . . If there is such a power, as I myself believe, it may well have corrupted the animal creation before man appeared.[46]

Or as another writer tersely put it: "we did not start this rebellion; we have been tempted into sharing it".[47] In Moltmann's words, it is "the enslaved creation that hopes for liberty".[48] The good news is that such hopes have a solid foundation. That we shall seek to lay in the final chapter.

Chapter 10

Hope for the Earth

Anyone who chooses to conclude a book of this kind with a chapter entitled "Hope for the Earth" (without even a question-mark in the title) may well be the victim of unkind thoughts. He might be imagined to be an incurable optimist, a kind of cosmic Mr Micawber waiting for something good to turn up; he might claim to have access to privileged data, unavailable to ordinary mortals; or he might be an unprincipled liar, trying to induce false euphoria much in the manner of politicians. The first two possibilities are certainly not true, nor, I hope, is the last. In fact there are two powerful reasons for exploring the possibilities of hope, first because humanity is "hungry for hope"[1], and universal hungers usually have something objective with which to satisfy them, and secondly because in the Christian Gospel there are indeed good grounds for hope. Indeed a "theology of hope"[2] is currently much in vogue.

The prospects outlined in the previous chapter force us to ask questions more fundamental than science can expect to answer, questions of value and purpose. Is the Earth, so beautiful yet so fragile, really a cosmic accident? Is it all in vain? And what of our own lives? The human spirit rebels against despair, is hungry for hope, and within science itself can find a clue to the enigma. For if the universe made no sense, showed no uniformity in nature, operated by no laws and gave increasing evidence of caprice the more we investigated it – then indeed there would be cause for nihilistic despondency of the kind espoused by Nietzsche. But the facts are all otherwise, and therein lie grounds for optimism. For in theology such regularities may find an explanation and a significance, and thus give substance to the strivings for hope within the human heart. More precisely, this hope may be located within Christian theology, "a theology of hope" that takes seriously the biblical claims of a God who was, is and will continue to be active in history. So let us explore the possibility – no more – that in the God of Christian

belief may lie the best hope for the future. To amplify and justify the claim that here indeed are grounds for optimism we can identify six propositions. As most of them raise questions of considerable weight for those with scientific inclinations we shall attempt to see whether, and in what senses, they may still be valid in our own age of science. One should point out in passing that the old idea that all religious concepts have been discredited by modern science owes more to Victorian mythology than to anything else.[3]

Intrinsic value

Proposition: The Earth is valued by God.

The picture sketched in the above chapters of an Earth fouled by human pollution and "fallen" in numerous other ways must not be seen in isolation. There are other considerations that must be taken into account, one of which is that God still values the Earth that he has made.

A contrast has often been drawn between the theology of Western and Eastern Christianity. It has been well said that the former has tended to be "world-denying", whilst the latter has been "world-affirming". The Eastern view has the Old and New Testaments on its side. There are more biblical references to Earth than to Heaven (an approximate ratio of 8:5 in the AV). Some of the Old Testament writers who first perceived the otherness of God from his creation saw also its great value to him. Thus in the book of Job we are given an idyllic picture of an Earth that is free from human interference and in which God delights.[4] The Psalms assert that "the Earth is the Lord's",[5] that it is full of God's riches,[6] his mercy,[7] his goodness[8] and his glory.[9] It was much in that spirit that the Psalmist lifted his eyes to other worlds, declaring that "The heavens declare the glory of God",[10] and that Jesus uttered his memorable injunction to consider the glory of the lilies of the field.[11]

When, with the coming of Jesus, we are told that "God so loved the world that he gave his only Son", it would be naïve indeed to equate "world" [κόσμος] with "planet Earth". Obviously much more than the planet was included: Christ was given "that all who believe in him should not perish but should have everlasting life".[12] But, equally, the planet was not *excluded*, and this is consistent with Christ's frequent references to the natural world, nearly all of which denote an affectionate familiarity with wheat, flowers, trees, seeds and fruit. His only reported miracle of judgement was on a barren fig-tree, and that tree was a failure, an anomaly and a fraud; it was not the delight that it should have been.[13] The fact is that here, and during

a storm on a lake when even the winds and waves obeyed him, as well as on numerous other occasions, he took for himself the rôle of God as Creator and Sustainer of the Earth he loved.

It is worth repeating that the Creation narratives in Genesis stress the *goodness* of all things created, including the Earth,[14] to say nothing of the delights of the first garden.[15] And as Moltmann has pointed out, the Sabbath rest of the Creator was an "ecological day of rest", when God enjoyed the Earth and all else that he had made.[16]

Creation and restoration

Proposition: God himself is active in creation/restoration.

In the Judaeo-Christian tradition God's care for the Earth is abundantly apparent in his involvement in its welfare. He is described as Most High over all the Earth,[17] Lord of the whole Earth,[18] Judge of all the Earth[19] and King of the Earth.[20] It is not Israel's God but the pagan deities who are said to be asleep, away on a journey or even relieving themselves after the manner of a man.[21] Taking only the book of Psalms, we find more explicit references to God's active care of the Earth that include the following:

- The Lord reigns . . . the World is firmly established, it cannot be moved;[22]
- Your thunder was heard in the whirlwind, your lightning lit up the world; the Earth trembled and quaked[23];
- You care for the land and water it; you enrich it abundantly;[24]
- In his hands are all the corners of the Earth and the strength of the hills is his also;[25]
- You established the Earth and it endures;[26]
- He sends his command to the Earth; his word runs swiftly. He spreads the snow like wool and scatters the frost like ashes. He hurls down hail like pebbles.[27]

To suppose that all these allusions to natural phenomena are just the rather charming anthropomorphisms of a primitive people is to miss the main thrust of the biblical narrative. Psalmists and prophets are united in attributing the maintenance of the world to a transcendent Creator. In so doing they stand in dramatic contrast to all available contemporary literature. If they are wrong, then their mistake lies not in peripheral detail but in the total world-view that underpinned Christianity as well as Judaism and, to a considerable extent, Islam.

CREATION AND RESTORATION

The sequel to the ancient story of Noah's Flood (itself an act of divine judgement) is perhaps of even greater interest. As a token of God's care and love for his creation the rainbow is invested with a new significance:

> It will be the sign of the covenant between me and the Earth. Whenever I bring clouds over the Earth and the rainbow appears in the clouds, I will remember my covenant between me and you and all living creatures of every kind. Never again will the waters become a flood to destroy all life. Whenever the rainbow appears in the clouds, I will see it and remember the everlasting covenant between God and all living creatures of every kind on the Earth.[28]

This covenant was not with humanity alone but "between me and the Earth". Nor was it merely negative, for it was accompanied with the promise:

As long as the Earth endures,
Seedtime and harvest,
Cold and heat,
Summer and winter,
Day and night
Will never cease.[29]

To speak of *the* biblical doctrine of Creation might seem more than a little simplistic, for many elements are present in Scripture, and it is not always clear how they relate to one another. Yet amongst the themes common to Old and New Testaments is this recurrent notion of a Creator who is involved continuously with his creation, not merely the once-for-all watchmaker of deistic philosophy or the "interventionist" God of the semi-deists.

For a fresh appreciation of this insight we are at least partly indebted to science. The "continuous creation" theories of Fred Hoyle and others, far from undermining biblical theology as was once feared, have enabled people to think more generally in such ways, though there is no necessary logical connection between the scientific and theological views. Much more powerful than any particular theory of cosmology was the advent of Darwinism, which sharpened the theological issues with uncomfortable precision. Charles Kingsley expressed it as well as any: now that evolution had decreased the credibility of a God who occasionally "interfered" in his creation (by inventing a new species, for example), people "have to choose between the absolute empire of accident, and a living, immanent, ever-working God".[30] It was – and is – a sobering choice: chance *versus* continuing creation.

The same expression of radical theism may be found in the New Testament, where it is given new Christological meaning. Although Christ, as second Person of the Trinity, was "in the beginning" and "through him all things were made",[31] yet he is also described as *"sustaining* all things by his powerful word".[32] Paul goes even further:

> By him [Christ] all things were created, things in heaven and on Earth, visible and invisible, whether thrones or powers or rulers or authorities: all things were created by him and for him. He is before all things, and in him all things hold together.[33]

Even this "upholding" activity of God is not all. Through Christ God so identifies with the suffering of Earth that one can legitimately speak of God's suffering with creation.[34] Not even a bargain-price sparrow falling unnoticed into the market gutter can do so "without your Father".[35] Here is mystery indeed, but here too hope for an Earth in which hope has almost died.

Human stewardship

Proposition: Human beings have an instrumental function in Earth's recovery.

At this point the proposition that we encounter commands assent outside and inside the Christian community. Even if you deny being accountable to God, you must surely accept responsibility for the wellbeing of your fellow-humans, in this and subsequent generations. And so must I. The future welfare of humanity is a *moral* issue, from whatever source our morality derives: Christianity, humanism, or whatever. The effect of panic measures, however, would be to compound the evil. Action like that taken in 1989 by a Conference of the Economic Summit Nations (G7) and the European Commission (Brussels) in framing a set of proposals on "Environmental ethics"[36] is greatly to be welcomed. So also are the numerous steps taken by the EC[37] and other international bodies.

In the light of the problems outlined in previous chapters many attempts have been made to define and codify a system of environmental ethics, as bibliographies amply testify.[38] Notable among attempts to focus precisely on the general ethical issues are books by Berry[39] and Attfield[40] and numerous shorter papers,[41] while others give an abundance of illustrative material and case studies without necessarily seeking to create a synthesis.[42] And of course there are dozens of books on specific aspects (animal rights, wilderness con-

servation, chemical control and so on). Many other more general works have large sections on environmental ethics.[43]

While all ethical systems must have some basis outside themselves, by no means all are constructed upon theological foundations. One contention of this book, however, is that in biblical theology lie important clues to ethical problems, perhaps especially so in matters of the environment. If there is any way in which God *has* spoken to humanity through Christ, to ignore such indications would be foolish in the extreme. In that sense it has been well said that "Ecological ethics . . . are the ethics of faith."[44]

Whatever theological views we may or may not hold, we cannot evade one specific challenge, that of *stewardship* of Earth's resources. There is even an etymological link between "stewardship" and "ecology" in that the latter derives from the Greek word for house or household (οικος), while a steward (οικονὁμος) was one whose responsibilities were classically over the household on behalf of his master. Today such stewardship may be conceived in terms of our responsibility to our family, to our neighbours, to posterity in general, or (most powerfully) to God himself. There are good biblical grounds for stewardship, not least in some parables of Jesus[45] but also in much Old Testament teaching about care for the land. In this connection it is worth recalling the remarks (pp. 87–8) of Calvin ("Let everyone regard himself as the steward of God" . . .) and Derham ("These things are the gifts of God, they are so many talents entrusted us by the infinite Lord of the world, a stewardship . . . "). Hope for the Earth lies at least to some extent in a widespread realization of this responsibility. Erich Sauer puts it bluntly:

> The destiny and redemption of the Earth remain indissolubly united with the existence and development of the human race. . . . *Man* is the instrument for the redemption of the earthly creation.[46]

Stewardship will work at all the levels we noticed in the previous chapter (p. 139). At a *conceptual* level it must involve great effort to understand the complex systems that operate on our planet, physical, chemical and biological. If this is correct, the need for a public understanding of science is greater than ever before in history. It is perhaps no accident that a text for an Open University course that became a public best-seller was the book *Understanding the Earth*.[47] Then at the *perceptual* level the need to value the Earth highly as a treasure committed to our trust requires an empathy with nature and a sympathy with those at the forefront of the environmental battle. Such attitudes in ourselves can be nurtured by frequent contacts with the natural

world, by intuitive insights from many sources and also by serious study of biblical teaching on the subject. Sadly, churches in the affluent West usually have such considerations almost at the bottom of their agendas. But if knowledge needs to be upgraded to values, values must be turned into action or the whole exercise is in vain. So at a *relational* level our practical strategy for relating to the Earth must be stimulated by an increased sense of responsibility and obedience to the dictates of conscience. It is precisely here that unaided and often weary human beings most commonly fail. But it is also in such circumstances that God the Holy Spirit can give to those who ask the strength to mount up with wings as eagles and accomplish much in his service.[48]

There are countless illustrations of these principles at work. One must suffice: an account by the present Director of the Royal Botanic Gardens at Kew of a search for appropriate technology in Amazonia.[49] He describes the technological assistance given by the local church to the Aymara Indians of Bolivia as a good example of "missionary earth-keeping"[50] and demonstrates how this strategy addresses problems of social injustice as well as those of agriculture and ecology. The partnership was between church and farmer, between missionaries and Amazonians, and above all between human beings and God.

Divine destiny

Proposition: Earth's destiny is part of God's purpose.

However hard we humans try to exercise responsible stewardship, or however much we fail, the eventual destiny of the Earth will be no accident. If a sovereign God exists, as the Bible proclaims and Christians fervently believe, then all history is within his control, including those bits of it in which we exercise our own freewill. Indeed the ancient people of Israel saw God as Lord of nature *because* they had first seen him as Lord of history.[51] From the days of their first deliverance from Egypt this faith nourished them as crisis after crisis befell their nation, even including the mass deportation to Babylon. The New Testament takes up the theme with the Incarnation, Crucifixion, Resurrection and all that followed and will follow to the end of time. Human *and* Earth history are unidirectional, the fulfilment of a divine plan that even the sin of humanity cannot ultimately frustrate. The notion of a cyclical cosmos, an eventual equilibrium, a kind of changeless steady state, is totally incompatible with a biblical eshcatology of hope.[52]

DIVINE DESTINY

The future of the Earth has of course been the subject of an immense volume of apocalyptic literature. That includes many passages in the Christian Bible, most of them frankly obscure to modern men and women. However, there can be no doubt as to their central theme. Whether addressed to the Christian Church, fighting for its very life in the 1st-century Roman Empire, or to the universal church, contemplating the awful prospect of men acting like gods, the message is unvaryingly the same: God, the Creator, is also the Upholder and Redeemer of the whole universe. If history is "his story", in his eternal sovereignty is ground for a true theology of hope, even of optimism. However carelessly men and women may forget their stewardship, pollute the Earth, or bid fair to destroy it, the irrepressible faith of both Jew and Christian is that "The Lord reigns."

To illustrate the point there is an interesting story of the discovery of nuclear fission in the 1930s. By any ordinary reckoning, it should have been discovered by Fermi and Segri, working in Italy at the time. Yet as one of Fermi's students commented, "God, for his own inscrutable reasons, made everybody blind at that time, to the phenomenon of nuclear fission." Had that not been the case, it is probable that an atomic bomb could have been available in either Mussolini's Italy or Hitler's Germany as early as 1939. Even the participants reckoned some divine force was holding them back.[53] It is but one illustration of many that can offer real encouragement to those who believe in a sovereign Lord in control of his creation.

Returning to the theme of unidirectional history we may be reminded of Isaiah's proclamation that "the Earth shall wax old like a garment".[54] That passage was quoted by William Thomson (Lord Kelvin) as evidence of a prophetic anticipation of the Second Law of Thermodynamics.[55] Nor is this the only biblical passage to include the heavens in a general dissolution.[56] The general picture is of a gradual unwinding of a clock, or a slow wearing out of a garment.

However, other biblical writers suggest not a whimper but a bang; for example, Peter writes:

> But the day of the Lord will come as a thief in the night; in the which the heavens shall pass away with a great noise, and the elements shall melt with fervent heat, the earth also and the works that are therein shall be burned up.[57]

Whatever may be the meaning of the literal details of these passages, it is not hard to reconcile all of them with scenarios derived from science itself. What they unequivocally show is a theological basis for the

directionality of time's arrow so far as the physical universe is concerned.

Such passages have led some recent readers to go further and identify a nuclear Armageddon as the harbinger of mass destruction. Yet we have to ask if this is how the Good News of Christianity does predict the end – the *telos* – the determinate goal of human history. To argue, as some have done, that God could never use an act of human wickedness so monstrous as atomic war, in order to consummate his purposes for the Earth, seems like dangerously arrogant speculation. It ignores the distinction between history which God produces and that which he permits, and it overlooks the Psalmist's declaration that even the wrath of man can praise him. And it puts the actor in the position of asserting what the playwright can or cannot do. Of course, a literal identification of apocalyptic language with physical phenomena can be a dangerous exercise at the best of times. But in so far as the possibility remains that nuclear explosions might bring about the end of the world, surely energies must be redoubled to ensure that the possibility does not become a certainty.

Although a nuclear holocaust could conceivably be inferred from Scripture as heralding the end of the age, it would be extremely rash to be dogmatic. Meanwhile, the implications of the theology of hope need to be worked out, not as a facile optimism, but as a measured response to the God who has acted in history through the Cross and Resurrection of Christ, and who will continue to act until the last second of time has expired.

If, then, God has a definite destiny in mind for the Earth, we can find cause for great encouragement. But it is possible to go much further. John Polkinghorne has written:

> God's purpose must be construed, not narrowly in terms of humankind alone, but in the widest possible terms embracing the whole universe.[58]

That vision of a cosmic redemption reminds us of the scale, not just of our own terrestrial dilemma, but also of the awesome love and purposes of God Almighty.

The day of the trumpet

Proposition: The Earth will welcome its Creator.

In our modern scientific age it is clear that science may *predict* the eventual fate of the Earth (as discussed in the last chapter), or it may actively help to

produce a final consummation, at least for this planet, in some kind of nuclear holocaust. Yet long predating the age of modern science is a third view of the end: a personal, visible return to Earth of the risen Jesus Christ himself. Christians have differed widely as to how or when this might be. Some – despite clear warnings not to do so[59] – have hazarded a guess at precise times and dates, and have mostly lived to regret their rashness. Often this has involved the wildest of speculative excursions through those parts of the Bible termed "apocalyptic", above all the book of Revelation, the Apocalypse itself. It was C. H. Spurgeon who said: "Only fools and madmen are positive in their interpretations of the Apocalypse".[60] This has not hindered wave after wave of fanciful interpretations, perhaps reaching their peak amongst orthodox denominations in the West just before the Second World War and now largely appropriated by sects on the fringe of orthodoxy.

Until assailed by arguments purportedly in the name of science, a belief in the Christ who would some time return to his own world has been well-nigh universal in the Christian Church. This is hardly surprising in view of the weight of biblical testimony for it (over 300 references being claimed). It therefore becomes necessary to ask whether modern science renders improbable the whole idea of a personal return of Christ.

Objections to an outmoded cosmology

At first glance it seems that science suggests the idea is not so much impossible as meaningless. Surely, it may be argued, the whole cluster of ideas centred round the Ascension and Return is based on the now discredited three-decker universe? Great play was made with this theme by John Robinson in *Honest to God* (1963).[61] An ascent to a physical heaven "up there", or a return in the opposite direction, has no conceivable place in the universe of current cosmology. In this he was following Rudolf Bultmann, who, denying a three-decker universe (and much else) in the name of modern science, embarked on his process of "demythologizing" the New Testament.[62]

The attempts to make the Gospel more accessible to our contemporaries would be more impressive if supported by evidence that modern science *had* eroded this particular model of the universe. In fact none exists, for the simple reason that the Earth-centred cosmos disappeared not in the 20th but in the 17th century. As we have seen (p. 9), Copernicus' famous *De revolutionibus* appeared in 1543, though its full impact was delayed for some years. Even then there was little theological opposition, with the regretta-

ble exception of the Galileo affair. This itself is not surprising, since, quite apart from Copernicus, influential theologians were reluctant to tie their interpretations to popular cosmology. For example, Luther and Calvin (neither of them renowned for their support of Copernicus) denied that God was confined to a restricted, spatially defined Heaven. As Calvin said,

> Because the dullness of our minds could not otherwise conceive of his [God's] ineffable glory, it is designated to us by the heaven, than which we can behold nothing more august or majestic.[63]

In modern times the Ascension story has been readily understood without the ancient model of the universe, one of the most convincing popular accounts being by C. S. Lewis.[64]

Objections derived from the size of the universe

If the abandoned three-decker universe is not a reason for disputing either the Ascension or the Return of Christ, there could still be a problem in the sheer scale of the universe as disclosed by modern science. The immensities of space and the infinite variety of objects revealed by modern telescopes could constitute a formidable difficulty. Is it credible that the whole cosmos exists for man's benefit and that its destiny is affected by the coming of Christ to one insignificant planet? It is hard to be unmoved by the simple fragility and vulnerability of our tiny home in the vast abyss of the cosmos. One must therefore repeat that there is another, more cogent reason for rejecting the argument that, because we are so small a part of a gigantic cosmos, our little planet could never be the place to which the Creator returns in majesty and judgement. This is the distinction in logic between *scale* and *value*. There is no logical reason at all for supposing that "large" means "important", any more than there is for saying "small" necessarily means "beautiful". Emotionally, the propositions are easy to accept, but not so in logic. Furthermore there is always danger in reductionism – saying that our home is *nothing but* a tiny planet in space, or that a man is *nothing but* an assembly of material particles. There is therefore a sense in which whatever science may discover about the world, nothing can diminish the significance of Earth's rôle in the Christian drama, for that rôle cannot be expressed in terms accessible to scientific enquiry.

To these more serious objections several things may be said. The problem is, of course, not new. It was raised in an acute form by much earlier speculations about the plurality of worlds. Were other parts of the universe

THE DAY OF THE TRUMPET

inhabited, or are we alone in space? The matter was discussed in the 17th, 18th and, especially, the 19th centuries[65] and is no new phenomenon forced upon us by recent scientific advances. Many Christians felt comfortable with a plurality of worlds, while others were hostile. The issue may ultimately be resolved by further scientific discovery. It now seems certain that no other planet of the solar system is so favoured (or disadvantaged). As we are now aware of countless other galaxies, each with innumerable sunlike stars, and given the size of the universe, the chances of life appearing on one or more planets must surely be considerable. At present it must be an open question. But if life were to be found "in outer space" theological alarm-bells might start ringing, to cries about a possible infinity of Incarnations, Crucifixions, Resurrections and so on.

Such alarm would be needless, and for several reasons.

1. If there is life elsewhere it does not follow that it is sentient or in any respects like our own. *Star Wars* is an unreliable guide to the possibility of quasi-human existence beyond the Earth.
2. If another race like our own were to be discovered, it would not follow that such creatures would ever have displayed the "bentness" of our own race, ever sunk to the depths of cruelty surpassing those of the "lower" animals, or ever been in need of redemption and release.
3. Even if living creatures on some planet deep in space had done all these things and had (in effect) cocked two fingers at their Creator, it is still not necessarily true that their redemption would be in the same manner as ours.

So there is little use in disturbing ourselves over contingencies that we do not even know are possible. We have quite enough to do and think about in connection with the fate of the one planet we know well, planet Earth.

As was seen in Chapter 2, even the Copernican displacement had little effect on contemporary estimates of the value and uniqueness of Earth. The sheer antiquity of this problem should warn us against ascribing a unique rôle to modern science in nourishing our religious scepticism, in respect either of the structure or of the scale of the universe.

Objections on the basis of miracle

However, there may be another way in which science casts doubt on the likelihood of a "Parousia", or personal Return of Christ to the Earth. Such an event must depend on the Resurrection of Jesus, an event claimed as the supreme miracle of Christianity. If this itself did not occur, and if Jesus is not

alive after death, there is no sense in which he could be said to "return". Here the doubters speaking in the name of science are really invoking the old objection to miracle. Underlying scepticism about both events lies the view that the world is a closed system of cause and event, as, of course, popular imagination depicts the modern scientific attitude. Such is the view of Bultmann and his followers in their attempts to demythologize the Gospel, to which three things may briefly be said in reply.

First, Thomas Torrance has criticized Bultmann's limitation of eschatology to an act of God at the end of the world (and not during our world of space and time). It is totally at variance with the whole biblical concept of an active God. As he says, it is "the antithesis of what the New Testament means, for in it, eschatology is constituted by the act of the eternal within the temporal, by the acts of God within our world of space and time".[66]

Secondly, if this New Testament picture really were irreconcilable with the scientific process, one would expect to find scientists of all kinds leading the attack on such naïve, pre-scientific mythology. In fact, the reverse is the case: many who have contributed most to the mechanical view of the universe have cheerfully embraced biblical teaching on this matter, and some have even stressed the very biblical passages that concentrate on the Return of Christ. It was Isaac Newton himself who became utterly absorbed in the study of the apocalyptic books of the Bible, asking: "If they are never to be understood, to what end did God reveal them?" Enormous volumes of his private notes survive to this day revealing his concern to know God's purpose for a world which alarmed him by its idolatry and corruptions of original Christianity as he saw it.[67]

Then, thirdly, it must never cease to surprise us that the evocation of "science" by some theologians in support of their particular views of Scripture has occurred at exactly the time that science has ceased to be so dogmatic, has recognized a little of its limitations and has left far behind such claims to pre-eminent knowledge as it ever made. To quote Torrance again:

> Theologians, historians and sociologists are often found still trapped within the cultural split between the sciences and the arts, thrown up by the nineteenth century ambivalent reaction to the mechanistic universe, and still operating in the backwater of dualist ideas long since left behind in the advance of the pure sciences.[68]

It is sometimes imagined that the Second Advent would be a kind of stab into the cosmos from outside, a rare intervention of a wrathful deity pro-

voked beyond measure by the iniquity of man, a discontinuity with all that has gone before it. But that view is a kind of latter-day deism, as incompatible with the Bible as it is with science. To reduce an argument to that level of thinking is of little service to anyone. Just as biblical writers are united in their view of the continuous creative activity of God, so the New Testament speaks only of one "Parousia", beginning at the Incarnation and completed on the last day. Only we, with the limitations of our space–time continuum, find it convenient to speak of them as two quite separate events. As Pannenberg has remarked: "If Jesus has been raised, then the end of the world has begun",[69] a process completed by the return of Christ to his own Earth.

It may be that the "Parousia" has to be interpreted in terms of the "becoming" of the process theologians, or perhaps the "omega point" of Teilhard de Chardin and his followers. Or it may be a lot simpler than that. It may also be much nearer than we think, not only because of the threat posed by science but because of the great achievements of science in communications technology allowing, probably within our generation, all men to have the Gospel preached unto them, which is one of the pre-conditions set by our Lord himself.[70] We simply do not know. However, in the evocative image of C. S. Lewis, we can be sure that, when the author comes on to the stage, that's the end of the play.

A new creation

Proposition: There will be a new creation.

And so the end of the Earth as we know it will be the climax of God's creative activity through history, the opening up in time of closed systems, and that means "the openness *par excellence* of all life systems, and hence also their eternal livingness, not their finite petrification".[71] In other words, creation is to be freed from *decay*, though as one physicist ruefully remarked:

> How that could be so, in the light of the Second Law of Thermodynamics, is a sign of the ongoing tension between the "now" and the "not yet".[72]

The symmetry between the beginning and end of history is striking, the latter symbolized by the appearance of Christ, the Second Adam. Whereas the first Adam failed, the Second Adam succeeded; the first was set to till a garden, while the Second will be head of a new creation; the first brought

death and pain (at least to his own race), but the Second brought life, and joy and immortality. How unfortunate it is that this glorious prospect has so often been hi-jacked by cranks, eccentrics and semi-heretical sects. It is frequently represented as a kind of local vindication of the Church, or as the triumph of the faithful. But as Tom Torrance has reminded us:

> God does not abandon his creation when he has saved man, for all creation, together with man, will be renewed when Christ comes again.[73]

As Paul wrote to the Church in Rome:

> I consider that our present sufferings are not worth comparing with the glory that will be revealed in us. The creation waits in eager expectation for the sons of God to be revealed. For the creation was subjected to frustration, not by its own choice, but by the will of the one who subjected it, in hope that the creation itself will be liberated from its bondage to decay and brought into the glorious freedom of the children of God. We know that the whole creation has been groaning as in the pains of childbirth right up to the present time.[74]

So a new Earth and a new Heaven will emerge, profoundly changed yet strangely related to the Earth and Heaven familiar to us today. The Resurrection body of Christ was like that: untouchable by death, unrestrained by space–time laws, yet recognizable to his friends and even bearing the marks of the nails. When we speak about "the end of the play", in one sense we are wrong: the liberation of the Earth will not be an end so much as a beginning. The story is told of Goethe, who one spring day came across a chrysalis about to be transformed into a butterfly. He cried:

> Just listen, will you, how it knocks and strives towards the light! That must be what St. Paul meant, when he speaks of the groaning of creation.[75]

Let the final word be from the Apocalypse itself, the book of Revelation. Its opening vision is of the King arriving in judgement:

> Look, he is coming with the clouds,
> And every eye will see him,
> Even those who pierced him,
> And all the peoples of the Earth will mourn because of him.
> So shall it be! Amen.[76]

A NEW CREATION

We then are given a bird's-eye view of the whole panoply of Christian history until the book reaches its climax:

> Then I saw a new heaven and a new Earth, for the first heaven and the first Earth had passed away.

A vision of the redeemed Church of Christ leads the prophet to proclaim:

> And I heard a loud voice from the throne saying, "Now the dwelling of God is with men, and he will live with them. They will be his people, and God himself will be with them and be their God. He will wipe every tear from their eyes. There will be no more death or mourning or crying or pain, for the old order of things has passed away."
>
> He who was seated on the throne said, "I am making everything new!" Then he said, "Write this down, for these words are trustworthy and true."
>
> He said to me: "It is done. I am the Alpha and the Omega, the Beginning and the End. To him who is thirsty I will give to drink without cost from the spring of the water of life. He who overcomes will inherit all this, and I will be his God and he will be my son."[77]

Here indeed is hope for the Earth; hope for suffering, captive, longing humanity! And here, meanwhile, is challenge enough for all who can embrace this hope and can open mind and heart to the gracious purposes of God for his creation.[78] By demonstrating genuine environmental concern as part of its ministry the Church may yet fulfil the age-old prophetic word to "prepare the Way of the Lord". No steward ever worked harder than when he knew his master was on his way. But inseparable from such labour goes the task of proclamation:

> Tidings of a new creation
> to an old and weary Earth,[79]

for at the very heart of Christianity lies that ringing message of imperishable hope.

Notes

Chapter 1

1. J. M. Templeton in John Marks Templeton and James Ellison (eds), *Riches for the mind and spirit* (San Francisco, HarperCollins, 1990), p. 209.
2. Recent books include F. Schaeffer, *Pollution and the death of man: the Christian view of ecology* (London, Hodder & Stoughton, 1970); R. J. Berry, *Ecology and ethics* (London, Inter-Varsity Press, 1972); L. Wilkinson (ed.), *Earth keeping: Christian stewardship of natural resources* (Grand Rapids, Eerdmans, 1980); R. Elsdon, *Bent world* Leicester, Inter-Varsity Press, 1981); R. Moss, *The Earth in our hands* (Leicester, Inter-Varsity Press, 1982); K. Innes, *Caring for the Earth*, Grove Ethical Studies 66 (Nottingham, Grove,1987); Science, Religion and Technology Project (Church of Scotland) Report, *While the Earth endures: a report on the theological and ethical considerations of responsible land-use in Scotland* (Edinburgh, 1986).
3. Fairly early papers of a general kind include R. J. Berry, Alternatives and accusations in Christians' attitudes to the environment, *Faith and Thought* **102**, 1975, pp. 131–50, and E. D. Cook, Theological aspects of ecology, *ibid.*, pp. 184–96; more recent papers include R. Elsdon, A still-bent world: some reflections on current environmental issues, *Science and Christian Belief*, **1**, 1989, pp. 99–121; D. A. Hay, Christianity in the global greenhouse, *Tyndale Bulletin*, **41**, 1990, pp. 109–27; R. J. Berry, Christianity and the environment, *Science and Christian Belief*, **3**, 1991, pp. 3–14; and M. Stanton and D. Guernsey, Christians' ecological responsibilities: a theological introduction and a challenge, *Perspectives in Science and Christian Faith*, **45**, 1993, pp. 1–7.
4. For overviews see also J. McPherson, Ecumenical discussion of the environment 1966–1987, *Modern Theology*, **7**, 1991, pp. 363–71, and references therein; R. J. Berry, A bibliography on environmental issues, *Science and Christian Belief*, **3**, 1991, pp. 15–18; and *Evangelical Theological Review*, **17**, 1993, the whole issue being devoted to "Evangelicals and the environment: theological foundations of environmental stewardship".

NOTES

5. Lynn White, The historic roots of our ecologic crisis, *Science*, **155**, 1967, pp. 1203–7.

Chapter 2

1. e.g. References to "pillars of the earth" (as 1 Samuel 2: 8) and to subterranean waters (as Genesis 8: 2, Psalms 24: 2 and 136: 6).
2. On early cosmology see, e.g., B. Farrington, *Greek science* (London, Penguin, 1953); G. de Santillana, *The origins of scientific thought* (New York, Mentor, 1961).
3. Farrington, *Greek Science*, p. 79.
4. C. Kaiser, *Creation and the history of science* (London, Marshall Pickering, 1991), pp. 12–15.
5. D. S. Wallace-Hadrill, *The Greek patristic view of nature* (Manchester, Manchester University Press, 1968), p. 104.
6. For theological reactions to events associated with "the Copernican revolution" see, e.g., R. Hooykaas, *Religion and the rise of modern science* (Edinburgh, Scottish Academic Press, 1973); D. C. Goodman and C. A. Russell (eds), *The rise of scientific Europe 1500–1800* Sevenoaks, Hodder & Stoughton, 1991).
7. e.g. C. E. Hummel, *The Galileo connection* (Downers Grove, Illinois, Inter-Varsity Press, 1986, pp. 80–125); P. Redondi, *Galileo: heretic*, tr. R. Rosenthal Princeton, Princeton University Press, 1987); M. A. Finocchiaro, *The Galileo affair: a documentary history* (Berkeley, University of California Press, 1989).
8. Galileo Galilei, Letter to the Grand Duchess Christina (1615), in Finocchiaro, *The Galileo affair*, p. 96.
9. J. Kepler, *Epitome of Copernican astronomy* (1618–21), tr. C. G. Wallis, *in Great books of the Western world* (Chicago, Encyclopaedia Britannica Inc., 1952), vol. xvi, p. 869.
10. R. Hooykaas, The impact of the Copernican transformation in *The "conflict thesis" and cosmology*, Open University Course AMST 283, (Milton Keynes, Open University Press, 1974), Block I, p. 67.
11. J. H. Brooke, *Science and religion: some historical perspectives* (Cambridge, Cambridge University Press, 1991), pp. 85–6.
12. Kepler, *Epitome*, p. 916.
13. H. and H. A. Frankfort, in H. Frankfort *et al.*, *Before philosophy* (Harmondsworth, Penguin, 1951), p. 257.
14. *Ibid.*, p. 258.
15. R. C. Dales, The de-animation of the heavens in the middle ages, *Journal of the History of Ideas*, **41**, 1980, pp. 531–50.
16. Kaiser, *Creation and the history of science*, pp. 12–15.
17. Augustine, *Liber retractionum*, cited in Dales, The de-animation, p. 533.
18. Jeremiah 7: 18.

NOTES

19. Isaiah 66: 1; Matthew 5: 35.
20. Francis of Assisi, *Song of the creatures* (1225), tr. Matthew Arnold.
21. G. K. Chesterton, *St Francis of Assisi* (London, Hodder & Stoughton, 1926), p. 104.
22. See, e.g., J. Godwin, *Robert Fludd: Hermetic philosopher and surveyor of two worlds* (Boulder, Shambhala, 1979).
23. N. Copernicus, Preface to *De revolutionibus* (1543), tr. C. G. Wallis, *Great books of the Western world* (Chicago, Encyclopaedia Britannica Inc., 1952), vol. xvi, p. 508.
24. William Gilbert, *De magnete* (1600), tr. P. F. Mottelay, in *Great books of the Western world* (Chicago, Encyclopaedia Britannica Inc., 1952), vol. xxviii, p. 104.
25. H. Butterfield, *The origins of modern science 1300–1800* (London, Bell, 1950), p. viii.
26. E. J. Dijksterhuis, *The mechanization of the world-picture* (Oxford, Clarendon Press, 1961).
27. R. Boyle, *A disquisition about the final causes of natural things* (London, 1688), p. 36.
28. See R. Hooykaas, *Religion and the rise of modern science* (Edinburgh, Scottish Academic Press, 1972), *passim*; C. A. Russell, *Cross-currents: interactions between science and faith* (Leicester, Inter-Varsity Press, 1985), pp. 54–79; Brooke, *Science and religion*, pp. 117–51.
29. Cited in R. S. Westman and J. E. McGuire, *Hermeticism and the scientific revolution* (Los Angeles, Clark Memorial Library, University of California, 1977), p. 41.
30. H. Miller, *The testimony of the rocks* (Edinburgh, W. P. Nimmo, 1881), pp. 348–82.
31. T. H. Huxley, *Proceedings of the Royal Institution*, **2**, 1856, pp. 193.
32. See O. Stanley, Huxley's treatment of "Nature", *Annals of Science*, **18**, 1957, pp. 120–27.
33. The fact that this is a giant leap of faith, comparable with that taken by a Christian believer, does not, of course, minimize its potential threat.
34. W. Osborne Greenwood, *Christianity and the mechanists* (London, Religious Book Club), 1942.
35. e.g., F. H. T. Rhodes in D. M. McKay (ed.), *Christianity in a mechanistic universe*, (London, Inter-Varsity Fellowship), 1965, pp. 11–48.
36. See, e.g., A. R. Peacocke, *Creation and the world of science* (Clarendon Press, 1979), *passim*.
37. D. M. McKay, *The clockwork image: a Christian perspective on science* (Leicester, Inter-Varsity Press, 1974).
38. J. Polkinghorne, *Science and creation: the search for understanding* (London, SPCK, 1988); *Reason and reality: the relationship between science and theology* (London, SPCK, 1991).
39. Russell, *Cross-currents*, pp. 56–64; Hooykaas, *Religion and the rise of modern science*, pp. 13–19.

NOTES

40. C. S. Lewis, *Miracles*, 8th impression (London, Fontana, 1982), p. 110.

Chapter 3

1. D. Bebbington, *Patterns in history*, (Leicester, Inter-Varsity Press, 1979), pp. 21–42.
2. This was imagined by the Egyptians to correspond to the time when "wandering" and "fixed" years coincide, i.e. after 1,470 "fixed years".
3. Ecclesiastes 1: 4–7, 9.
4. See Bebbington, *Patterns in history*, chs 2 and 3.
5. E. Frank (1945), cited in J. Baillie, *The belief in progress* (London, Oxford University Press, 1950), p. 79.
6. G.L. Davies, The concept of denudation in seventeenth-century England, *Journal of the History of Ideas*, **27**, 1966, pp. 278–84.
7. See N. Cohn, *The pursuit of the millennium* (London, Temple Smith, 1970).
8. Cited in Marjorie Hope Nicholson, *Mountain gloom and mountain glory* (Ithaca, New York, Cornell University Press, 1959), pp. 102–3.
9. I. H. Murray, *The Puritan hope* (Edinburgh, Banner of Truth Trust, 1975), p. 48.
10. As Basil Willey reminds us, B. Willey, *The eighteenth-century background* (Harmondsworth, Penguin, 1972), p. 33.
11. John Donne, poem The anatomie of the world (1633), lines 300–02.
12. John Donne poem, The anniversarie (1633), lines 7–8.
13. A concise historical account, sympathetic to "Flood geology", is B. C. Nelson, *The Deluge story in stone: a history of Flood theory in geology* (Minneapolis, Bethany Fellowship, 1968).
14. 128–79 (for a variety of opinions, mainly conservative); J. C. Whitcomb and H. M. Morris, *The Genesis flood* (Philadelphia, Presbyterian and Reformed Pub. Co., 1968) (for the diluvialist position); D. R. Siemens Jr, Some relatively non-technical problems with flood geology, *Perspectives in Science and Christian Faith*, **44**, 1992, pp. 169–74, and More problems with flood geology, *ibid.*, pp. 228–35 (for a strong critique of diluvialism from a fairly conservative stand-point).
15. Sermon on "Original Sin" in J. Wesley, *Sermons on several occasions*, First Series, reprint (London, Epworth Press, 1967), p. 504.
16. T. Burnet, *The theory of the earth* (London, 1684), pp. 144–5.
17. See Nicholson, *Mountain gloom and mountain glory*, pp. 212–24.
18. Burnet, *The theory of the earth*, p. 140.
19. Blaise Pascal, *Pensées*, II, 145.
20. E. L. Tuveson, *Millennium and Utopia* (New York, Harper & Row, 1964), p. 152.
21. Job 14: 18–19.
22. Isaiah 24: 1–4.
23. Psalm 102: 25–6.

NOTES

24. G. L. Davies, The eighteenth-century denudation dilemma and the Huttonian theory of the earth, *Annals of Science*, **22**, 1966, pp. 129–38 (138).
25. P. Townby and L. Whibley (eds), *Correspondence of Thomas Gray*, vol. III (Oxford, Clarendon Press, 1971), p. 1088 (letter of 1769).
26. D. Defoe, *A tour through the whole island of Great Britain* (1724–6), Everyman Edition (London, Dent, 1962), vol. II, p. 269.
27. Herbert Croft, *Some animadversions upon a book intituled "the Theory of the Earth"* (London, 1685), Preface and pp. 38 and 183.
28. D. Kubrin, Newton and the cyclical cosmos: providence and the mechanical philosophy, *Journal of the History of Ideas*, **28**, 1967, pp. 325–46.
29. See G. N. Cantor, Revelation and the cyclical cosmos of John Hutchinson, in L. J. Jordanova and R. Porter (eds), *Images of the earth* (Chalfont St Giles, British Society for the History of Science, 1979), pp. 3–22.
30. See R. Porter, *The making of geology* (Cambridge, Cambridge University Press, 1980), ch. 3 (The re-creation of the Earth), pp. 62–90.
31. G. L. Davies, *The earth in decay: a history of British geomorphology 1578–1878*, (London, Macdonald, 1969).
32. G. L. Davies, The concept of denudation in seventeenth-century England, *Journal of the History of Ideas*, **27**, 1966, pp. 278–84 (280–1).
33. See Nicholson, *Mountain gloom and mountain glory*, p.99.
34. e.g. R. Hooykaas, *Religion and the rise of modern science* (Edinburgh and London, Scottish Academic Press, 1973).
35. On the history of natural theology generally see J. H. Brooke, *Science and religion: some historical perspectives* (Cambridge, Cambridge University Press, 1991), pp. 192–225 and 380–6.
36. Thomas Robinson, *An essay towards a natural history of Westmorland and Cumberland* (London, 1709), pp. 3–4.
37. W. Derham, *Physico-theology*, 4th edn (London, 1716), p. 71.
38. Defoe, *A tour*, vol. II, p. 269.
39. John Ray, *The Wisdom of God manifested in the works of creation*, 3rd edn (London, 1701), pp. 91, 222–3.
40. Croft, *Some animadversions*.
41. J. Keill, *An examination of Dr Burnet's 'Theory of the Earth'* (Oxford, 1698), pp. 31–3.
42. John Whitehurst, *An inquiry into the original state and formation of the earth* (London, 1778), p. 17.
43. J. Hutton, *Transactions of the Royal Society of Edinburgh*, 1798, 1.
44. M. J. S. Rudwick, The shape and meaning of earth history, in D. C. Lindberg and R. L. Numbers (eds), *God and nature: historical essays on the encounter between Christianity and science* (Berkeley, University of California Press, 1986), pp. 296–321.
45. J. Playfair, *Illustrations of the Huttonian theory of the earth* (1802).
46. Thomas Burnet, *The theory of the earth* (London, 1684), Preface.

NOTES

47. D. S. Wallace-Hadrill, *The Greek patristic view of nature* (Manchester, Manchester University Press, 1968), p. 17.
48. *Ibid.*
49. Nevertheless a "young Earth" is a cornerstone of most modern "creationist" theories.
50. J. Lamarck, *Hydrogeology* (1802), tr. A. V. Carozzi (Urbana, University of Illinois Press, 1964), p. 61.
51. A. Sedgwick, *Proceedings of the Geological Society*, **1**, 1831, pp. 313.
52. See V. P. Marston, Science, methodology and religion in the work of Adam Sedgwick, Open University Ph.D. thesis, 1984.
53. J. Clerk Maxwell, letter to Bishop of Gloucester and Bristol, 1876, in L. Campbell and W. Garnett, *Life of James Clerk Maxwell* (London, 1882), p.394.
54. See J. D. Burchfield, *Lord Kelvin and the age of the earth* (London, Macmillan, 1975).
55. W. Thomson, On a universal tendency in nature to the dissipation of mechanical energy, *Philosophical Magazine*, **4**, 1852, pp. 304–6.
56. Isaiah 51: 6 (AV).
57. See C. W. Smith, Natural history and thermodynamics: William Thomson and "The dynamical theory of heat", *British Journal for the History of Science*, **9**, 1976, pp. 293–319; William Thomson and the creation of thermodynamics, 1840–1855, *Archives of the History of the Exact Sciences*, **16**, 1977, pp. 231–88.
58. S. P. Thompson, *The life of William Thomson, Baron Kelvin of Largs* (London, Macmillan, 1910), vol. I, p. 246.

Chapter 4

1. B. Ward, *Space ship Earth* (London, Hamilton, 1966).
2. David Attenborough, *The living planet* (London, Guild Publishing, 1984), p. 308.
3. For a recent overview, see D. Alexander, *Natural Disasters* (London, UCL Press, 1993).
4. Genesis 6–8.
5. C. L. Woolley, *The Times*, 15 March 1929; *Ur of the Chaldees* (Harmondsworth, Penguin, 1938), pp. 24–5.
6. e.g. M. Mallowan, Noah's Flood reconsidered, *Iraq*, **26**, 1964, pp. 62–82.
7. L. Mayer and D. Nash (eds), *Catastrophic flooding* (Boston, Allen & Unwin, 1987).
8. V. R. Baker and J. E. Costa, in Mayer and Nash, *ibid*, pp. 10–13.
9. Genesis 9: 12–17; the rainbow was at that time invested with a new, symbolic significance, a perpetual reminder *to all humanity* (not merely the people of Israel) of the great Covenant.
10. R. A. Warrick, Volcanoes as a hazard: an overview, in P. D. Sheets & D. K. Grayson (eds), *Volcanic activity and human ecology* (New York, Academic Press, 1979), pp. 161–94.

NOTES

11. See *Nature*, **361**, 1993, p. 193; with the kind permission of Geoff's widow, Evelyn, the lecture on which this chapter is based was dedicated to his memory, a tribute to a distinguished and courageous colleague.
12. B. F. Houghton, *Geyserland: a guide to the volcanoes and geothermal areas of Rotorua* (Lower Hutt, New Zealand, Geological Society of New Zealand, 1982).
13. I am indebted to Professor Bob White for first drawing my attention to this eruption.
14. S. Thorarinsson in Sheets and Grayson (eds), *Volcanic activity*, pp. 150–6.
15. B. Franklin, Meteorological imaginations and conjectures, *Memoirs of the Manchester Literary and Philosophical Society*, **2**, 1785, pp. 373–7 (375–6) (communicated 22 December 1784).
16. Article Earthquake in *New Illustrated Bible Dictionary* (Leicester, Inter-Varsity Press, 1980).
17. Exodus 19: 18.
18. Genesis 19: 24; Amos 4: 11.
19. Joshua 6: 20.
20. A. Nur, And the walls came tumbling down, *New Scientist*, 6 July 1991, pp. 45–8.
21. Matthew 27: 51.
22. Acts 16: 26.
23. See, e.g., C. Vita-Finzi, *Recent earth movements: an introduction to neotechtonics* (London, Academic Press, 1986).
24. Data from B. A. Bolt, *Earthquakes* (New York, W. H. Freeman, 1988), p. 6.
25. R. S. Stein, G. C. P. King and J. Lin, *Science*, **258**, 1992, pp. 1328–32.
26. Data from Bolt, *Earthquakes*, pp. 224–6, 236–7.
27. C. J. Humphreys, The Star of Bethlehem – a comet in 5 BC – and the date of the birth of Christ, *Quarterly Journal of the Royal Astronomical Society*, **32**, 1991, pp. 389–407; it is suggested that the Magi had been previously alerted by a triple conjunction of Saturn and Jupiter (7 BC) and a massing of those two planets with Mars (6 BC).
28. H. G. Wells, *In the days of the comet* (1906) (London, Collins, 1954).
29. D. W. Hughes, The influx of comets and asteroids to the Earth, *Philosophical Transactions of the Royal Society*, **A303**, 1981, pp. 353–8.
30. B. G. Marsden, *The Times*, 30 October 1992.
31. G. F. Zimmer, The use of meteoric iron by primitive man, *Journal of the Iron and Steel Institute*, **94**, 1916, pp. 306–49.
32. e.g. the poem by John Donne beginning "Goe and catche a falling starre" (1633).
33. Thus John Evelyn, having just observed a meteor in 1685, confided to his *Diary* the following fears: "What this may portend (for it was very extraordinary) God only knows; but such another phenomenon I remember I saw . . . about the trial of the great Earl of Strafford, preceding our bloody Rebellion" (modernized spelling) (cited in A. J. Meadows, *The high firmament* (Leicester, Leices-

NOTES

ter University Press, 1969), p. 115).
34. Brewer's *Dictionary of phrase and fable* (2nd edn 1894), (New York, Avenel Books, 1978), p. 444.
35. On meteorites generally see J. C. Burke, *Cosmic debris: meteorites in history* (Berkeley, University of California Press, 1986).
36. H. J. Melosh, Tunguska comes down to Earth, *Nature*, **361**, 1993, pp. 14–15.
37. W. G. Hoyt, *Coon Mountain controversies* (Tucson, University of Arizona Press, 1987).
38. T. J. Ahrens and A. W. Harris, Deflection and fragmentation of near-Earth asteroids, *Nature*, **360**, 1992, pp. 429–33.
39. P. Dodson and L. P. Tatarinov, Dinosaur extinction, in D. B. Weishampel, P. Dodson and H. Osmólska, *The dinosauria* (Berkeley, University of California Press, 1992), pp. 55–62.
40. L. W. Alvarez, W. Alvarez, F. Asaro and H. W. Michel, Extra-terrestrial cause for Cretaceous and Tertiary extinction, *Science*, **208**, 1980, pp. 1095–108.
41. W. Alvarez et al., Impact theory of mass collisions and the invertebrate fossil record, *Science*, **223**, 1984, pp. 1135–41.
42. Alvarez *et al.*, Impact theory, pp. 1135–41.
43. K. J. Hsü et al., Mass mortality and its universal consequences, *Science*, **216**, 1982, pp. 249–56.
44. Dodson and Tartarinov, Dinosaur Extinction, p. 57.
45. For a review of meteorite constitution see S. F. Mason, *Chemical evolution* (Oxford, Clarendon Press, 1991), pp. 85–96.
46. H. C. Urey, Biological materials in meteorites: a review, *Science*, **151**, 1966, pp. 157–66.
47. B. Nagy, *Carbonaceous meteorites* (Amsterdam, Elsevier, 1975).
48. H. C. Urey, On the early chemical history of the Earth and the origins of life, *Proceedings of the National Academy of Sciences*, **38**, 1952, pp. 351–63.
49. S. C. Miller, Production of some organic compounds under possible primitive Earth conditions, *Journal of the American Chemical Society*, **77**, 1955, pp. 2351–68.
50. M. Engel and B. Nagy, Distribution and enantiomeric composition of amino acids in the Murchison meteorite, *Nature*, **296**, 1982, p. 837.
51. A recent corroboration of the standard view came from analyses of calcium carbonate near fossil tree roots. It seems that in the warm Cretaceous periods the CO_2 level was about six times its present value, while cold periods of prehistory seem to have been preceded by times of massive CO_2 removal (as in the formation of the coal-forests): T. Appenzeller, Searching for clues to ancient carbon dioxide, *Science*, **259**, 1993, pp. 908–9.
52. Tyler Volk, When climate and life finally devolve, *Nature*, **360**, 1992, p. 707.
53. Bolt, *Earthquakes*, pp. 155–79.
54. By mid-November 1993, no such event had occurred.
55. Richard Dale, TV programme *QED* on BBC1, 14 April 1993.
56. On "earthquake-proof" buildings generally see D. J. Dowick, *Earthquake resist-*

NOTES

ant design (Chichester, England, John Wiley, 1977); K. H. Jacob and C. J. Turkstra (eds), Earthquake hazards and the design of constructed facilities in the Eastern United States, *Annals of the New York Academy of Sciences*, **558**, 1989, especially numerous papers on pp. 262–453.
57. Ahreus and Harris, Deflection and fragmentation, p. 433.
58. Volk, When climate and life, p. 707.
59. M. Cross, Recycling the greenhouse effect, *The Independent*, 5 April 1993, p. 16.
60. Genesis 1: 28.
61. Cartoon in *Punch*, 7 February 1934, p. 163.
62. Luke 13: 4.
63. Job 40: 4–5; 42: 1–6.
64. Job 38: 1.
65. Bill McKibben, *The end of nature* (Harmondsworth, Penguin, 1990), pp. 69–70, 71.
66. A. Farrer, *A science of God?* (London, Bles, 1966), pp. 87–8.
67. *Ibid*, p. 90.
68. J. Wesley, *Works* (London, 1812), vol. XI, pp. 403–96.
69. J. Wesley, hymn Thee will I love (1739), from J. Scheffler (1657).

Chapter 5

1. Revelation 7: 3 (AV).
2. An early example is J. S. Collis, The triumph of the tree (1950), reprinted in his *A vision of glory* (London, Charles Knight, 1972), pp. 157–237.
3. For continuation of this theme see K. Thomas, *Man in the natural world, changing attitudes in England 1500–1800* (Harmondsworth, Penguin, 1984).
4. Hosea 4: 13; Deuteronomy 16: 21; Ezekiel 6: 13 etc.
5. 1 Kings 5: 6–10 etc.
6. Hosea 14: 6.
7. Psalm 96: 12; 148: 9 etc.
8. Joel 1: 12, 19.
9. 2 Kings 3: 19, 25.
10. Jonah 4: 5–8.
11. Ezekiel 20: 47; Luke 3: 9.
12. Deuteronomy 20: 19–20.
13. Habakkuk 2: 17 (GNB).
14. Revelation 9: 20–1.
15. Revelation 8: 7, 8–9, 10–11, 12–13; 9: 3–6, 15–19.
16. See P. D. Moore, The exploitation of forests, *Science and Christian Belief*, **2**, 1990, pp. 131–40; J. Evans, Use and abuse of tropical forests, *ibid.*, 141–4; G. T. Prance, Appropriate technology and Christian belief: a case study of Amazonia,

NOTES

ibid., **5**, 1993, pp. 5–17.
17. S. Boyle and J. Ardill, *The greenhouse effect: a practical guide to the world's changing climate* (Sevenoaks, Hodder & Stoughton, 1989), pp. 115–16.
18. The literature on this subject is vast, and includes: Boyle and Ardill *ibid.*; H. Schneider, *Global warming: are we entering the Greenhouse Century?* (Cambridge, Lutterworth, 1984); D. J. Pullinger (ed.), *With scorching heat and drought? A report on the greenhouse effect*, SRT Project (Edinburgh, Church of Scotland, 1989).
19. J. Houghton, in Report of Ciba Foundation's First Annual Debate (on the greenhouse effect), Sheffield, 11 September 1989, in *Ciba Foundation Bulletin*, **24**, 1989, p. 3.
20. Taken from Pullinger, *Scorching heat*, p. 12.
21. T. Loftas, The oceans have become the sinks of the world, *Ceres*, **5**, 1972, pp. 35–9.
22. See R. Gambell, Whaling – a Christian position, *Science and Christian Belief*, **2**, 1990, pp. 15–24.
23. E. Walford, *Old and new London* (London, Cassell, n.d. [*c.* 1880]), vol. v, p. 238.
24. P. Brimblecombe, *The big smoke: a history of air pollution in London since medieval times* (London, Methuen, 1987).
25. *Punch*, **29**, 1855, p. 26.
26. Lynn White Jr, The historical roots of our ecologic crisis, *Science*, **155**, 1967, pp. 1203–7.
27. See, e.g., W. A. Campbell, *The chemical industry* (London, Longman, 1971).
28. R. A. Smith, On the air of towns, *Memoirs of the Chemical Society*, **11**, 1859, pp. 196–235.
29. R. A. Smith, *Air and rain – the beginnings of a chemical climatology* (London, Longmans, 1872).
30. E. Suess, *Die entstehung der Alpen* (Wien, Braumüller, 1875).
31. G. B. Kauffman, Biosphere pioneer, *The World and I*, **6**, 1991, pp. 316–23.
32. S. A. Arrhenius, *Philosophical Magazine*, **41**, 1896, pp. 237–75.
33.
 pollution 2nd ed. (London, Royal Society of Chemistry, 1992); J. A. G. Drake (ed.), *The chemical industry – friend to the environment?* (Cambridge, Royal Society of Chemistry, 1992).
36. The term was recently applied by the UK media to certain poisonous constituents of rotting apples (such as the natural product patulin) which had been unwittingly transmitted into apple juice! The problem had nothing whatever to do with the chemical industry or any of its products.
37. K. Warren, *Chemical foundations: the alkali industry in Britain to 1926* (Oxford, Clarendon Press, 1980).
38. In chemical terms the processes were:
 $2NaCl + H_2SO_4 = Na_2SO_4 + 2HCl$;
 $Na_2SO_4 + 4C + CaCO_3 = Na_2CO_3 + CaS + 4CO$.
39. A. E. Dingle, The monster nuisance of all: landowners, alkali manufacturers,

NOTES

40. From D. P. Laxen and M. J. R. Schwar, *'Acid rain' and London*, (London, GLC, 1985), p. 4.
41. See R. W. Johnson and G. E. Graham, *The chemistry of acid rain* (American Chemical Society Symposium Series no. 349 (Washington, American Chemical Society, 1987); B. J. Mason, *Acid rain: its causes and effects on inland waters* (Oxford, Clarendon Press, 1992).
42. R. M. Harrison and D. P. H. Laxen, *Lead pollution: causes and control* (London, Chapman & Hall, 1981); M. Rutter and R. R. Jones, *Lead versus health: sources and effects of low level lead exposure* (Chichester, England, John Wiley, 1983).
43. R. Carson, *Silent spring* (Harmondsworth, Penguin, 1962).
44. N. Dudley, *This poisoned earth: the truth about pesticides* (London, Piatkus, 1987).
45. For an early response see J. Thomson and D. C. Abbott, *Pesticide residues: history, alternatives and analysis*, Royal Institute of Chemistry Lecture Series, 1966, no. 3 (London, Royal Institute of Chemistry, 1966).
46. R. M. Sharpe and N. E. Shakkebaek, Are oestrogens involved in falling sperm counts and disorders of the male reproductive tract?, *Lancet*, **341**, 1993, pp. 1392–5.
47. From G. J. Marco, R. M. Hollingworth and W. Durham (eds), *Silent Spring revisited* (Washington DC, American Chemical Society, 1987), p. 164
48. T. H. Jukes, DDT, bystander or participant?, *Nature*, **259**, 1976, p. 443.
49. T. M. Sugden and T. Flint (eds), *CFCs in the environment* (Chichester, Horwood (for the Society of Chemical Industry), 1980).
50. R. P. Wayne, Punching a hole in the stratosphere, *Proceedings of the Royal Institution*, **61**, 1989, pp. 13–49.
51. J. C. Farman, B. G. Gardiner and J. D. Shanklin, Large losses of total ozone in Antarctica reveal seasonal ClO_x/NO_x interaction, *Nature*, **315**, 1985, pp. 207–10.
52. J. A. Pyle and J. C. Farman, Antarctic chemistry to blame, *Nature*, **329**, 1987, pp. 102–3.
53. M. Chipperfield, Satellite maps ozone destroyer, *Nature*, **362**, 1993, pp. 592–3; J. Waters *et al.*, *ibid.*, 597–602.
55. From Boyle and Ardil, *Greenhouse effect*, p. 15.
54. Report Air pollution and the chemical industry, *Chemical Age*, **77**, 1957, pp. 369–70.
56. P. J. Morris and C. A. Russell, *Archives of the British chemical industry 1750–1914: a handlist*, British Society for the History of Science Monograph no. 6, (Faringdon, British Society for the History of Science, 1988), p. 171.
57. B. Wynne, *Rationality and ritual: the Windscale inquiry and nuclear decisions in Britain*, British Society for the History of Science Monograph no. 3, (Chalfont St Giles, British Society for the History of Science, 1982).
58. *Report* of National Radiological Protection Board, 1983.
59. P. A. H. Saunders, BEIR [Biological effects of ionising radiation] III, *Atom*, 1980, pp. 268–70; Genetic effects of ionising radiation, *ibid.*, 1981, pp. 146–51; The

effects of radiation on man, *ibid.*, 198–202.
60. Chernobyl: lessons to be learned, *Chemistry in Britain*, **22**, 1986, pp. 506–7 (507).
61. *Chernobyl*, pamphlet from the Central Electricity Generating Board, 1986.
62. For the most recent analysis of the subject see F. Warner and R. M. Harrison, *Radioecology after Chernobyl* (Chichester, England, John Wiley, 1993).
63. I. Welsh, The NIMBY syndrome: its significance in the history of the nuclear debate in Britain, *British Journal for the History of Science*, **26**, 1993, pp. 15–32 (32).
64. P. E. Hodgson, *Our nuclear future?* (Belfast, Christian Journals, 1983), p. 131.
65. Revelation 6: 4–8.
66. Revelation 6: 15.

Chapter 6

1. R. A. Maduro and R. Schauerhammer, *The holes in the ozone scare* (Washington, 21st Century Science Associates, 1992); see also *New Zealand Herald*, 30 December 1992, p. 3.
2. J. Gribbin, *New Scientist*, 13 February 1993, p. 16.
3. M. Oppenheimer, Stratospheric sulphate production and photochemistry of the Antarctic circumpolar complex, *Nature*, **328**, 1987, pp. 702–4.
4. See, e.g., J.-C. Pecker and S. K. Runcorn (eds), *The earth's climate and variability of the sun over recent millennia: geophysical, astronomical and archaeological aspects* (London, Royal Society, 1990).
5. R. S. Webb and J. T. Overpeck, *Nature*, **361**, 1993, pp. 497–8.
6. N. E. Borlaug, Ecology fever, *Ceres (FAO Review)*, **5**, 1972, pp. 21–5.
7. R. Boardman, *Pesticides in world agriculture* (London, Macmillan, 1986).
8. G. J. Marco, R. M. Hollingworth and W. Durham, Many roads and other worlds, in *Silent Spring revisited* (Washington, American Chemical Society, 1987), p. 198.
9. C. A. Russell, Taking the waters: chemistry and domestic water supply in Victorian Britain, in M. Fetizon and W. J. Thomas (eds), *The role of oxygen in improving chemical processes* (Cambridge, Royal Society of Chemistry, 1993), PP. 174–87.
10. C. Hamlin, *A science of impurity: water analysis in nineteenth century Britain* (Bristol, Hilger, 1992).
11. R. A. McCance, *Medical Research Council Special Report* no. 275, 1951, 21 (cited in Magnus Pike, *Food, chemistry and nutrition,* Royal Institute of Chemistry Lectures, Monographs and Reports, 1954 no. 5 (London, Royal Institute of Chemistry, 1954), p. 2).
12. T. R. Malthus, *Essay on population* (London, 1798).
13. G. E. Fussell, *Crop nutrition: science and practice before Liebig* (Lawrence, Coronado Press, 1971).
14. K. Hudson, *Patriotism with profit: British Agricultural Societies in the eighteenth and nine-*

NOTES

teenth centuries (London, Evelyn, 1972).
15. W. Crookes, Presidential Address, *Reports of the British Association*, 1898, pp. 3–38.
16. O. C. Bockman, O. Kaarstad, O. H. Lie and I. Richards, *Agriculture and fertilizers: fertilizers in perspective* (Oslo, Agricultural Group of Norsk Hydro a.s., 1990).
17. Amos 4: 9.
18. Jonah 4: 7.
19. Joel 2: 25 (AV).
20. Exodus 10; Joel 1; Nahum 3: 15; Psalm 105: 34 etc.
21. J. Thomson and D. C. Abbott, *Pesticide residues: history, alternatives and analysis*, Royal Institute of Chemistry Lecture Series 1966 no. 3, (London, Royal Institute of Chemistry, 1966).
22. R. L. Wain, *Chemical aspects of plant disease control*, Royal Institute of Chemistry Lectures, Monographs and Reports, 1959, no. 3, (London, Royal Institute of Chemistry, 1959).
23. R. J. Cremlyn, *Agrochemicals: preparation and mode of action* (Chichester, England, John Wiley, 1991), pp. 1–16.
24. *Ibid.*, p. 13.
25. S. O. Duke, J. J.Menn and J. R. Plimmer, *Pest control with enhanced environmental safety*, ACS Symposium Series no. 524 (Washington, American Chemical Society, 1993).
26. Cremlyn, *Agrochemicals*, p.359.
27. P. Bowler, *The Fontana history of the environmental sciences* (London, Fontana, 1992), p. 548.
28. S. Boyle and J. Ardill, *The greenhouse effect* (Hodder & Stoughton, London, 1989), p. 237.
29. T. Fisher Unwin, *Industrial Rivers of the United Kingdom* (1888), cited in K. Warren, *Chemical foundations: the alkali industry in Britain to 1926* (Oxford, Clarendon Press, 1980), p. 100.
30. Warren, *ibid.*
31. J. Fenwick Allen, *Some founders of the chemical industry* (London, Sherratt & Hughes, 1906), pp. 245–6.
32. W. A. Campbell, *A century of chemistry on Tyneside, 1868–1968* (London, Society of Chemical Industry, 1968), p. 25.
33. D. W. F. Hardie, John Glover, *Chemical Age*, **78**, 1957, p. 816.
34. J. Lomas, *A manual of the alkali trade* (London, Crosby Lockwood, 1880), p. 145.
35. J. Morrison, Presidential Address 1878–1879, *Transactions of the Tyne Chemical Society*, 1878, pp. 164–71 (167).
36. W. Weldon, On some recent improvements in industrial chemical processes, *Journal of the Society of Chemical Industry*, **1**, 1882, pp 39–48 (42).
37. J. Hutchinson, evidence to House of Lords Select Committee on Injury from Noxious Vapours, 1862 (XIV), p. 177.
38. A. E. Dingle, The monster nuisance of all: landowners, alkali manufacturers,

and air pollution 1828–64, *Economic History Review*, **35**, 1982, pp. 529–48 (539).
39. T. K. Rabb, The effects of the Thirty Years' War on the German economy, *Journal of Modern History*, **34**, 1972, pp. 40–51.
40. R. B. Pilcher, Chemists at war, *Proceedings of the Institute of Chemistry*, **1**, 1917, pp. 29–30; to be fair he also referred to the conflict as 'an engineers' war'.
41. T. I. Williams, *The chemical industry* (Wakefield, EP Publishing, 1972), p. 72.
42. D. W. F. Hardie and J. D. Platt, *A history of the modern British chemical industry* (Oxford, Pergamon, 1966), p. 101.
43. M. Clarke, Report on meeting of the Institute of medicine at the National Academy of Science, Washington, *Nature*, **317**, 1985, p. 278.
44. The SCOPE Report, *Environmental consequences of nuclear war*, A. B. Pittock *et al.*, vol. I, *Physical and atmospheric effects*; M. A. Harwell and T. C. Hutchinson, vol. II, *Ecological and agricultural effects* (Chichester, England, John Wiley, 1985/6).
45. *Ibid.*, vol. I, p. 181.
46. *Ibid.*, vol. II, p. 480.
47. L. Dotto, *Planet Earth in jeopardy* (Chichester, England, John Wiley, 1986), p. 2; this book is a commissioned popular account of the findings of the SCOPE Report.
48. K. Denbigh, *Chemical Engineer*, April 1986, p. 30–32.
49. J. Stott, *Issues facing Christians today* (London, Marshall Pickering, 1984), p. 116; the original article was in *The Observer*, 13 October 1963.
50. F. Bacon, *Novum organum*, (London, 1620), Book ii, aphorism 52.
51. J. Calvin, *Commentary on Genesis*, 1554, tr J. King, 1847, reprinted Banner of Truth Trust (Edinburgh, 1965), p. 125.
52. W. Derham, *Physico-theology: or a demonstration of the being and attributes of God, from his works of creation*, 4th edn (London, 1716), pp. 281–2.
53. See e.g., C. A. Russell, *Pollution and the pipes of Pan*, Inaugural Lecture at the Open University, 10 May 1983.
54. H. Davy, *Fragmentary remains of Sir Humphry Davy*, ed. J. Davy (London, 1858), p. 14.
55. H. Davy, cited in A. Treneer, *The mercurial chemist* (London, Methuen, 1963), pp. 54–5.
56. H. Davy, A discourse introductory to a course of lectures on chemistry, 1802, in *Collected Works of Sir Humphry Davy* (London, 1839), vol. ii.
57. B. Farrington, *Greek science* (Harmondsworth, Penguin, 1953), p. 312.
58. J. G. Crowther, *Social relations of science* (London, Cresset Press, 1967), p. 1.
59. J. D. Bernal, *The social function of science* (Cambridge, Massachusetts, MIT Press, 1967), pp. 379–80.
60. Genesis 1: 26–8 (AV).
61. Genesis 1: 26–8.
62. I. L. McHarg, *Design with nature* (New York, Natural History, 1969), p. 26.
63. H. Montefiore, Man's dominion, ch. 7 in E. Barker (ed.), *The responsible church* (London, SPCK, 1966), pp. 77–90 (77).

NOTES

64. N. Young, *Creator, creation and faith* (London, Collins, 1976), p. 51.
65. Genesis 24: 16.
66. Ezekiel 43: 5 and 44: 4.
67. Montefiore, *Man's dominion*, p. 79.
68. A. Richardson, *Genesis 1–11: the creation stories and the modern world-view* (London, SCM, 1966), pp. 55–6.
69. Science, Religion and Technology Project Working Report, *While the Earth endures* (Edinburgh, SRT Project, 1986), pp. 6–8.
70. J. Moltmann, *God in creation: an ecological doctrine of creation* (London, SCM, 1985), pp. 5–7, 276–96.
71. An early 20th-century discussion of "the sacramental universe" was in William Temple's Gifford Lectures for 1933/4: W. Temple, *Nature, man and God* (London, Macmillan, 1934), pp. 473–95; see also A. Peacocke, A sacramental view of nature, in H. Montefiore (ed.), *Man and Nature* (London, Collins, 1975), pp. 132–42; and *idem*, *Creation and the world of science* (Oxford, Clarendon Press, 1979), pp. 289–91.
72. O. Hannaway, *The chemists and the Word: the didactic origins of chemistry* (Baltimore, Johns Hopkins University Press, 1975), pp. 55–6.
73. O. Croll, Admonitory Preface to *Basilica Chymica* (1609), pp. 96–7, in Hannaway, *The chemists and the Word*, pp. 48–9.
74. Hannaway, *ibid.*, p. 49.
75. 2 Samuel 23: 17.
76. Charles Kingsley, *Madam How and Lady Why, or lessons in earth lore for children*, 2nd edn (London, Macmillan, 1889), pp. 25–6.

Chapter 7

1. For a general account see A. Dieterich, *Mutter Erde: ein Versuch über Volksreligion* (Leipzig, Teubner, 1925).
2. A. J. Watson, A. J. Lovelock and J. E. Lovelock, *The Gaia hypothesis and Daisyworld*, Royal Society soirée leaflet, 17/18 June 1987.
3. M. Eliade, *The forge and the crucible*, tr. S. Corrin (New York, Harper & Row, 1962), pp. 52, 34.
4. See, e.g., Carolyn Merchant, *The death of Nature: women, ecology and the Scientific Revolution*, (New York, Harper & Row, 1982).
5. See, e.g., Rosemary R. Ruether, *New woman, new earth: sexist ideologies and human liberation* (New York, Seabury Press, 1975), pp. 186–214; Anne Primavesi, *From Apocalypse to Genesis: ecology, feminism and Christianity* (Minneapolis, Fortress Press, 1991).
6. T. Jacobsen, in H. Frankfort *et al.*, *Before philosophy* (Harmondsworth, Penguin, 1951), pp. 150–79.

NOTES

7. Genesis 16: 1; it has even been suggested that El Shaddai means the God-of-the-breasts. Its context here, in the book of Job and elsewhere implies also a "motherhood" of God; compare Isaiah 66: 13.
8. Some Greek and Roman "predecessors" of current ecological ideas are traced in I. M. B. Wiman, Expecting the unexpected: some ancient roots to current perceptions of nature, *Ambio*, **19**, 1990, pp. 62–9.
9. Cited by H. and H. A. Frankfort in Frankfort *et al.*, *Before philosophy*, p. 249.
10. G. de Santillana, *The origins of scientific thought* (New York, Mentor, 1961), p. 43.
11. Virgil, *Aeneid* VII.136.
12. Brewer's *Dictionary of Phrase and Fable* (article "Mother Earth").
13. Horace, *Odes*, III.iv, 73–4.
14. D. S. Wallace-Hadrill, *The Greek patristic view of nature* (Manchester, Manchester University Press, 1968), p. 105.
15. S. H. Nasr, *Islamic science: an illustrated study* (London, World of Islam Festival Publishing Co., 1976), p. 51.
16. E. Spenser, *The Faerie Queene* (1590), Book II, Canto xi, lines 396–401.
17. *Ibid.*, Book II, Canto vii, lines 145–8.
18. Pliny, *Natural History* 34.49.
19. F. Bacon, 1627, cited in Eliade, *The forge and the crucible*, p. 45.
20. De Rosnel, 1672, cited *ibid.*, p. 44.
21. As one writer remarks, "the chemical doctrine of seeds was by no means simple" (N. E. Emerton, *The scientific reinterpretation of form* (Ithaca, New York, Cornell University Press, 1984), pp. 177–208 (195)).
22. On alchemy see F. Sherwood Taylor, *The alchemists* (New York, Schumann, 1949); E. J. Holmyard, *Alchemy* (Harmondsworth, Penguin, 1957); J. Read, *Through alchemy to chemistry* (London, Bell, 1961); R. P. Multhauf, *The origins of chemistry* (London, Oldbourne, 1966) etc.
23. Eliade, *The forge and the crucible*, p. 51.
24. The three words "alembic", "aludel" and "alcohol" are all from Arabic alchemy.
25. Eliade, *The forge and the crucible*, p. 57.
26. G. Agricola, *De re metallica* (1556), tr. H. C. Hoover and L. H. Hoover (New York, Dover, 1950).
27. See Emerton, *The scientific reinterpretation of form*, p. 219.
28. O. Hannaway, *The chemists and the Word: the didactic origins of chemistry* (Baltimore, The Johns Hopkins University Press, 1975), pp. 22–57.
29. G. Agricola, *De re metallica*.
30. Francis of Assisi, Canticle to the sun (1225), tr. W. H. Draper *c.* 1909.
31. Rosita Shiosee, IPIC Resource Pack, in E. and M. Colebrook (eds), *Earthsong: a green anthology of poetry, readings and prayers* (Worthing, Churchman, 1990), pp. 47–8.
32. Sue Lightfoot, poem Gaia, *ibid.*, p. 90.
33. Evelyn Holt, poem The glory which is Earth, *ibid.*, p. 25.

NOTES

34. Sir George Trevelyan, 1989, cited in M. Cole, T. Higton, J. Graham and D. C. Lewis (eds), *What is the New Age?* (Sevenoaks, Hodder & Stoughton, 1990), p. 90.
35. Sir George Trevelyan, 1987, *ibid.*, p. 88.
36. Sir George Trevelyan, Advertisement for Wrekin Trust Conference, 1989, *ibid.*, p. 89.
37. Bill McKibben, *The end of nature* (Harmondsworth, Penguin, 1990), pp. 164–7.

Chapter 8

1. O. Mayr, *The origins of feedback control* (Cambridge, Massachusetts, 1970).
2. R. Porter, *The making of geology: Earth science in Britain 1660–1815* (Cambridge, Cambridge University Press, 1980), p. 111.
3. J. Hutton, *Transactions of the Royal Society, Edinburgh*, **1**, 1788, p. 216.
4. A. von Humboldt, *Kosmos*, 4 vols, 1845–58.
5. J. Grinevald, Sketch for a history of the idea of the biosphere, in P. Bunyard and E. Goldsmith (eds), *Gaia, the thesis, the mechanisms and the implications* (Camelford, Wadebridge Ecological Centre, 1988), pp. 1–32.
6. E. Suess, *Die Entstehung der Alpen* (Wien, Braumüller, 1875), p. 159.
7. G. B. Kauffman, Biosphere pioneer, *The World and I*, **6**, 1991, pp. 316–23.
8. Grinevald, Sketch for a history, pp. 11–12.
9. See, e.g., F. W. J. McCosh, *Boussingault: chemist and agriculturalist*, (Dordrecht, Reidel, 1984), pp. 123–47.
10. J. W. Mellor, *Modern inorganic chemistry* (London, Longman, 1919), p. 507; I am grateful to Dr W. A. Campbell for this reference.
11. The question why this particular mix of gases in air was so suitable for life was taken by some evolutionists as simply another case of organisms adapting to whatever environment they encountered. But even if true, this "explanation" fails to address the question why that environment was so well regulated in the first place.
12. A. Hansson, *Mars and the development of life* (London, Ellis Horwood, 1991).
13. J. Lovelock, *The ages of Gaia: a biography of our living Earth* (Oxford, Oxford University Press, 1988).
14. J. Lovelock, *Gaia: a new look at life on Earth* (Oxford, Oxford University Press, 1979), p. 11.
15. J. Lovelock, Hands up for the Gaia hypothesis *Nature*, **344**, 1990, pp. 100–2.
16. Lovelock, *The ages of Gaia*.
17. From A. Watson, Gaia, *New Scientist*, 6 July 1981 (diagram by Peter Gardiner).
18. G. P. Ayers and J. L. Gras, *Nature*, **353**, 1991, pp. 834–5.
19. This natural source releases more than five times more sulphur than the total world output of power stations!
20. *New Scientist*, **132**, 9 November 1991, p .2.

NOTES

21. From A. Watson, Gaia.
22. Lovelock, *Gaia: a new look at life on Earth*, p. 11.
23. *Ibid.*, p. 8.
24. A. J. Watson, A. J. Lovelock and J. E. Lovelock, The Gaia hypothesis and Daisyworld, Royal Society soirée leaflet, 17/18 June 1987.
25. A somewhat similar terminology has been applied to the "anthropic principle" which has long been recognized as having several shades (or depths) of meaning (J. D. Barrow and F. J. Tipler, *The anthropic cosmological principle* (Oxford, Clarendon Press, 1986)).
26. Lovelock, Hands up for the Gaia hypothesis, p. 100.
27. H. Davy letter to T. R. Underwood, in Anne Treneer, *The mercurial chemist: a life of Sir Humphry Davy* (London, Methuen, 1963), p. 80.
28. On ecofeminism see Chapter 7, notes 4 and 5.
29. C. Deane-Drummond, God and Gaia: myth or reality?, *Theology*, **95**, 1992, pp. 277–85 (281).
30. *Ibid.*, p. 278.
31. One such writer is thus unwittingly creating a result that he actually fears from Gaia, that it might "drive an unnecessary wedge between science and theology"! (L. Osborn, The machine and the Mother Goddess: the Gaia hypothesis in contemporary scientific and religious thought, *Science and Christian Belief*, **4**, 1992, pp. 27–41 (40–1)).
32. Lovelock, Hands up for the Gaia hypothesis, p. 102.
33. J. C. A. Craik, The Gaia hypothesis – fact or fancy?, *Journal of the Marine and Biological Association*, **69**, 1989, pp. 759–68.
34. A. Watson, Gaia, *New Scientist*, 6 July 1991, Inside Science no. 48, p. 2. This, however, is to ignore the experiential testing to which the people of God are invited ("Taste and see that the Lord is good", "Prove me now . . ." etc.).
35. M. R. Legrand, R. J. Delmas and R. J. Charlson, Climate-forming implications from Vostok ice-core sulphate data, *Nature*, **334**, 1988, pp. 418–20.
36. E.g. J. W. Kirchner, Gaia metaphor unfalsifiable, *Nature*, **345**, 1990, p. 470.
37. M. Hesse, *Models and analogies in science* (London, Sheed & Ward, 1963), pp. 97–8.
38. C. A. Russell, *The history of valency* (Leicester, Leicester University Press, 1971), pp. 314–16.
39. A. G. N. Flew, *New Biology*, **28**, 1959, pp. 37–8.
40. Thus Lawrence Osborn has reported that in 1,200 New Age publications substantial reference to Gaia appears in only seven, in conformity with a general hostility to science among those groups: Osborn, The machine and the Mother Goddess, p. 38.
41. Lovelock, Hands up for the Gaia hypothesis, pp. 100–2.
42. L. Thorndike, *A history of magic and experimental science during the first thirteen centuries of our era* vol. I (New York, Columbia University Press, 1923), p. 583.
43. E.g. Tony Higton, The environment as religion, in M. Cole *et al.*, *What is the New*

NOTES

Age? (Sevenoaks, Hodder & Stoughton, 1990), pp. 78–95 (88).
44. *Ibid.*, p. 90.
45. W. Prout, *Chemistry, meteorology, and the function of digestion considered with reference to natural theology*, 3rd edn (London, Churchill, 1845), p. 197.
46. E. C. Brewer, *Theology in science: or the testimony of science to the wisdom and goodness of God*, 7th edn, (London, Jarrold, n.d.), p. 208.
47. Cited in M. Eliade, *The forge and the crucible*, tr. S. Corrin (New York, Harper & Row, 1962), p. 46.
48. C. Schönbein, cited in C. C. Gillispie, *Genesis and geology: a study of the relations of scientific thought, natural theology and social opinion in Great Britain, 1790–1850* (New York, Harper & Row, 1959), pp. 200–1.
49. Revelation 4: 11 (AV).
50. P. Russell, *The awakening Earth: our next evolutionary leap* (London, Routledge & Kegan Paul, 1982).
51. K. Pedler, *The quest for Gaia* (London, Souvenir Press, 1979), p. 8.
52. J. Moltmann, *God in Creation: an ecological doctrine of creation*, tr. M. Kohl, 2nd impression (London, SCM, 1989).

Chapter 9

1. Sound tape in the author's possession.
2. Shakespeare, *The Tempest*, Act IV, Scene 1.
3. Attributed to William James and cited in W. R. Inge, *God and the astronomers* (London, Longmans, 1934), p. 30.
4. Fichte, cited in K. Heim, *The world: its creation and consummation*, tr. R. Smith (Edinburgh, Oliver & Boyd, 1962), p. 149.
5. References to these phenomena are scattered throughout the earlier part of the book, especially Chapter 4, and are not repeated here.
6. W. Thomson, On a universal tendency in nature to the dissipation of mechanical energy, *Philosophical Magazine*, **4**, 1852, pp. 304–6.
7. Debates as to the absolute rule of the Second Law are not relevant to the present argument.
8. G. L. Murphy, Time, thermodynamics and theology, *Zygon*, **26**, 1991, pp. 359–72 (370).
9. P. Russell, *The awakening Earth: the global brain* (London, Ark, 1984).
10. Isaiah 44: 24.
11. Psalms 29: 3–10; 89: 8–10; 135: 7.
12. Deuteronomy 28: 20–5, 27, 38–40; Psalms 105: 26–36; 107: 33–4.
13. Deuteronomy 26: 1–11; Psalm 65: 9–13.
14. Job 41.
15. Psalm 104: 26.

NOTES

16. 2 Kings and 2 Chronicles, *passim*.
17. C. S. Lewis, *Miracles* (London, Fontana, 8th impression, 1982), pp. 86–7, 97 (first published 1947).
18. E.g. M. Fox, *Original spirituality* (Santa Fe, Bear, 1983, pp. 88–92.
19. Acts 17: 24–31.
20. By a curious coincidence the historian George Macaulay Trevelyan, OM, FRS, was an uncle of Sir George Lowther Trevelyan, Bart, founder of the Wrekin Trust.
21. G. M. Trevelyan, *England under the Stuarts*, 17th edn (London, Methuen, 1938), p. 53.
22. R. O. Crombie, cited in M. Cole, J. Graham, T. Higton and D. C. Lewis, *What is the New Age?* (London, Hodder and Stoughton, 1990), p. 93.
23. C. S. Lewis, *Out of the silent planet* (London, Pan Books, 1952), p. 141.
24. E.g. Matthew 6: 5, 16; 18: 6–9; 21: 40–5; 23: 1–36 etc.
25. Heim, *The world*, pp. 106–7.
26. John 3: 16.
27. Genesis 3: 1–24.
28. P. Townby and L. Whibley (eds) *Correspondence of Thomas Gray* (Oxford, Clarendon Press, vol. III, 1971), p. 1088 (letter of 1769).
29. D. Defoe, *A Tour through the whole Island of Great Britain* (1724–6) Everyman Edition, (London, Dent, 1962), vol. II, p. 269.
30. See S. E. Alsford, Evil in the non-human world, *Science and Christian Belief*, **3**, 1991, pp. 119–30.
31. Genesis 3: 1–24.
32. Romans 8: 22.
33. Genesis 18: 25; cf. Psalm 94: 2; 96: 13; 98: 9 etc.
34. Habakkuk 3: 6–12.
35. Ezekiel 8: 12; 9: 9.
36. Malachi 4: 6.
37. 1 Corinthians 15: 21 (AV).
38. Isaiah 11: 6–8.
39. H. Berkhof, God in nature and history, *Faith and Order Studies* (WCC), **50**, 1968, p. 19.
40. J. Polkinghorne, *Reason and reality: the relationship between science and theology* (London, SPCK, 1991), p. 100.
41. See E. L. Mascall, *Christian theology and natural science*, (London, Longmans, 1956), pp. 32–6; R. J. Thompson, The theology of nature in the light of Creation, Fall and Redemption, *Faith and Thought*, **111**, 1985, pp. 145–60.
42. N. P. Williams, *The ideas of the Fall and of original sin* (London, Longman, 1927).
43. A. O. Dyson, *We believe* (London and Oxford, Mowbray, 1977), p. 46.
44. I. Trethowan, *An essay in Christian philosophy* (London, Longman, 1954), p. 128.
45. E.g. Zechariah 3: 1; Jude 6: Revelation 12: 10.

NOTES

46. C. S. Lewis, *The problem of pain* (London, Bles, 1940), pp. 122–3.
47. K. Ward, *Rational theology and the creativity of God* (Oxford, Blackwell, 1982), pp. 205–6.
48. J. Moltmann, *God in creation: an ecological doctrine of creation*, tr. M. Kohl, (London, SCM, 1985), p. 39.

Chapter 10

1. N. Baines, *Hungry for hope* (London, Darton, Longman & Todd (Daybreak), 1991).
2. E.g., J. Moltmann, *Theology of hope*, tr. M. Kohl (London, SCM, 1967).
3. See e.g., C. A. Russell, The social origins of the conflict thesis, *Science and Christian Belief*, **1**, 1989, pp. 3–26. There is now a large literature exposing the fallacy of a "conflict" interpretation.
4. Job 36: 22–37: 24; 38: 2–41: 34.
5. Psalm 24: 1; also 97: 5.
6. Psalm 104: 24 (AV).
7. Psalm 119: 64 (AV).
8. Psalm 33: 5 (AV).
9. Psalm 72: 19.
10. Psalm 19: 1.
11. Matthew 6: 28.
12. John 3: 16.
13. Matthew 21: 19.
14. Genesis 1: 10, 12, 21, 25.
15. Genesis 2: 8–14.
16. J. Moltmann, *God in creation*, tr. M. Kohl (London, SCM, 1985), pp. 276–96.
17. Psalm 83: 18.
18. Psalm 97: 5.
19. Genesis 18: 25; cf. Psalm 94: 2; 96: 13; 98: 9 etc.
20. Psalm 47: 2, 7; Zechariah 14: 9.
21. 1 Kings 18: 27.
22. Psalm 93: 1; 96: 10.
23. Psalm 77: 18.
24. Psalm 65: 9
25. Psalm 95: 4 (BCP version of *Venite*).
26. Psalm 119: 90.
27. Psalm 147: 15–17.
28. Genesis 9: 13–16 (a "P" narrative on traditional critical theory).
29. Genesis 8: 22 (a "J" narrative on traditional critical theory).
30. C. Kingsley, letter to F. D. Maurice, 1863, in *Charles Kingsley: his letters and memories*

NOTES

of his life (London, H. S. King, 1877), vol. ii, p. 171.
31. John 1: 1, 3.
32. Hebrews 1: 3.
33. Colossians 1: 16–17.
34. Moltmann, *God in Creation*, p. 211.
35. Matthew 10: 28–9.
36. R. J. Berry, Environmental knowledge, attitudes and action: a code of practice, *Science and Public Affairs*, **5**(2), 1990, pp. 13–23.
37. C. Taylor and A. Press, *Europe and the environment: the European Community and environmental policy* (London, The Industrial Society, 1992).
38. E.g. R. F. Nash, *The rights of nature: a history of environmental ethics* (Madison, University of Wisconsin Press, 1989), pp. 273–8; E. Katz, Environmental ethics: a select bibliography, 1983–1987, *Research in Philosophy and Technology*, **9**, 1989, pp. 251–85.
39. R. J. Berry, *Ecology and ethics* (London, IVP, 1972).
40. R. Attfield, *The ethics of environmental concern* (Blackwell, Oxford, 1983).
41. E.g., R. Moss, The ethical underpinnings of man's management of nature, *Faith and Thought*, **111**, 1985, pp. 23–56.
42. E.g. L. Timberlake, *Only one Earth: living for the future* (London, BBC Books/Earthscan, 1987); R. J. Berry (ed.), *Environmental dilemmas: ethics and decisions* (London, Chapman & Hall, 1993).
43. See e.g. those in Chapter 1, notes 2–4.
44. F. Bridger, Ecology and eschatology: a neglected dimension, *Tyndale Bulletin*, **41**, 1990, pp. 290–301 (301).
45 Luke 12: 42–8; 19: 12–27; 20: 9–18.
46. E. Sauer, *The king of the earth: the nobility of man according to the Bible and science* (Exeter, Paternoster Press, 1967), p. 97.
47. I. G. Gass, P. J. Smith and R. C. C. Wilson, *Understanding the Earth*, 2nd edn (Horsham, Artemis Press, for the Open University Press, 1972).
48. Isaiah 40: 31.
49. G. T. Prance, Appropriate technology and Christian belief: a case study of Amazonia, *Science and Christian Belief*, **5**, 1993, pp. 5–17.
50. C. de Witt and G. T. Prance (eds), *Missionary earthkeeping* (Macon, Mercer University Press, 1992).
51. A. Richardson, *The Bible in the age of science* (London, SCM, 1961), pp. 138–9.
52. Moltmann, *God in creation*, p. 208.
53. R. Jungk, *Brighter than a thousand suns*, tr. J. Cleugh (London, Gollancz, 1958), p. 60.
54. Isaiah 51: 6 (AV).
55. W. Thomson, draft MS Dynamical theory of heat, cited in C. W. Smith, Natural philosophy and thermodynamics: William Thomson and "The dynamical theory of heat", *British Journal for the History of Science*, **9**, 1976, pp. 293–319.
56. Psalm 102: 25–7; Hebrews 1: 10–12 etc.

NOTES

57. 2 Peter 3: 10–12 (AV).
58. J. Polkinghorne, *Science and creation: the search for understanding* (London, SPCK, 1988), p. 65.
59. Matthew 24: 36.
60. C. H. Spurgeon, *The sword & the trowel* (1867), p. 470.
61. J. A. T. Robinson, *Honest to God* (London, SCM, 1963).
62. R. Bultmann in H. W. Bartsch (ed.), *Kerygma and Myth* (London, SPCK, 1957), p. 3.
63. J. Calvin, *Institutes*, cited in J. Dillenberger, *Protestant thought and natural science* (London, Collins, 1981), p. 36.
64. e.g. C. S. Lewis, *Miracles* (London, Bles, 1947), pp. 177–86.
65. See, e.g., J. H. Brooke, Natural theology and the plurality of worlds: observations on the Brewster–Whewell debate, *Annals of Science*, **34**, 1977, pp. 221–86.
66. T. F. Torrance, *Space, time and resurrection* (Edinburgh, Handsel Press, 1976), p. 151.
67. See, e.g., F. E. Manuel, *The religion of Isaac Newton* (Oxford, Clarendon Press, 1974).
68. Torrance, *Space, time and resurrection*, p. 182.
69. W. Pannenberg, *Jesus – God and man* 2nd edn (Philadelphia, Westminster, 1977), p. 67.
70. Matthew 24: 14.
71. Moltmann, *God in creation*, p. 213.
72. G. L. Murphy, Time, thermodynamics and theology, *Zygon*, **26**, 1991, pp. 359–72 (370).
73. Torrance, *Space, time and resurrection*, p. 155.
74. Romans 8: 18–22.
75. K. Heim, *The world: its creation and consummation*, tr. R. Smith (Edinburgh, Oliver & Boyd, 1962), p. 145.
76. Revelation 1: 7.
77. Revelation 21: 1–7.
78. A recent analysis has suggested that environmental action is inhibited not so much by biblical literalism as by a rigid religion that focuses on so-called "certainties" (such as the date of the Parousia, for instance?) and neglects the gracious image of a God who cares intensely for his world: A. Greeley, Religion and attitudes towards the environment, *Journal for the Scientific Study of Religion*, **32**, 1993, pp. 19–28.
79. Hymn by a former Dean of Durham, C. A. Alington, significantly beginning "Ye that know the Lord is gracious" (1951).

Select bibliography

Attfield, R., *The ethics of environmental concern* (Oxford, Blackwell, 1983).
Berry, R. J., A bibliography on environmental issues, *Science and Christian Belief*, **3**, 1991, 15–18.
Berry, R. J., Christianity and the environment, *Science and Christian Belief*, **3**, 1991, 3–14.
Berry, R. J., *Ecology and ethics* (London, Inter-Varsity Press, 1972).
Berry, R. J., Environmental knowledge, attitudes and action: a code of practice, *Science and Public Affairs*, **5**(2), 1990, 13–23.
Bolt, B. A., *Earthquakes* (New York, W. H. Freeman, 1988).
Boyle S. & J. Ardill, *The Greenhouse effect: a practical guide to the world's changing climate* (Sevenoaks, Hodder & Stoughton, 1989).
Bridger, F., Ecology and eschatology: a neglected dimension, *Tyndale Bulletin*, **41**, 1990, 290–301.
Brimblecombe, P., *The big smoke: a history of air pollution in London since mediaeval times* (London, Methuen, 1987).
Brooke, J. H., *Science and religion: some historical perspectives* (Cambridge, Cambridge University Press, 1991).
Burke, J. C., *Cosmic debris: meteorites in history* (Berkeley, University of California Press, 1986).
Carson, R., *Silent spring* (Harmondsworth, Penguin, 1962).
Craik, J. C. A., The Gaia hypothesis – fact or fancy?, *The Journal of the Marine Biological Association* (**69**, 1989, 759–68).
Cremlyn, R. J., *Agrochemicals: preparation and mode of action* (Chichester, Wiley, 1991).
Dales, R. C., The de-animation of the heavens in the middle ages, *Journal of History of Ideas*, **41**, 1980, 531–50.
Dotto, L., *Planet Earth in jeopardy* (Chichester, Wiley, 1986).
Duke, S. O., J. J. Menn, J. R. Plimmer, *Pest control with enhanced environmental safety*, ACS Symposium Series no. 524 (Washington, American Chemical Society, 1993).
Eliade, M., *The forge and the crucible*, trans. S. Corrin, (New York, Harper, 1962).

SELECT BIBLIOGRAPHY

Elsdon, R., *Bent world* (Leicester, Inter-Varsity Press, 1981).
Elsdon, R., A still-bent world: some reflections on current environmental issues, *Science and Christian Belief*, **1**, 1989, 99-121.
Evans, J., Use and abuse of tropical forests, *Science and Christian Belief*, **2**, 1990, 141-4.
Harrison, R. M. (ed.), *Understanding our environment: an introduction to environmental chemistry and pollution* (London, Royal Society of Chemistry, 2nd ed. 1992).
Harwell M. A. & T. C. Hutchinson, The SCOPE Report, *Environmental consequences of nuclear war*, vol. II, *Ecological and agricultural effects* (Chichester, Wiley, 1985/6).
Hay, D. A., Christianity in the global greenhouse, *Tyndale Bulletin*, **41**, 1990, 109-127.
Hodgson, P. E., *Our nuclear future?* (Belfast, Christian Journals Ltd., 1983).
Hooykaas, R., *Religion and the rise of modern science* (Edinburgh, Scottish Academic Press, 1973).
Jordanova, L. J. & R. Porter (eds), *Images of the earth* (Chalfont St Giles, British Society for the History of Science, 1979).
Kaiser, C., *Creation and the history of science* (London, Marshall Pickering, 1991).
Katz, E., Environmental ethics: a select bibliography, 1983-1987, *Research in Philosophy and Technology*, **9**, 1989, 251-85.
Lovelock, J., *Gaia: a new look at life on Earth* (Oxford, Oxford University Press, 1979).
Lovelock, J., *The ages of Gaia: a biography of our living Earth* (Oxford, Oxford University Press, 1988).
Mason, B. J., *Acid rain: its causes and effects on inland waters* (Oxford, Clarendon Press, 1992).
McKay, D. M., *The clockwork image: a Christian perspective on science* (Leicester, Inter-Varsity Press, 1974).
McKibben, B., *The end of nature* (Harmondsworth, Penguin, 1990).
Merchant, C., *The death of Nature: women, ecology and the Scientific Revolution* (New York, Harper & Row, 1982).
Moltmann, J., *God in creation: an ecological doctrine of creation* (London, SCM, 1985).
Moore, P. D., The exploitation of forests, *Science and Christian Belief*, **2**, 1990, 131-40.
Murphy, G. L., Time, thermodynamics and theology, *Zygon*, **26**, 1991, 359-72.
Pannenberg, W., *Jesus - God and man* (Philadelphia, Westminster, 2nd ed., 1977).
Pecker, J-C. & S. K. Runcorn (eds), *The earth's climate and variability of the sun over recent millennia: geophysical, astronomical and archaeological aspects* (London, Royal Society, 1990).
Pittock, A. B. *et al.*, The SCOPE Report, *Environmental consequences of nuclear war*, vol I, *Physical and atmospheric effects* (Chichester, Wiley, 1985/6).
Polkinghorne, J., *Reason and reality: the relation between science and theology* (London, SPCK, 1991).
Polkinghorne, J., *Science and creation: the search for understanding* (London, SPCK, 1988).
Prance, G. T., Appropriate technology and Christian belief: a case study of

SELECT BIBLIOGRAPHY

Amazonia, *Science and Christian Belief*, **5**, 1993, 5–17.
Primavesi, A., *From Apocalypse to Genesis: ecology, feminism and Christianity* (Minneapolis, Fortress Press, 1991).
Rudwick, M. J. S., The shape and meaning of earth history, in D. C. Lindberg & R. L. Numbers, *God and nature: historical essays on the encounter between Christianity and science* (Berkeley, University of California Press, 1986).
Russell, C. A., *Cross-currents: interactions between science and faith* (Leicester, Inter-Varsity Press, 1985).
Sheets, P. D. & D. K. Grayson (eds), *Volcanic activity and human ecology* (New York, Academic Press, 1979).
Torrance, T. F., *Space, Time and Resurrection* (Edinburgh, Handsel Press, 1976).
Wallace-Hadrill, D. S., *The Greek patristic view of nature* (Manchester, Manchester University Press, 1968).
Warner, F. & R. M. Harrison, *Radioecology after Chernobyl* (Chichester, Wiley, 1993).
Watson, A., Gaia, *New Scientist*, 6 July, 1991, "Inside Science no. 48", p.2.
White, L., The historic roots of our ecologic crisis, *Science*, **155**, 1967, 1203–207.
Wilkinson, L., (ed.), *Earth keeping: Christian stewardship of natural resources* (Grand Rapids, Eerdmans, 1980).

Index

accidents 66–7
accommodation 16
acid rain 57, 60
age of the Earth 30–4
Agent Orange 83
aggression 82–6
Agricola, G. 102–104
agriculture 63, 75–8, 138
al-Farabi 98
alchemy 100–104, 122
Alkali Acts 64, 81
alkali industry 58–60, 80–81
Allhusen, C. 80
Alsted, J. 21
Amazonia 37, 53, 80, 148
amino-acids 44
ammonia 76, 110–11
Anaximenes 7
Antarctica 64, 120
"anti-geologists" 16
Apocalypse [Biblical book of Revelation] 21, 24, 26, 51, 151, 154, 156
Apollo 8 35
Aquinas, T. 8
Ardill, J. 80
Aristotelianism 8–10, 21, 103
Aristotle 8
Arrhenius, S. A. 57
arrogance 86–93
artificial manures 75–6, 110–11

asteroids 43–4, 47–8
atmosphere 44–6, 65, 109–14, 120, 123–4
Attenborough, D. 35, 53
Attfield, R. 146
Augustine 10, 13–14, 20–21
Avicenna 98
Babylonians 6, 52, 77, 132, 148
Bacon, F. 87, 89, 99
Bazalgette, J. W. 74
Becher, J. 103
Beeckman, I. 16
Berkhof, H. 140–41
Bernal, J. D. 89
Berry, R. J. 146
Bethlehem, Star of 42
Bhopal 64, 66–7
Bible, books cited
 Genesis 48, 86, 89–91, 137–9, 144–5
 Deuteronomy 132
 2 Samuel 92
 2 Kings 75, 132
 2 Chronicles 132
 Job 25, 49, 132, 143
 Psalms 25, 90, 132, 143–4
 Ecclesiastes 20
 Isaiah 25, 33, 132, 139–40
 Ezekiel 91

INDEX

Habbakuk 51-2, 139
Zechariah 144
Malachi 139
Matthew 143-4, 146, 151, 155
Luke 49, 147
John 137, 143, 146
Romans 138, 140, 156
1 Corinthians 140
Colossians 146
Hebrews 146
2 Peter 49, 138, 140, 149
Revelation 51-2, 71, 93, 121, 125, 156-7
Bible, problems of exegesis 28, 31, 51-2, 89-91
bioaccumulation 61
biology 16-7, 112
biosphere 57, 108
Bordeaux mixture 77
Borlaug, N. 73
Boussingault, J. B. 112
Bowler, P. 79
Boyle, R. 15-16
Boyle, S. 80
Brahe, Tycho 9
Brewer, E. C. 124
Brooke, J. H. 11
Brown, G. 38, 46
Buckland, W. 124
Buddhism 20
Bultmann, R. 151, 154
Burnet, T. 22-6, 28, 36, 137
Butter Yellow 60
Butterfield, H. 15

Calder Hall 67
Calvin, J. 9, 26-7, 87, 147, 152
Calvinism 26-7, 91-2
"Captain Planet" 106
carbon cycle 45, 109-10
Carson, R. 61, 73
Celsus 30
CFCs [chlorofluorocarbons] 63, 66, 73, 130

Chadwick, E. 74
Chardin, Teilhard de 108, 155
chemical industry 58-67
chemistry 8, 17, 75-8, 88, 91-2, 100-104, 112
Chernobyl 68-70
Chesterton, G. K. 13
China 20, 37, 40-41
"China syndrome" 70
cholera 74
Clausius, R. J. E. 32
Clean Air Acts 54, 64
cloud reflection 115
Comets 41-2
 Capricornus 42
 Halley's 42-3, 50
 Swift-Tuttle 42, 128
 Tycho Brahe's 8, 10, 41-2
conflicts between science and religion 10-11
Copernicanism 7, 9-10, 28, 119-20, 151-3
Copernicus, N. 3, 7, 9, 14
creation, continuous 144-6
Croft, H. 26, 28
Croll, O. 91-2, 103
Crombie, R. O. 134
Crookes, W. 76
crop nutrition 75
Crowther, J. G. 89
Cudworth, R. 16

Daisyworld 95, 115-16
Dales, R. C. 12
Darwin, C. 33
Darwinism 11, 28, 31-2, 34, 140, 145
Davies, G. 26
Davy, H. 8, 75, 88, 118
Dawkins, R. 121
DDT 61-3, 73, 130
de-animation 12
de-deification 12

INDEX

Defoe, D. 26, 137–8
denudation 25, 27
Derham, W. 27, 88, 147
Descartes, R. 16
design 17, 27, 34
dinosaurs 43–4, 115
dioxins 83
dominionism 87, 89
Donne, J. 22
"Doomsday conspiracy" 73
Drebbel, C. 107
Dyson, A. 141
"Earth Day" 1–2
"Earth First!" 106
earthquakes 25, 39–41, 47
 Alaska 41
 Biblical examples 40
 Calcutta 41
 California 40, 47
 Campania 40
 China 40
 Japan 39, 47
 Latur 41
 Lisbon 40, 50
 Shenshi 41
 Tangshan 41
Eckhart, Meister 133
ecofeminism 96, 119
ecological ethics 1, 147
eggs 102–103
Egypt 12, 97, 132
electricity 8
elements 8, 99, 103
Eliade, M. 96, 100–101
Environmental Defense Fund 63
Environmental Protection Agency 66
Epicureans 20
erosion 28
eschatology 148–57
Eudoxus 7
European Commission 146
Eusebius 98

exhaustion 76, 130
expendability 18
Fall of man 87, 137–41
Faraday, M. 55, 74
Farrer, A. 49–50
Farrington, B. 89
fatalism 46
feedback control 95, 107
Fermi, E. 149
Flagstaff, Arizona 43
Flixborough 66
Flood geology 23
Flood of Noah ["Deluge"] 23, 25–6, 30–31, 36–7, 42, 145
flooding 36–7
Fludd, R. 13
fogs 54
forests 51–3, 56, 80, 88
fossils 16
Fox, M. 133
Francis of Assisi 13, 87, 104
Frankfort, H. and H. A. 12
Frankland, E. 8, 74–5
Franklin, B. 39
furnaces 101–102
G7 Conference 146
Gaia 94–5, 97, 105, 107–25, 129–30
Galileo 10
Geneva Protocol 83
geological cycle 28
geology 108
Ghana 77
Gilbert, J. H. 75
Gilbert, W. 14
Glauber, J. R. 101
Glover, J. 81
Goethe, J. W. von 156
Golding, W. 113
Goldsmith, O. 107
Gossage, W. 60
Gray, T. 26, 137
Greece 7–8, 20, 97

189

INDEX

greed 79–82
greenhouse effect 45, 48, 53, 57, 84, 95, 114, 130
Greenwood, W. O. 17
Gregory 8

Haber, F. 76
Halley, E. 42
Hannaway, O. 91–2
Hassall, A. 74
Hawking, S. 9
heaven (distinction from Earth) 7
Herculaneum 37
Hesiod 75
Hesse, M. 121
Higton, T. 123
history 3–4, 149–50, 155
 cyclic views 20, 26
 linear views 21, 24
 necessity 3
Hodgson, P. 70
Holt, E. 105
homoeostasis 113, 130
Horace 98
Hoyle, F. 145
Humboldt, A. von 108
Humphreys, C. 42
Hutchinson, J. (author) 26
Hutchinson, J. (industrialist) 82
Hutton, J. 28, 30, 36, 108, 113
Huxley, T. H. 17, 33

Iceland 38, 41
ignorance 72–8
insects 55–6, 73, 77
Ionians 7
Iraq 83
Islam 98, 144

Jacobsen, T. 96
Japan 47–8, 53
Jesus Christ 143–4, 146
 in creation 144, 146

incarnation 91, 125, 136, 148, 153
 return 150–55
 teaching 49, 143, 146–7, 151, 155
Johnson, S. 81
Joule, J. P. 32
Judaism 2, 12, 15–17, 21, 51, 125, 132, 144
judgement 71, 139–40
Jupiter 10, 138

Kaiser, C. 8
Keill, J. 28
Kelvin, Lord [William Thomson] 17, 32–3, 129, 149
Kepler, J. 11, 16
Kingsley, C. 93, 145

Lake District [England] 26–7, 137
Lamarck, J. B. 30
Laplace, P. 8, 16
Lawes, J. B. 75
lead 60
Lebanon 52
Leblanc process 58–60
Lewis, C. S. 18, 132, 135, 141, 152, 155
Liebig, J. von 63, 75
Lightfoot, J. 30
Lightfoot, S. 105
Lockyer, N. 8
Lomas, J. 81
London 54–5
Lovelock, A. J. 95
Lovelock, J. E. 95, 112–13, 115, 117, 120–22, 130
Luther, M. 26, 152
Lutheranism 9
Lyell, C. 16, 28, 30, 37

magnetism 14
malaria 73
Malthus, T. 75, 77
Margulis, L. 117
Mars 112–13, 120

INDEX

marxism 89
materialism 17
Maurus [Abbott of Fulda] 7
Maxwell, G. 86
Maxwell, J. Clerk 31
Mayer, J. R. von 32
McHarg, I. 90
McKay, D. M. 17
mechanistic views 15–18
Mede, J. 21
Mellor, J. W. 112
Mendes, C. 80
mercury (element) 53–4
Mercury (planet) 11
Merseyside 56, 58, 80, 82
Mesopotamia 12, 37, 94, 96–7
meteorites 42–4
methane 109
Mexico City 66
Millardet, P-M-A. 77
millennium 21, 23–4
Miller, H. 16
Minemata Bay 53–4
mines, mining 14, 98–9
miracles 154
Mississippi 37
Moltmann, J. 91, 125, 141, 144
Montefiore, H. 90–91
Moon 44, 54
More, H. 16
Morrison, J. 81
"Mother Earth" 14, 94–106, 116–19, 121–3
mountains 22–7, 137
Murchison [Australia] 44
Muspratt, J. 56, 60

natural disasters 35–45, 52, 137, 139
natural theology 27, 49, 123–5
nature worship 13
neo-Platonism 14, 16
neptunism 36
"New Age" 4, 18, 105, 116, 122, 134

New Zealand 38, 47, 103
Newton, I. 16, 26, 42, 154
Nga Puia o-te-Papa 103
Nicholson, M. H. 23
Nietzsche, F. W. 136, 141
Nimbus 7 64
Ninhursaga 97
Nintu 12
nitrogen cycle 110–12
nuclear power 67–71
nuclear warfare 56, 83–6, 145
nuclear winter 55, 84–5, 131

oceans 53
oil spillage 53
Open University 38, 147
organismic world-view 12–13, 15–16, 105–106
organophosphorus compounds 62
Origen 13, 30
ozone 45, 63–4, 73

Pakistan 77
Pallisy 124
panentheism 133
Pannenberg, W. 155
pantheism 13, 131–5
Papin, D. 107
Paracelsianism 91, 99, 103
Pascal, B. 22, 24
patristic writings 20–21, 98
PCBs [polychlorobiphenyls] 63
Pedler, K. 125
pesticides 60–63, 77
Pindar 97
plankton 44, 115
plant disease 77
Plato, Platonism 7, 13–14, 20–21, 132
Playfair, J. 28
Playfair, L. 77
plurality of worlds 153
plutonism 36
Polkinghorne, J. 17, 141, 150

INDEX

pollution 58–71, 130, *passim*
 of air 54, 56, 58–60, 67, 81, 102
 of oceans 53–4
 of rivers 54, 63
Pompeii 37–8
population 57, 74–5, 134
Porter, R. 108
Porton Down 83
post-modernism 4, 18, 134
potato famine 77
poverty 80
Prance, G. 148
process theology 155
Prout, W. 123–4
providence 50, 125
Ptolemy 7, 10
Puritanism 27, 46
Pythagoras 7

Qutang Gorge 37

radiation 44–5
radioactive dating 34
radioactivity 33
rainbow 145
Ray, J. 27
reductionism 16–17, 152
Reformation 9, 12, 24
Richardson, A. 91
Robinson, J. 151
Robinson, T. 27
romanticism 8, 118
Rome 97
Royal Society 15, 94–5
Rudwick, M. J. S. 28
Russell, P. 125

sacramentalism 91–2
Schiaparelli, G. V. 43
Schönbein, C. 124
science and environment 56–71
science, nature of 119–22, 154
Scientific Revolution 15, 21, 27
SCOPE 84–5

Sedgwick, A. 31
self-compensation 73, 107–16, 123–4
self-sufficiency 17
Sellafield 67
Seveso 66
Sevin 67
sewage 54, 74
Shakespeare, W. 127
Shiosee, R. 104–105
Siloam, Tower of 49
Singers, H. 66
Smith, Adam 107
Smith, R. Angus 56–7
Snow, J. 74
spacecraft 19, 35
Spenser, E. 98–9
Spurgeon, C. H. 151
stewardship 5, 146–8
Stoics 20
Stott, J. 86
sublimation 101
Suess, E. 57, 108
Sun 43, 54, 84
 cycles 73
 heat of 32, 45, 48, 73, 114, 128–9
 prominences 10
sunspots 10
supernova 8, 10
Sweden 8

technology 46–8, 57
teleology 121, 123–5
Templeton, J. vii, 2
Tennant, C. 60
Thales 7, 14
Thames 54–5
Theophilus of Antioch 30
thermodynamics 32, 112–13, 117, 120, 129, 149, 155
Thorndike, L. 123
Three Mile Island 68
Tillich, P. 139
Torrance, T. 154, 156

INDEX

Torrey Canyon 53, 58
trees 52–3, 56
Trevelyan, G. 105, 123
Trevelyan, G. M. 134
Tunguska 42–3
Tyne Chemical Society 81
Tyneside 58–9, 80–81
typhoid 74–5

Ussher, J. 28, 30

Venus 10–11, 42, 113
Verdnasky, V. 108
Viking mission 120
Virgil 97
vitalism 17
volcanoes 37–40, 138
 Etna 37, 98
 Galeras 38, 46
 Lakagigar 38–9
 Tarawera 38
 Vesuvius 37–8
voyages of discovery, Portuguese 10

Warner, F. 84
Wars 82–6
 English Civil War 21
 First World War 83
 Second World War 83, 136
 Thirty Years War 83
 Vietnam War 83
water supply 63, 74–5
Watson, A. J. 95, 120
Watt, J. 107
Watts, W. 10
weathering 56, 114
Weldon, W. 82
Wellington [New Zealand] 47
Wells, H. G. 42
Werner, A. G. 36
Wesley, J. 21, 50
whaling 54
Whiston, W. 42
White, L. 3, 56, 86–7, 89
Williams, N. P. 141
Windscale 67
Woodward, J. 26
Woolley, L. 37
Woulfe, P. 104
Wrekin Trust 105

Yangtze 37
Young, N. 90–91

For Product Safety Concerns and Information please contact our EU representative GPSR@taylorandfrancis.com
Taylor & Francis Verlag GmbH, Kaufingerstraße 24, 80331 München, Germany

www.ingramcontent.com/pod-product-compliance
Lightning Source LLC
Chambersburg PA
CBHW060606230426
43670CB00011B/1990